D0619653

KITAJ:
PICTURES AND
CONVERSATIONS

KITAJ: PICTURES AND CONVERSATIONS

Julián Ríos

HAMISH HAMILTON · LONDON

HAMISH HAMILTON LTD

Published by the Penguin Group
Penguin Books Ltd, 27 Wrights Lane, London W8 5TZ, England
Penguin Books USA Inc., 375 Hudson Street, New York, New York 10014, USA
Penguin Books Australia Ltd, Ringwood, Victoria, Australia
Penguin Books Canada Ltd, 10 Alcorn Avenue, Toronto, Ontario, Canada M4V 3B2
Penguin Books (NZ) Ltd, 182–190 Wairau Road, Auckland 10, New Zealand

Penguin Books Ltd, Registered Offices: Harmondsworth,
Middlesex, England

First published in Spain under the title *Impresiones de Kitaj: La Novela Pintada* by
Mondadori España, S.A., 1989

English edition first published in Great Britain by
Hamish Hamilton Ltd 1994
10 9 8 7 6 5 4 3 2 1

This book is a shorter version of *Impressions of Kitaj: The Painted Novel*, which first
appeared in a Spanish translation published by Mondadori España SA in 1989.

The publishers would like to thank Marlborough Fine Art (London) Ltd for their help
in the production of this book.

Extracts from 'The Hollow Men' and *The Waste Land* reprinted by permission of the
Estate of T. S. Eliot from *Collected Poems 1909–1962*, published by Faber and Faber
Ltd and Harcourt Brace & Company. Extracts from 'Canto LXXXI' and 'Canto
CXVI' by Ezra Pound reprinted by permission of the Ezra Pound Literary Property
Trust from *The Cantos of Ezra Pound*, published by Faber and Faber Ltd and New
Directions Publishing Corporation. Permission to reprint a section of the poem 'Blues
for Lonnie Johnson', first published in *An Ear in Bartram's Tree* (University of North
Carolina Press, Chapel Hill, 1969) is granted by Jonathan Williams.

Filmset in Monophoto Baskerville by Selwood Systems,
Midsomer Norton
Printed in Great Britain by Butler & Tanner Ltd, Frome and London

A CIP catalogue record for this book is available from the British Library
ISBN 0–241–13236–3

CONTENTS

'What is the use of a book', thought Alice, 'without pictures or conversations?'

Lewis Carroll, *Alice's Adventures in Wonderland*

PREFACE
IMPRESSIONS OF KITAJ

Kitaj is China in Russia, that is, Cathay, and I remember that
when in the spring of 1986 we took the first steps towards this
book, without having yet detailed its itineraries, I announced to
R. B. Kitaj, after receiving a new catalogue of his work, that
without pretending to play Polo I was about to begin my travels
to Kitaj. I was a foreigner in a vast country – as e. e. cummings
well observed, an artist is his own and unlimited country –
working in the foreign languages of English and art. But as every
cloud has a silver lining, the lack of excessive familiarity with
those languages could paradoxically provide, thanks to that
curious phenomenon the Russian formalists called
'defamiliarization', a new vision. A foreigner usually sees words,
even their trails and entrails, for instance the strange 'liver' in
Liverpool, with more acuity than one accustomed to using and
spending them as ordinary coins. Or he even coins them for a
change. This is why I maintain, maybe heretically, that at heart
the creative writer is a foreigner in his own language. But
anyhow, as I am neither a critic nor an art historian nor a
connoisseur but only a novelist who occasionally writes
empathetically on a few painters who stimulate him creatively,
I always had in mind, while preparing this book, the advice of
the rigorous Valéry that one should excuse oneself for being so
bold as to speak about painting. So how was this intruder going
to speak about painting? In two ways, though I don't know if
they are legitimate: by speaking with the painter and by trying
to speak *with* his painting.

R. B. Kitaj wanted to converse with me in my field – writing – and proposed from the beginning that our conversations be written, a continuation of a correspondence that started in 1980 and became more intensive towards the end of the decade. So the painter became my guide – sometimes my '*lazarillo*', a blind man's guide – through his own painting. But every real work of art, and especially such complex art as Kitaj's, goes further than the intentions and explanations of its author, who after all, at heart, realizes it, as San Juan de la Cruz said, '*con un no saber sabiendo*', with a knowing ignorance. Hence the need also to address the work itself.

The novelist Julio Cortázar, who wrote occasional but very precise poetic prose on art, observed that some pictures ask for the critic's eye and others rather for the voice of the poet. I would say that Kitaj's painting incites the fictionist we all have inside us, invites an imagination-accomplice, and would ultimately require the efforts of a supreme novelist for whom poetry, criticism and fiction would be one and the same. But on the other hand, his paintings depict situations and characters, take the appearances of a painted novel, and so to speak with them in the same language and above all to try to listen to what they say, in the chapter 'The Trees of Knowledge' I preferred to have three fictional characters, A, B and C, carry on the conversation.

The mosaic structure of this book allows a partial reading of each of the chapters or 'mosaics', which centre on important thematic aspects of Kitaj's work. It is also an invitation to see between the lines, to read between the images. The illustration is the heart or *cor* – to say it in emblematic terms – and the accompanying text the *anima* of the book. And vice versa, because reversals abound in the country called Kitaj and sometimes the word is the tell-tale heart ... In any case, in front of a work as rich and mysterious as Kitaj's, explication involves new complications. And going through it one discovers secret pages and stories which may never be deciphered and might be saying that art, like life, has its secrets. Or mysteries, in Mallarmé's terms. There must be something secret in the depth of all things. To say it graphically I would like to conclude this preface with Kitaj's secret page. Every author wants the reader to be the secret sharer.

Secret Page, c. 1963

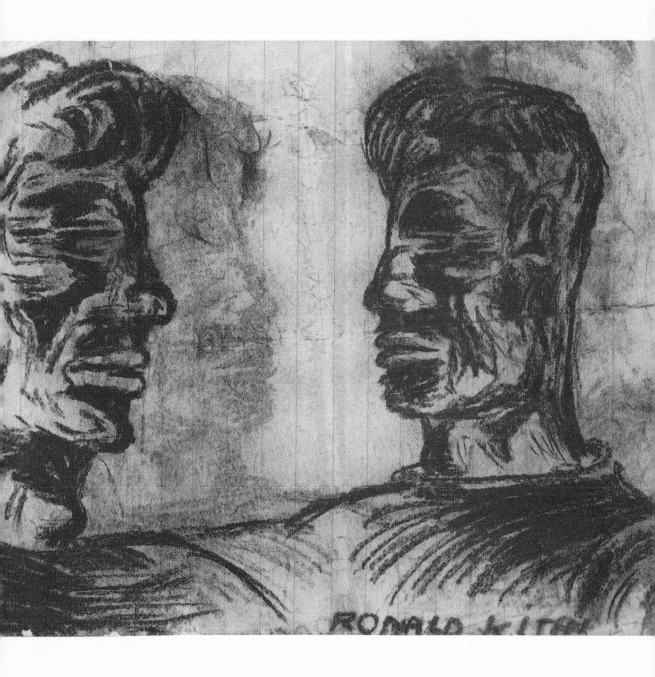

*From the Troy Days, c.*1942–5

DRAWING ACCOUNTS

Drawing the human form each day seems to me a natural passage toward the other shore. It's my way forward, my manifest destiny, helped by some few who have gone before.

R.B.K.

J.R. Novalis, in his seminal *Encyclopaedia*, remarked that in the painter the hand becomes 'the seat of instinct', and in an interview you talked about the instinct for drawing from the human form. Would you talk about this instinct for drawing in general, through the various phases of your formative years? For example, the importance of Abstract Expressionist concepts of 'gesture' or the Surrealist method of automatic drawing? Have you experienced since childhood the compulsion to draw? Is there any drawing not destroyed from the Troy days?

R.B.K. Here is one I did in Troy when I was about twelve. It was my neo-Expressionist period.

J.R. Before this Trojan drawing you must have made many others, because from 1937 till 1942 you attended the children's classes at the Cleveland Museum of Art. Those were your first art lessons, and you have said that you remember drawing from the Greek statues there. So academic training is deeply rooted in your life. This is a question which divides artists. I know you are for the teaching of life drawing, and I remember a conversation years ago in which you expressed some regret at not having had more classic training in your earliest youth. And between 1951 and 1953, you followed art studies in Vienna with Albert Paris von Gütersloh and Fritz Wotruba. Since in your interview with Timothy Hyman, 'A Return to London', you have spoken in detail of your 'Blue Danube'

I

period, I will put in your mouth now your own words from that time. So it returns, *la vie de Vienne revient* ...

1952 ... *very* Third Man! Vienna was bombed out, spent and bleak. I attended the Art Academy where Schiele had been a student. I worked in the studios of Professor Albert Paris von Gütersloh. There's a good portrait of Gütersloh as a young man by his friend Schiele. He was one of those morbid Viennese Surrealists not unlike Burra. You couldn't keep warm so I was always at the train station going somewhere – hiking in Salzkammergut, down to the sea at Fiume and Trieste. Very youthful Russian troopers were everywhere with acne and Sten guns examining papers. I read a lot in cafés that are now gone with the wind and ran in a louche pack of students who lived and loved in romantic attics. Kafka and Joycean exile meant more to me then than the gorgeous Bruegels and Velázquezes in the great Hapsburg collection. But I was drawing every day from models, rosy with cold, who were meticulously posed early in the morning (even to the placement of the joints of fingers). Gütersloh worked in his own adjoining studio, very grand with samovars and tapestries. He came to bless his students once a week or so. I was more 'influenced' by a man who was my closest friend at that time. He was an American painter named Frederic Leighborne Sprague. Fred was at least twenty years older than me, an ex-officer living on the GI Bill. He was the black sheep of a rich Back Bay family and had spent his youth burning the candle at both ends. His Redemption was upon him and he lived for two things: Roman Catholicism and Art. He hooked me on his version of the art and *almost* converted me to his Church. He got me as far as weekly private sessions with one of the loveliest men I've ever come across. Monsignor Ungar, a leading Roman Catholic scholar in Vienna. (I painted a little portrait of Ungar.) Believe it or not, I could thrive on contention in those days – not the timid soul I am today – and I really fought for my immoralism against that regular dosage of received wisdom. As to the art, Fred Sprague led me through the unexplored backwaters of Mittel Europa. Schiele and Klimt were almost unknown outside Austria then. And, as is so often the case (like the circle around Picasso in Barcelona), there was a fabled wider circle of artists who are not exported even now, like Max Oppenheim, the very interesting Richard Gerstl, Arnold Schoenberg (as a painter), and the odd types teaching at the Academy like Herbert Boeckl, whose form of undigestible figurative Cubism would seem now like a classical instance. Sprague and I would visit rural monasteries where he executed murals from time to time and we would touch on the lives of those modest men and come away in an aura. In Vienna, although he had very little money, he somehow found Schubert's elegant old

rooms to rent in the medieval Annagasse and it was there we argued art and anarchy. To this day, I still mix some colours the way he did. He looked like Francis X. Bushman and had silver hair down to his shoulders.

Could you add something about your impressions of that Vienna and the people who impressed you most at that time? I would like to see your Monsignor Ungar portrait.

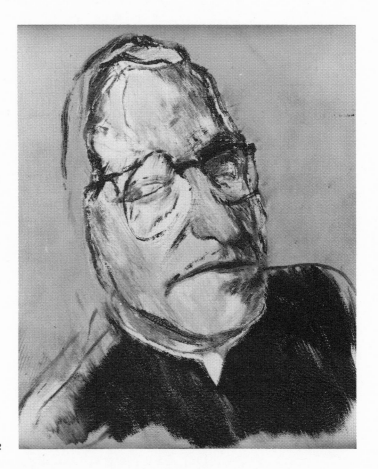

Monsignor Ungar, Vienna, *c.* 1952

R.B.K. In Vienna I was impressed by a certain brutality mixed in the same dumpling batter as the famous Viennese sweetness – many older and younger people one met were provincial, savage, blind to the recent past. Now I know the facts (since Waldheim): that 10 per cent of Austrians were Nazi Party members; in Germany only 7 per cent were! I think that gives a good picture

of some of those Kärntnerstrasse Kauboys, as we used to call them. Many top Nazis were Austrian – Hitler, Eichmann, Kaltenbrunner, Death Camp commanders like Stangl, etc. You could smell them in the streets. The people who made Vienna great, both Jews and non-Jews, were gone or silenced, exhausted. But I did meet some extraordinary people from another Austria, a golden Austria.

J.R. Perhaps something is rotten in the state of Austria. One of its greatest writers, Robert Musil, named it *Cackania* ... But there is another state – of mind – that I would call *Kafkania*, which you have known for a long time. And I think it was in Vienna that you started to explore in depth the universe or multiverse of Kafka. How was your *Wienerisch/venerisch* world?

R.B.K. Don't forget, I was very young, nineteen or twenty, and my colleagues were students at the Academy. My world was composed of students, landladies and girls. I met the American girl there, at a University anatomy night class, who would become my first wife. Our romance was conducted along the Brown Danube and in the pretty outlying districts. One rarely saw the professors. But yes, I did experience Kafkania there, maybe for the only time in my life outside his books. Nothing was modernized, you see, and so a clerk, an office, a concierge, an atmosphere, a peculiar street, a rented room, would seem as K. had seen them. And another strange thing – just as Kafka invokes the Terror to come, Vienna in 1950 was a vestige of the same Terror just past, just experienced.

J.R. Did somebody in Vienna inspire your *Little Convert*?

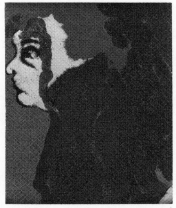

Little Convert, c. 1953

R.B.K. I gave *Little Convert* a title only recently – because, aged twenty, I almost became a Catholic in Vienna for about two weeks. The Little Convert doesn't look like me because I never became one!

J.R. And from 1958 till 1959 you attended the Ruskin School of Drawing and Fine Art in Oxford. Some of the paintings of that period show your interest in the human form and that you were drawing from life. Was Miss Ivy Cavendish a model?

R.B.K. Yes, Ivy Cavendish was an elderly model.

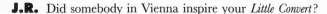

4

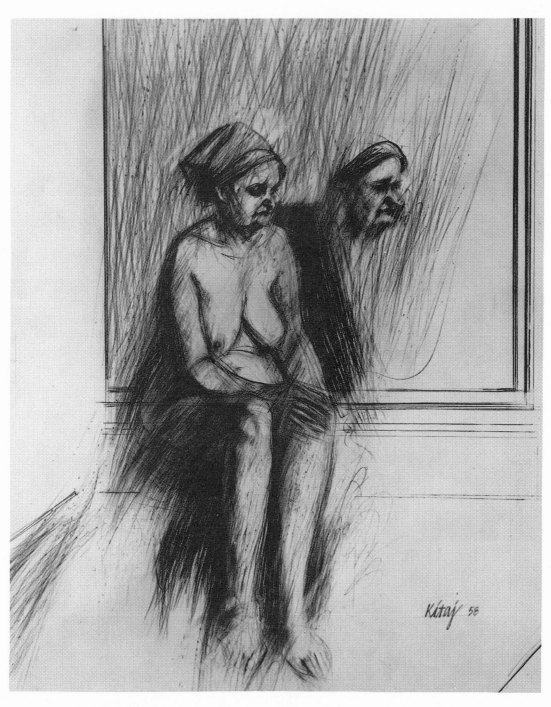

Miss Ivy Cavendish (Oxford), 1958

J.R. And how was your life among the English dons?

R.B.K. Again, my life was among students, not dons – except that I was befriended by the great and controversial Professor Edgar Wind, who was appointed to the first Professorship in Fine Art in Oxford's 1,000-year history. His lectures were fabulous and have gone into legend. My closest pals, oddly enough, were three young American philosophers. I'm still close to them today. Mainly, I began my family. My son Lem was born there at Oxford in 1958, and yes, I spent most of the two years drawing and painting from life in those great Ashmolean rooms.

J.R. Oxford seems to have been of decisive importance in your intellectual formation: the influence of Professor Edgar Wind, the Ashmolean Museum, the iconological discoveries, the art studies ...

R.B.K. Yes, my iconological studies were born there at the Ashmolean, where I discovered the Warburg tradition through their wonderful publications, which quickly caught my Surrealist eye (the one in the centre of my forehead). I think I spent my last shilling buying the complete set of *Warburg Journals* (in Blackwell's antiquarian department), which I still cherish to this day for their magical plates and arcane texts. Oxford in the late fifties was a last refuge for that great generation of Jewish scholars. Even their art books turned up in the Broad Street shops. I bought Maréesgesellschaft facsimile editions and original Expressionist and Impressionist prints in the Struck and Duret publications. But I guess what I remember best were the Raphael drawings in that little room upstairs at the Ashmolean. Pity I didn't copy them.

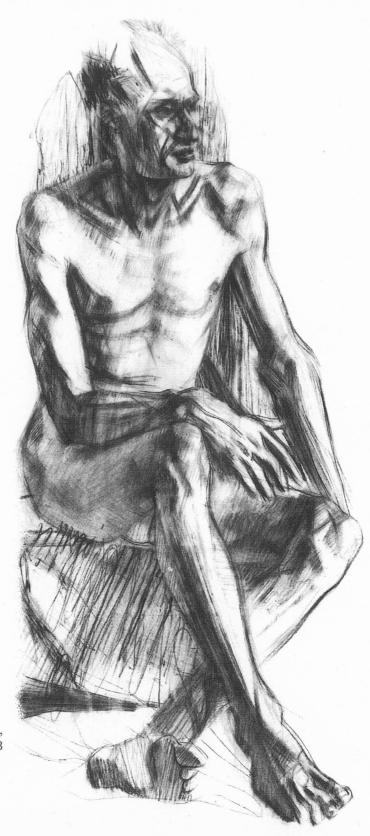

An Oxford Man (legs crossed),
1957‑8

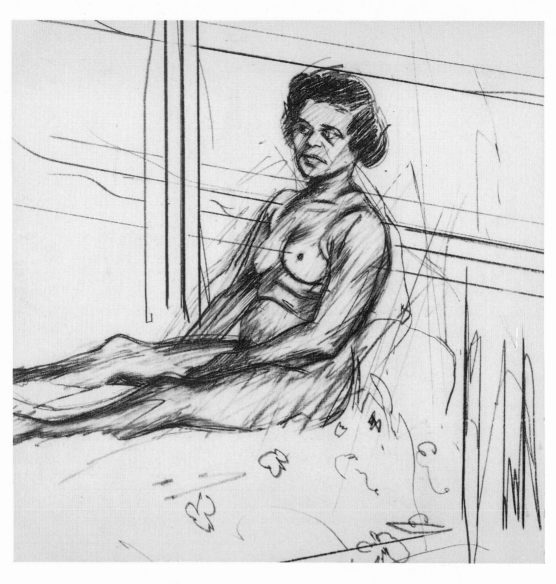

An Oxford Woman (seated, face left),
c. 1958

Tough Oxford Woman, 1957–8

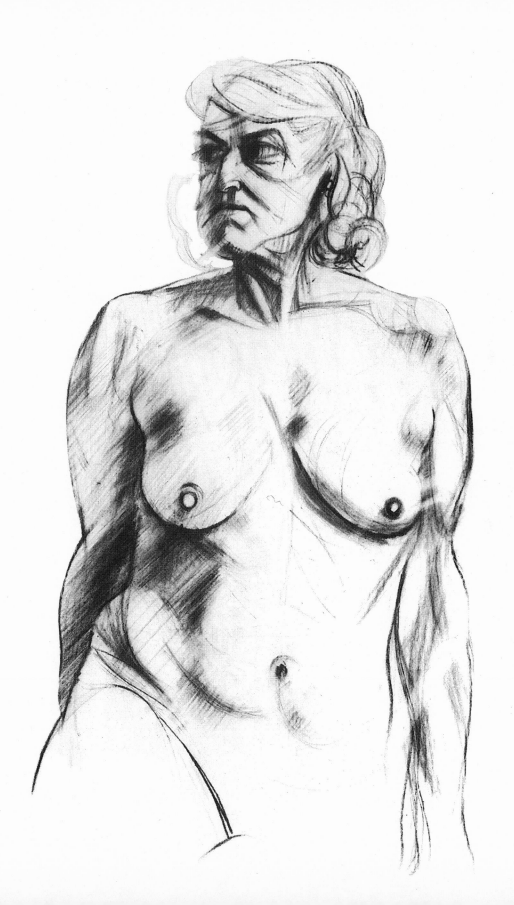

J.R. In 1960 you entered the Royal College of Art in London and for two years, till your graduation in 1962, you continued to draw from live models. But few nudes and drawings are known from this London period. Did you destroy them as you did your Viennese works?

R.B.K. Some are lost but some lie in portfolios. At the Royal College I began to spend most of my time painting, so there are fewer drawings. Some I gave or traded to friends. I also drew from the model straight on to canvas, which became my usual practice during that whole decade 1960–70. Drawing got covered up by oil paint. I never really stopped drawing. It just became subsumed in each picture. Then, around 1970, I began to make separate drawings on paper again, ashamed of myself for straying from the tradition as Picasso and Matisse had never done. As everyone knows but many forget, the two greatest modernists are also the two greatest draughtsmen of the human figure since Degas.

Drawing includes three and a half quarters of the content of painting. If I were asked to put up a sign over my door I should inscribe it: School for Drawing, *and I am sure that I should bring forth painters.*

Jean-Auguste Dominique Ingres, Notes and Thoughts on Art

J.R. During those years as a student and later on (1961–7) as a professor as well as a painter, draughtsmanship seems to be the backbone of your art. Do you think, with Ingres, that drawing is the probity of art?

R.B.K. Yes! But *mind* first. The sort of mind where ideas produce everything, including drawing, good drawing as opposed to ordinary drawing. I love his idea that drawing brings forth painters. In fact, now [1990] I dare to use drawing as never before in my painting practice. At the end of our century, maybe the diktat 'paint for paint's sake' gives cause for reflection. I'm not saying its writ is run – I really love painterly painting – but I have a feeling that emphatic drawing may reform painting with new bloodlines.

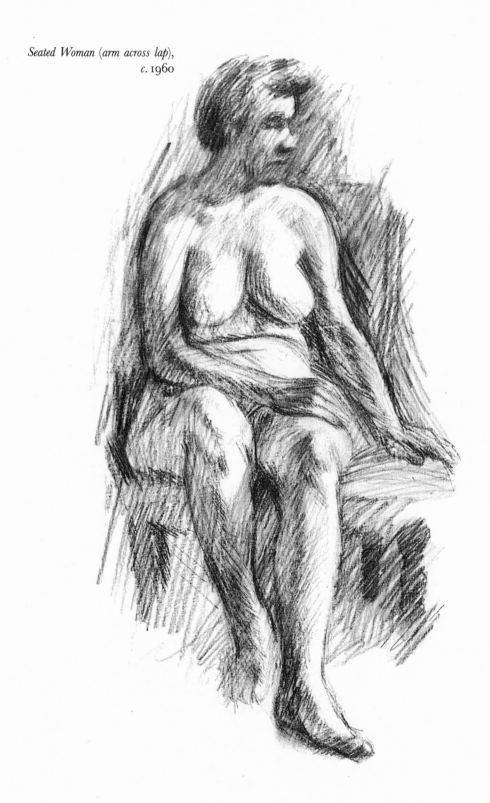

Seated Woman (arm across lap),
c. 1960

Painting ... was first invented, saith Patricius, *ex amoris beneficio*, for love's sake. For when the daughter of Dibutades the Sicyonian was to take leave of her sweetheart now going to wars, *ut desiderio ejus minus tabesceret*, to comfort herself in his absence, she took his picture with coal upon a wall, as the candle gave the shadow, which her father admiring perfected afterwards, and it was the first picture by report that ever was made.

Robert Burton, *The Anatomy of Melancholy*

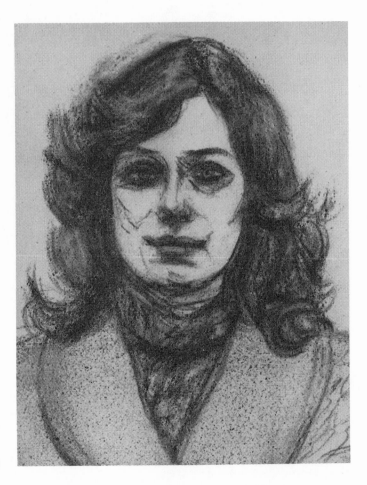

Sandra in Paris (detail), 1983

Grandmother Helene Kitaj, Aged 102,
1983

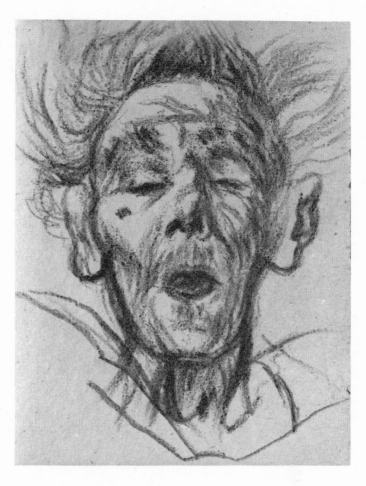

Between the idea
And the reality
Between the motion
And the act
Falls the Shadow.

T. S. Eliot, The Hollow Men

J.R. This fable of the invention of painting, art for love's sake, has always delighted me. The fable poses the old question about the 'real thing' and its mimesis. To paint is – like writing and in fact any artistic production – to cast away the substance for the shadow. At the same time this gives the possibility to recover the losses. Have you ever felt that you were a draughtsman in a game against time? Especially when you are painting someone you love ...

R.B.K. When I draw my little son, Max, of course it is a game against time because he moves. Sandra sits still because she doesn't like to pose, so I race against *her* time. My mother has nothing better to do, so I can slow down. When my cat died her career as a model ran out of time. And so on ...

13

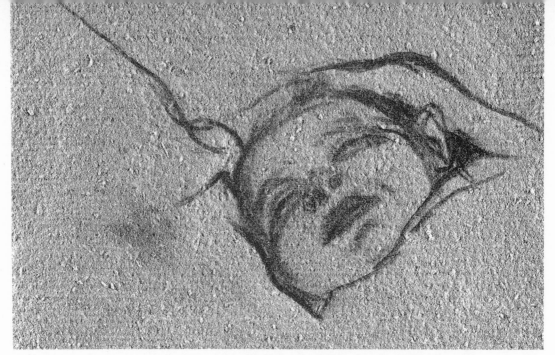

Max, 10 Minutes Old (detail), 1984

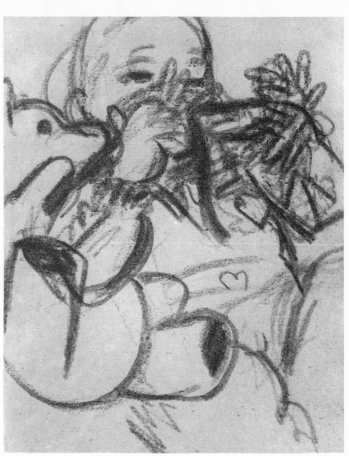

Max and Teddy, 1985

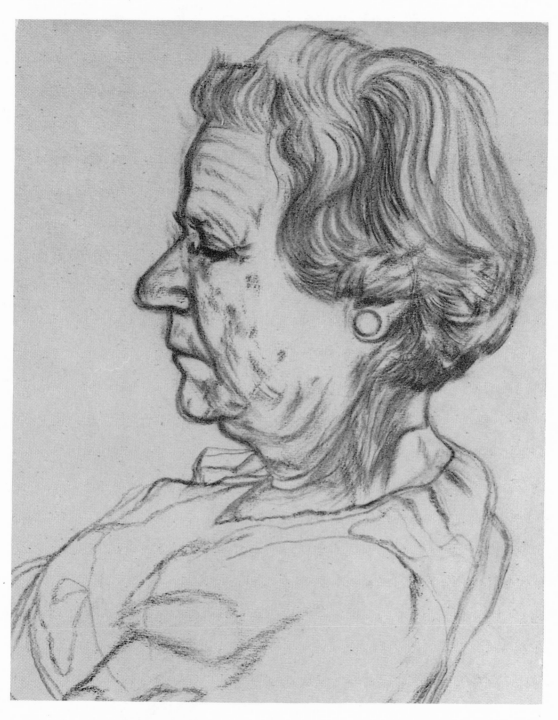

Mother (*face left*)

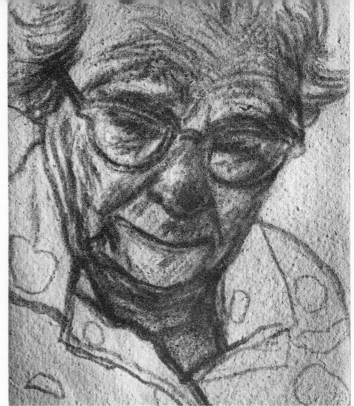

Mother (Weeping), 1982

Walter (Dr Kitaj at Troy), 1958

16

Lem (*Sant Feliu*), 1978

Dominie (Ninth Street), 1978–9

My Cat and Her Husband, 1977

THE TREES OF
KNOWLEDGE

For me, books are what trees are for the landscape painter.

R.B.K.

R.B.K. The *Erasmus Variations* is the first modernist painting I finished in England. Here too are the Erasmus doodles which inspired my picture. It was a long time ago. I was a fairly happy student at the drawing school John Ruskin founded at Oxford University. Ruskin wanted students to learn to draw so they could copy the gargoyles on European cathedrals when they made the Grand Tour. There was a bunch of us American ex-soldiers there on the GI Bill of Rights, chasing goyles, according to our Rights, when I made these gargoyles after the two Dutchmen – Erasmus and De Kooning. I thought De Kooning was the cat's meow, and I think it shows.

J.R. The cunning of these *Variations* lies in connecting De Kooning with his fellow citizen Erasmus: the marginal doodles of the great humanist of Rotterdam are repeated with 'muddyfications' which suggest the automatic methods of De Kooning. Besides, your 'copied' gargoyles are the best illustration of Huizinga's remark on Erasmus: 'Only when humour illuminated that mind did it become truly profound.'

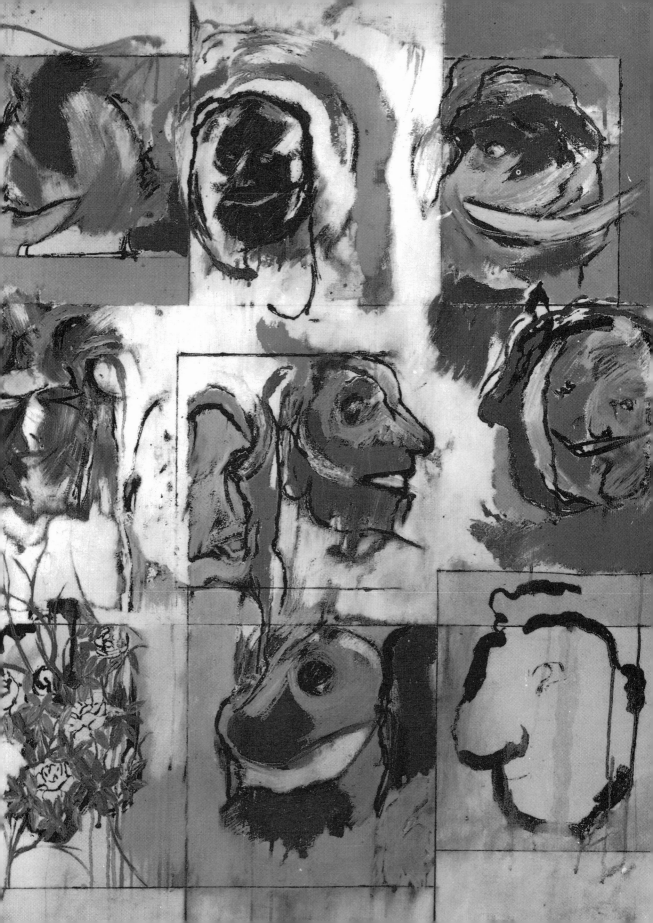

Sketches after Erasmus, c. 1958

Erasmus Variations, 1958

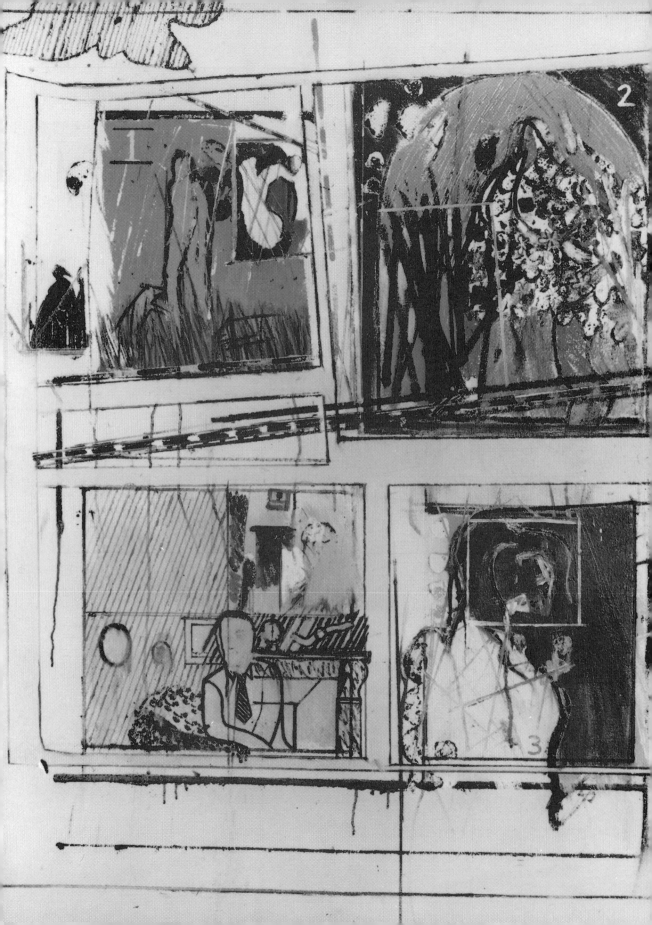

Madame Sosostris, famous clairvoyante,
Had a bad cold, nevertheless
Is known to be the wisest woman in
Europe,
With a wicked pack of cards. Here,
said she,
Is your card, the drowned Phoenician
Sailor,
(Those are pearls that were his eyes.
Look!)
Here is Belladonna, the Lady of the
Rocks,
The lady of situations.
Here is the man with three staves, and
here the Wheel,
And here is the one-eyed merchant, and
this card,
Which is blank, is something he carries
on his back,
Which I am forbidden to see. I do not
find
The Hanged Man. Fear death by water.
I see crowds of people, walking round
in a ring.
Thank you. If you see dear Mrs
Equitone,
Tell her I bring the horoscope myself:
One must be so careful these days.

T. S. Eliot, The Waste Land

J.R. As is known, interpretation is at the heart of Judaism. In the beginning was the Word, and, consequently, interpretation. Not a narrow interpretation but one that generates new questions and further interpretations. Interpretation against interpretation, to reinterpret Susan Sontag's title. I consider you an 'allusionist' and this intellectual ability – characteristic of the most lucid writers and painters of our time – could also be taken as your most prominent Jewish feature. In the Zohar it is said that 'the world doesn't exist but by the secret'. The world, therefore, is like a labyrinth of hidden allusions and esoteric paths. It would be out of place here to detail the parallels between cabbala and Tarot (for example, the twenty-two letters of the Hebrew alphabet and the twenty-two major arcana). Tarot has inspired different artists, Albrecht Dürer among them, and I imagine that in 'Le Grand Jeu', to use the French name, what has interested you most are the combinatory possibilities; in the same way that in *Specimen Musings of a Democrat* (1961) you had recourse to the *Ars Combinatoria* of the thirteenth-century Catalan philosopher and writer Ramon Llull, one of the precursors of cybernetics. Your *Tarot Variations* also resounds with the verbal music of *The Waste Land* – I don't find the Hanged Man, either. It is difficult to identify the face cards of your Tarot. Perhaps the bottom left-hand square, as it is not numbered, represents the Fool. Who knows? *Tarot Variations*, made at the time of *Erasmus Variations*, with which it has some similarities, plays with both visual and mental associations. I wonder if you were aware at that time of the 'Jeu de Marseille', a Tarot made by some Surrealist writers and painters in that city during the Second World War.

The mental and cultural space of *Tarot Variations* is extended (perhaps we are in a Babel library of the mind) in the diptych *Certain Forms of Association Neglected Before*, which might be related to another painting from 1961, *The Disinterested Play of Thought*. One wonders what kind of association the two readers on the left are establishing. But perhaps the association neglected before is that between the left side (or hemisphere) and the truly abstract right side. I am still losing myself in the left one. But now, do I hear voices, through the paper wall? Bright, mellow, asthmatic. Three voices – a young woman's (A), a middle-aged man's (B) and an old man's (C). C probably stands for Critic or even Cicerone.

Tarot Variations, 1958

Specimen Musings of a Democrat, 1961

Certain Forms of Association Neglected
Before, 1961

A.: Look!
C. (*reflectively*): At the mirror – or mirage – of *Tarot Variations*?
B. (*hissing*): Through a *gloss.*
C.: Darkly.
A. (*alarmed*): Do you see nothing?
C. (*hesitates*): Staring forms ...

A. (*nods*): Leaned out, leaning, hushing the room enclosed.

C.: And I bet that the numbered squares, 1, 2 and 3, are outlined in embryo in the unnumbered one, bottom left, where the figure with the necktie leans out.

B.: I too awaited the expected Gestalt ... Don't make a wild guess on a wild card.

A.: The joker ...

C. (*puzzled*): A riddle wrapped in an arcanum inside an image.

B.: Enigma Variations.

A.: Shuffle the pictures to get the magic message.

B.: In *Tarot Variations*, the medium, troubled oil on canvas, is the message.

A.: Maybe Madame Sosostris could provide an explanation.

C.: Or Mr Eliot.

B.: His presence is even more significant in another *toile*.

A. (*with complicity*): You! Toi, l'hypocrite lecteur!

C. (*frowns*): Blank reverse ...

B.: *If Not, Not.*

C.: A firm not.

B.: A bundle of allusions.

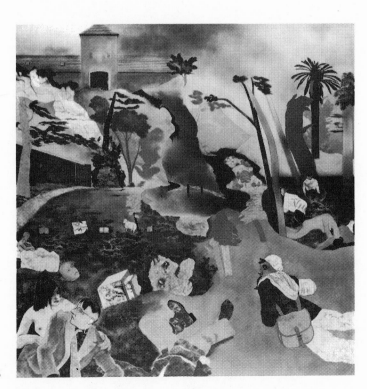

If Not, Not, 1975–6

C.: Starting with the title, which refers to the coronation oath of the medieval kings of Aragon guaranteeing the traditional Aragonese rights and freedoms. A bundle of bonds ...

B.: Broken?

A. (*lyrically*): A heap of broken images, where the sun beats.

B.: Bits to bits. These fragments ...

C.: Kitaj has turned to Eliot's runes. Eliot is one of the constants in Kitaj's art. For some time he even planned to paint his own *Waste Land* on the wall of the future British Library.

B.: Just as Virgil inspired the Renaissance landscape painters, T. S. Eliot, especially with his *Waste Land*, has provided painters of our time such as Bacon and Kitaj with a distinct, sometimes corrosive 'atmosphere'.

C.: Literary and pictorial allusions are balanced in *If Not, Not*.

B.: The purely pictorial ones are more evident, don't you think?

C.: Yes, they spring to the eye. Giorgione's *Tempest*; the landscape of Ambrogio Lorenzetti's *Good Government in the Country* ...

A.: A detail of which is quoted in *Land of Lakes*.

C.: Which, according to Kitaj, is an optimistic counterpart to *If Not, Not*.

B.: Perhaps only optimistic at first sight.

A.: An optical illusion?

C.: Allusion? Perhaps it would be interesting to look at *Land of Lakes* with the visual serenity of Ezra Pound's Canto XLIX in mind.

B.: The 'Seven Lakes' Canto. The serenity of verses, of the universe.

C. (*clears his throat*): Autumn moon; hills rise about lakes/against sunset ...

A. (*rallentando*): Boat fades in silver; slowly ...

B.: Pound is an important element in Kitaj's cultural world. A guide to Kulchurland.

C.: He taught him to look at the past creatively, to *Make It New*, as Kitaj commented in a note on two faces of Ezra Pound.

B.: The bad face was the fascist.

A.: Pound is his favourite anti-Semite.

B.: Besides Degas.

C.: Pound's fascism – which still hasn't been examined with the required objectivity – has many facets ...

B.: I must confess now that I can't look at *Land of Lakes* with a compound eye or with any optimism. In my view it's a deserted landscape, with no visible human figure, which reminds me of the final vision of Lévi-Strauss's *Tristes Tropiques*: the world started without man and will end without him. But nobody will see this most tragicosmic spectacle.

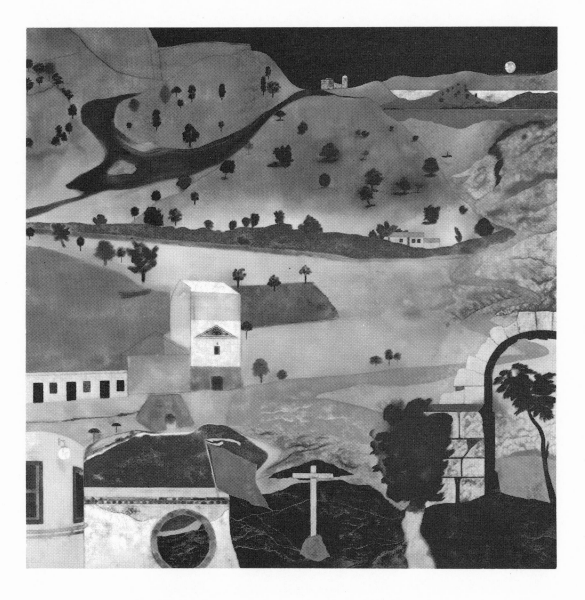

Land of Lakes, 1975–7

A.: An eye, inside an eternal triangle, stands above the land of lakes.
B.: An eye for an eye.
C.: An eye on a wall, as in some Tibetan buildings.
B.: To see or not to see – the landscape after a neutron bomb?
C.: And beneath the eye there's a cross – a prophetic sign?

A.: O men!

B.: Nemo, Noman's land.

C.: We could recall now the medieval figure of Nemo, Nobody, which Kitaj resurrected in *Yamhill* and *Notes towards a Definition of Nobody*, both from 1961.

B.: Bakhtin, in his seminal *Rabelais and His World*, has examined the inversion of impossibilities and negation in carnival. When everything is impossible or inadmissible, here comes Nobody. The negation becomes a mythical name.

C.: Kitaj's *Nobody* (not an omnipotent one, but an impotent and silenced victim, with padlocked lips) comes from an iconographical study in the *Journal of the Warburg and Courtauld Institutes*.

B.: At that time the *Warburg Journals* were a mine of visual information for Kitaj, and in the images illustrating the articles he found a sort of Surrealism *avant la lettre*.

A.: Perhaps Kitaj's first 'iconological' studies were made in *Life* magazine, which he collected eagerly from his boyhood.

B.: Studies from *Life* . . .

C.: Kitaj got much information from the reliable sources of the *Warburg Journals* in the early 1960s, and the figure of Aby Warburg, the father of iconology, fascinated him, as several paintings of that period show, for example *Warburg's Visit to New Mexico*, which he did in collaboration with Eduardo Paolozzi.

A.: And *Warburg as Maenad*.

B.: Warburg offered Kitaj a comparative history of images.

C.: What you see depends on what you know, as Ernst Gombrich, Warburg's biographer and a pioneer in the semiology of art, has so brilliantly demonstrated.

B.: He was recently portrayed by Kitaj.

A.: A portrait with *soul*, now in London's National Portrait Gallery.

C.: But going back to *Land of Lakes*, maybe we're in front of a kind of promised never-never land.

B.: Better to quote Nevermore, as maybe that raven on a white sheet is doing in *If Not, Not*.

A.: Bird of ill omen!

B.: A raving raven?

C.: A quote from Bellini.

A.: I prefer Matisse's *La Joie de Vivre*, to continue with the pictorial allusions of *If Not, Not*.

B.: The gates of death – Auschwitz's entry figures on top – will prevail against any gaieties. *If Not, Not* is the camouflaged *Triumph of Death* of our time.

A.: Under the beauty of colours.

C.: Suitable for a culture which opted for cosmetics instead of ethics.

B.: The joys of dyeing ...

C.: Besides Matisse's masterpiece there is also a suggestion of Gauguin's colours.

A.: And the aura of Gauguin's Edenic scenes.

B.: The rotten Eden: the Id den.

C.: Yes, the unconscious lies in ambush.

A.: Among the ruins.

B.: Ruin upon ruin ...

C.: Kitaj considered *If Not, Not* a sort of stream-of-unconsciousness painting.

A.: The artist portrayed himself in bed, embracing a child, as if he were drifting with that flotsam of images.

B.: A useless blue book, opened face down, beside him.

A.: Another open volume a bit further on.

B.: Some books have pictures and some pictures have books, Kitaj has said.

C.: He said this specifically about the serigraphic series *In Our Time*, which simply reproduced book covers from his library.

B.: But certainly the dictum is applicable to all Kitaj's work.

A.: A true painter does not live by art alone.

B.: Of course. A painter like Kitaj shows that to draw a single good line it is necessary to have already read many lines.

A.: The lines of life – because what we read also forms part of our lives.

C.: Literature in general is one of the ferments which acts creatively in Kitaj's art.

A.: Some critics qualify his art – or disqualify it – as literary.

B.: It is, to be more exact, *transliterary* – the art of translating and transposing literature into painting.

C.: Call it what you like. John Ashbery saw perfectly that it is one of Kitaj's most original innovations.

B.: Yes, he transmutes – and transmits – everything into painting.

A.: Critics have often praised his power to make pictures of ideas.

C.: Appropriately enough *idea* comes originally from the Greek *idein*, to see. But I don't think Kitaj is a painter of ideas.

B.: He is a man of ideas/images.

C. (*examines his cards*): Let me quote from Ashbery's *Hunger and Love in Their Variations*: 'How wonderful it would be if a painter could unite the inexhaustibility of poetry with the concreteness of painting. Kitaj, I think, comes closer than any other contemporary, and he does so not because he is painting ideas but because he is constantly scrutinizing all the chief indicators – poetry, pictures, politics, sex, the

attitudes of people he sees, and the auras of situations they bring with them – in an effort to decode the cryptogram of the world.'

B.: We have already mentioned Eliot and Pound, but now I'm thinking of the importance of Kafka and Benjamin in Kitaj's deciphering of the cryptogram or rebus of the world.

A.: A decipherment which results in a new rebus.

B.: That's art. And I would like to state that 'inexhaustibility' is a characteristic of art in general, not only of poetry. Benjamin saw it clearly, through Valéry, and remarked that in front of a true work of art the eye never gets satiated.

A.: Food for thought . . .

B.: Provisional provisions. And one is tempted to define Kitaj's pictures with the Benjamin title of *Denkbilder*.

A.: Images-thoughts.

B.: Kitaj thinks pictorially.

C.: I believe with Viktor Shklovsky that art is not a method of thinking, but a method of restoring sense perception of the world.

A.: A method to clean, periodically and partially, the doors of perception.

B.: Walter Benjamin sharpened Kitaj's fragmented perception of reality.

C.: And Benjamin's own perception was in turn sharpened and shaped by Baudelaire and Proust.

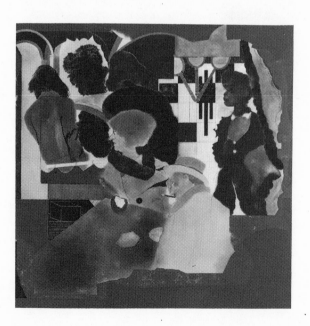

Arcades (after Walter Benjamin), 1972–4

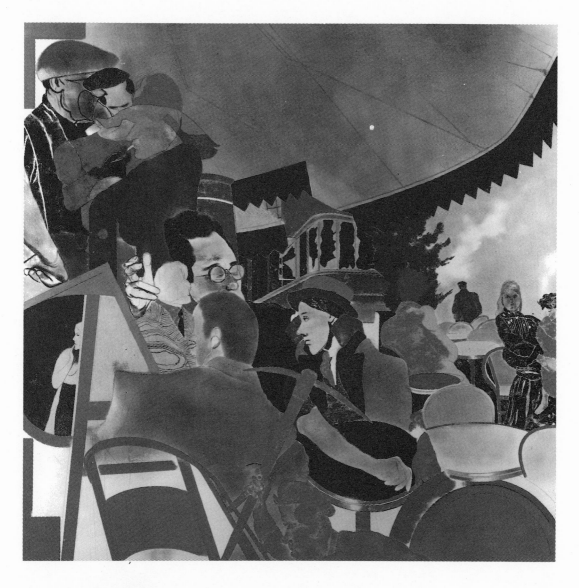

The Autumn of Central Paris
(after Walter Benjamin), 1972–3

A.: Benjamin inspired or rather inspirited two important Kitaj
 paintings: *Arcades* and *The Autumn of Central Paris*.
B.: *Arcades* is maybe a pictorial passage of *Passagen-Work*.
C.: Babel of stairs and arcades ... Similar – in masks and décor –
 to the allegorical constructions of Baudelaire.
A.: Benjamin's fellow *flâneur*, his *frère*.
B.: Arcades ambo, through these Arcades.

A.: The mysteries of the Baudelairean city of dreams are beautifully rendered in *The Autumn of Central Paris*.

B.: Autumnal *Caféerie* . . .

C.: Pathetic fall.

B.: A scene besieged by disquieting figures.

A.: Paris is well worth a massacre – a revolting refrain runs through its history.

B.: The overlapping of the daydream and the nightmare of history is remarkable in *The Autumn* . . .

C.: Yes. Kitaj made the montage of the oneiric Paris into the real Paris.

A.: It is Benjamin's Paris dominated by its phantasmagories.

B.: Phantasy agonies . . .

A.: Quite. Kitaj says the painting is set in the Paris of autumn 1940. A few months later Benjamin left the city to escape from the Nazis.

C.: Yes. In June he flew from Paris to Lourdes. And from there, in August I think, he went to Marseilles.

A.: The tragicomic image of Benjamin disguised as a French sailor in Marseilles, attempting in vain to board a cargo ship, would appeal to Kitaj.

C.: Benjamin finally succeeded in reaching the Spanish border town of Port Bou on 26 September, but there the Franco police denied him entry. Tired and ill, so as not to fall into the hands of the Gestapo, early in the morning he took a mortal dose of morphine.

B. (*pensive*): *La mort fine* . . .

C.: Not so refined – the agony was long-drawn-out, and his last gasps were accompanied by the mutterings of a Spanish priest.

A.: Walter Benjamin on his death bed – what a Kitaj painting!

B.: Benjamin is the *imago* that helps Kitaj to address his own Wandering Jewishness and, even more important, to give complex and complete artistic existence to it.

C.: In this sense *Arcades* and *The Autumn of Central Paris* are the Ur-paintings of the Diaspora series.

A.: Kitaj was bound to find a series of affinities in Benjamin.

C.: There's an invisible nexus which perhaps makes them more patent and potent: Aby Warburg. Benjamin frequented his Hamburg circle and admired his work as a detective in art history. From Warburg Benjamin got his love of detail.

B.: The cult and culture of the fragment.

A.: The fragmentation, the juxtaposition, of images and different styles or 'tiles', like in a mosaic, or in a Talmud page, is perhaps something that has its roots in Jewish culture.

C.: And in modernity.

B.: A Mosaic work – to render therefore unto Muses the things which are Muses'; and unto Moses the things that are Moses'.

C.: Instead of continuity, contiguity; two disparate images become, by proximity, a third one.

B.: A desperate one.

A.: Learn a style from a despair – as William Empson would urge.

C. (*impatient*): And that's a metaphorical operation. A Kitaj painting incites the viewer to imagine, to connect distant images and acts.

A.: Maybe only to reconnect.

C.: Maybe. It's necessary to discover what Valéry would call the 'secret affinities' of an artistic construction.

B.: A *metaphormosis* machine.

A.: Endless.

C.: Yes. The viewer tries to figure out what is going on in the painting but, at the moment a plot line forms in his mind, new images and possibilities emerge.

A.: New possibilities, new doubts. The machine of ambiguity never stops.

C.: See, for instance, *Study for the World's Body*.

A.: My favourite of Kitaj's pastels! I usually call it *The Interrupted Embrace*.

B.: The furtive embracers ...

C.: Why furtive? Perhaps they are simply a married couple.

B.: Adultery is quite common between adults.

C.: They could be a normal and happy couple. Or they could be relatives. Perhaps sister and brother.

B.: Incest is nicest.

C.: Let me continue. Perhaps an unexpected noise startled them. John Ashbery, however, I remember, suggested something so innocuous as a crack in the wooden floors.

B.: Cracks and forms in the violet air.

A.: So beautiful. She is, too, the violet.

B.: A dream of the red chamber? A turn of the key, a bad turn of the screw?

A.: Don't lose the keys.

C.: Staring at the *Study for the World's Body* I recalled an episode in Viktor Shklovsky's very *sui generis* biography. (*He opens* The Third Factory *and reads*)

'She loved me and didn't make me suffer. We kissed each other, though we hardly knew how.

And once we were exchanging kisses toward morning when something red suddenly banged at the window and the woman in

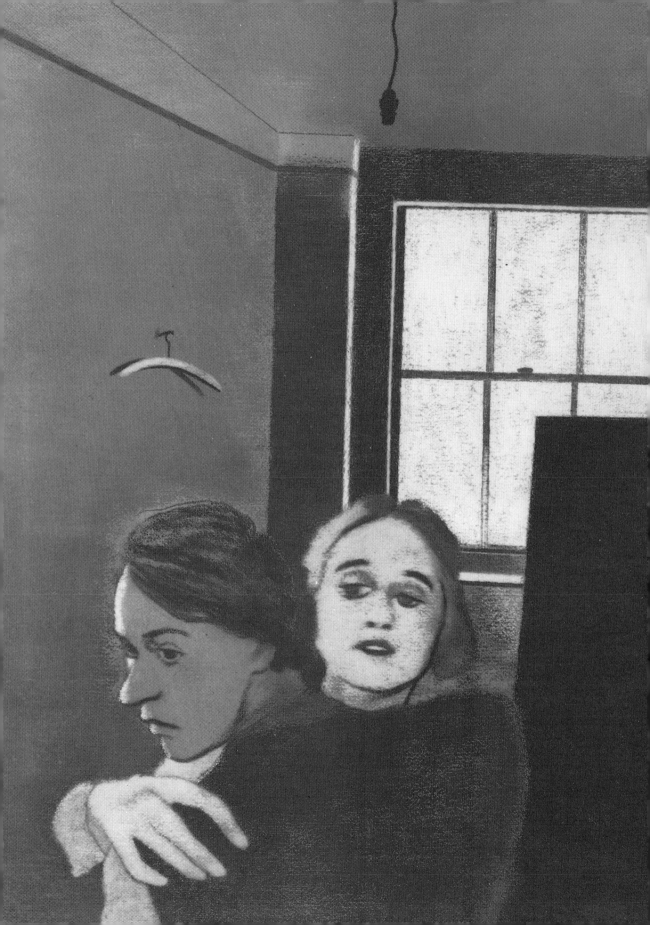

question started screaming. It was the tsar's name-day and the wind had shoved a flag into our window; it chose the bottom half.'

B.: We'll not keep the red flag flying here. Nothing interferes with the blank view of the window.

A.: Except the black parallelogram on the right, which could be a canvas.

B.: In that case the couple could be in a painter's studio.

C.: And the painter is absent, or is he the intruder? Or are they posing for him? In any case, as in *Las Meninas,* the unique presence suggested is definitively absent – on the other side of the painting.

B.: The empty light socket indicates that the room is in disuse. And the black rectangle could be a plank to seal up the window. They could be lovers in hiding or fugitives ...

C.: The title, which refers to John Crowe Ransom's book, suggests that the painting has an allegorical intention, besides the *intension* of its objects and figures. Poetry is the world's body.

B.: But Kitaj's pastel, through the concreteness of the image, shows what Ransom called 'physical poetry'. Physical poetry in action.

C.: In the act of becoming, through its metaphoric enigma, metaphysical poetry.

B.: A subtle magic of images – very physical, yet at the same time implausible or impossible – which often appears in Kitaj's paintings, for instance in another embrace in *Where the Railroad Leaves the Sea.*

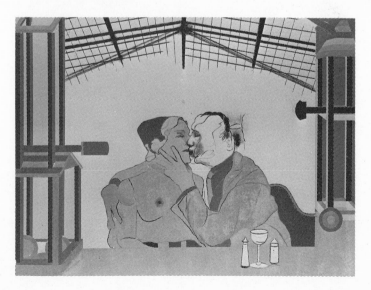

35

A.: The Kiss ... to recall the Garboesque look of the woman. Film stills have often been a resource and inspiration for Kitaj.

B.: The master keys ...

A.: To open the image to a new enigma.

C.: Exactly. For example, knowing that the Soviet silent classic of 1929, Ermler's *Oblomok imperii*, or *Fragment of an Empire*, is one of the many rare visual references in *The Man of the Woods and the Cat of the Mountains* enlarges the mystery.

A.: It's one of the most mysterious and ambiguous Kitaj paintings.

C.: Marco Livingstone, in his *R. B. Kitaj*, detailed many of this painting's references and interpreted it as an image of hope regained – perhaps just as the protagonist of *Fragment of an Empire* recovers his memory – and a homage by the artist to the woman he loves.

A.: The number 2 on the wall calendar might mark a memorable date.

B.: Two for two?

C.: But perhaps Kitaj wanted to make something imagined, not recalled.

B.: The accuracy of fiction and the fantasy of facts can be fused in the painter's vision.

A.: Supreme ambiguity ...

B.: Sustaining intricacy, delicacy, the dense dance of ideas and images.

C.: Yes. Kitaj shares Empson's belief that 'the machinations of ambiguity are among the very roots of poetry'.

B.: 'As in poetry, so in painting' – to return to the motto of Kitaj's first exhibition, in 1963.

A.: Painting as poetry.

B.: The supreme superfiction.

The Man of the Woods and the Cat of the Mountains, 1973

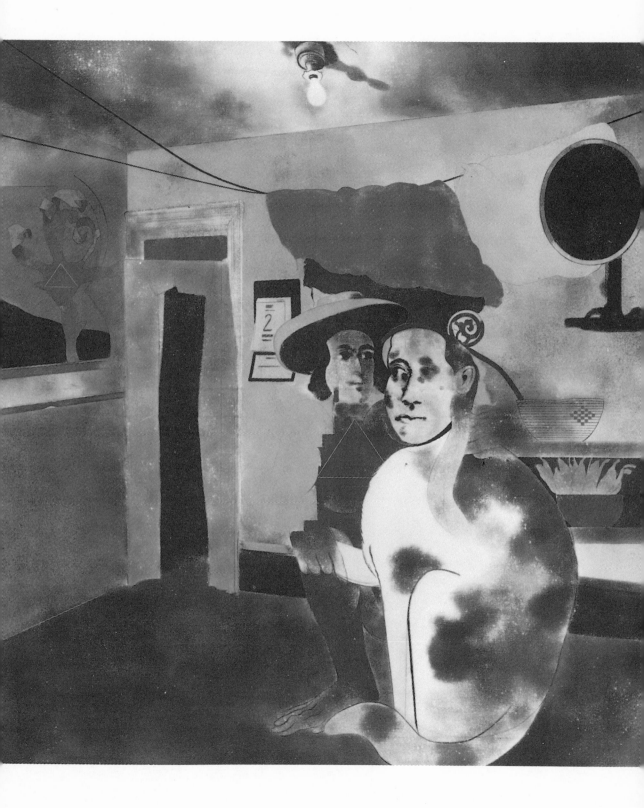

AMERIKA (I)

... a sudden burst of sunshine seemed to illumine the Statue of Liberty, so that he saw it in a new light, although he had sighted it long before. The arm with the sword rose up as if newly stretched aloft, and round the figure blew the free winds of heaven.

Franz Kafka, *Amerika*

I feel very 'American' ... always will ... The American language and culture and one's childhood secures that belonging and it is sustained by deep American friendships and interests and always renewed contact with America; nothing much in American life escapes my notice one way or another.

R. B. Kitaj

J.R. I would like to look back to when you visited America for the first time in nine years, I think in February 1965, to be at your first one-man show in New York, at the Marlborough-Gerson Gallery. After all that European training, and with the perspective of your time away, what were your first impressions of America? Did you find yourself immediately at home or feel, as Thomas Wolfe would say, that you can't go home again?

R.B.K. Not only did I go home again, I went crazy! I stumbled into the New York fast lane overnight: glamorous sex, spurious fame, new flashy artworld nonsense, etc. It was fun and painful. The New York I had known was gone – the bittersweet Manhattan of six-dollar-a-week Village furnished rooms, creative loneliness, the National Maritime Union hiring hall with its expectant adventure and deliverance. New York in the late forties and early fifties was a delight I often return to in sweet thought. I'm always at home in America, *and* can never go home! But I always try.

J.R. To be an expatriate, a displaced person, is a sign of the times. Your compatriot John Ashbery remarked that you, as a

displaced person, are well qualified to serve as a spokesman for our century. Perhaps for an artist, to be one's own spokesman is quite enough. Many spokesmen ended voiceless. But there is no doubt that you are a child of your century, and for a triple reason: as an artist, a Jew and an American.

I find that to be nonconformist and restless are particularly American features. Only inhabitants of cemeteries really belong to the land – the promised one. Don't you agree?

R.B.K. Yes! My latest fantasy is to buy a flat in Paris and die in the American Hospital at Neuilly aged ninety-five from a life of mistakes and homesickness.

J.R. But distance is not oblivion, as an old Hispanic song says, and it doesn't mean either that one is losing sight of one's country. On the contrary, it helps you to see it with more perspective.

J.R. In my view, the best complement – and compliment – to your *Randolph Bourne in Irving Place*, 1963, is the biographical vignette of him in John Dos Passos's *Nineteen Nineteen*, the second novel of his trilogy, *U.S.A.*, published the year you were born.

I just realized that Dos Passos doesn't appear in your private pantheon, he is never mentioned by you or your critics, as far as I can remember. Yet the devices he developed in *Manhattan Transfer*, and above all in his masterpiece, *U.S.A.* (the newsreel collages, 'The Camera Eye' with its surrealistic stream of consciousness, and the 'compressionistic' biographical sketches of public figures), resemble those you have used in multilevel works of the 1960s, such as *Randolph Bourne*, with the press cuttings and its cinematic image, or *The Ohio Gang*.

Randolph Bourne died six weeks after the Armistice, on 22 December, and John Dos Passos saw his ghost, almost like poor Akaki in Gogol's *The Overcoat*, haunting New York streets with the black cape he brought from Europe.

During the period you painted Randolph Bourne, his pacifism and radical ideals revived, and so I suppose you were calling up his crippled figure to see through the deformed present. The paranoia, fear of persecution, and isolation are suggestively depicted in the portrait of Bourne, half-disguised and turning his head in all directions. Were you aware of the *Nineteen Nineteen* vignette when you were painting your Randolph Bourne? Is there any particular incident in Bourne's life to which your painting alludes?

This little sparrowlike man,
tiny twisted bit of flesh in a black cape,
always in pain and ailing,
put a pebble in his sling
and hit Goliath in the forehead with it.
War, *he wrote, is the health of the*
state.

John Dos Passos, Nineteen
Nineteen

If any man has a ghost
Bourne has a ghost,
a tiny twisted unscared ghost in a black
cloak
hopping along the grimy old brick and
brownstone streets
still left in downtown New York,
crying out in a shrill soundless giggle:
War is the health of the state.

John Dos Passos, Nineteen
Nineteen

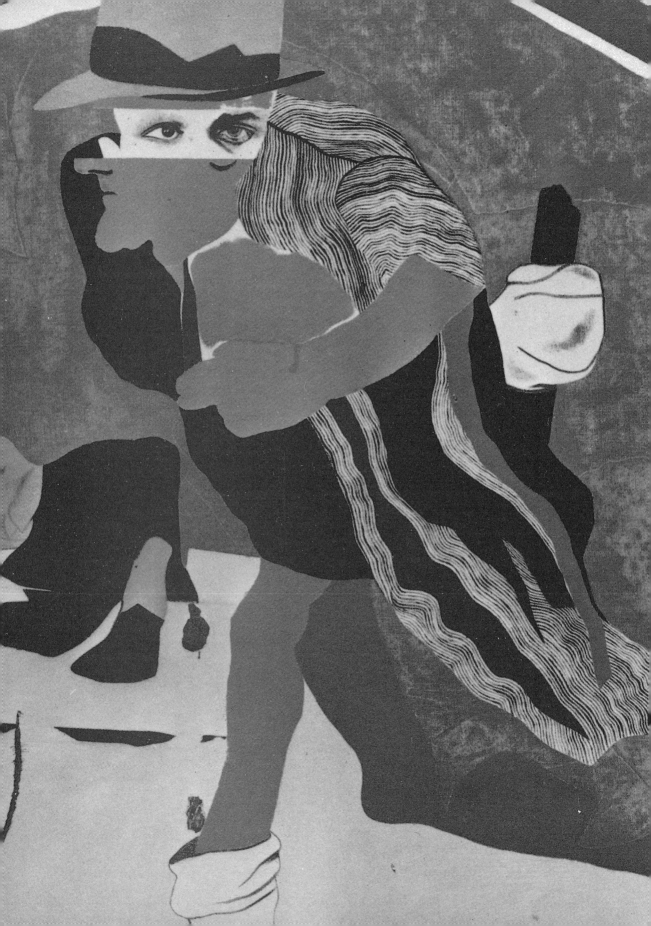

He was cartooned, shadowed by the espionage service and the counterespionage service; taking a walk with two girl friends at Wood's Hole he was arrested, a trunk full of manuscripts and letters was stolen from him in Connecticut.

John Dos Passos, Nineteen Nineteen

R.B.K. Strangely I never read Dos Passos or Faulkner, but always loved Hemingway and Fitzgerald. When I first came to New York aged seventeen to go to art school and also to sea, I lived in a slum rooming house a few doors from Irving Place, which was haunted by Bourne and the wonderful writer O. Henry and many other characters. But I really discovered the amazing Bourne later in a book by Edward Dahlberg – who is every bit as special as Bourne himself. I even got to know Dahlberg much later and spent some crazy evenings with him in London just before he died. My Bourne comes from him.

J.R. 'Drift and mystery': this slight alteration of a Walter Lippmann book title could also be used as a subtitle for your *Walter Lippmann* (1965–6). To start with the mystery: in the foreground there is the man holding a drink, with a cigarette in his left hand, who's in the same position as Robert Donat in a crucial scene of Hitchcock's 1935 movie *The Thirty-Nine Steps*.

R.B.K. Donat, yes ...

J.R. After I don't know how many steps, a woman and a man face each other. And the blonde girl with braids is ascending or descending the ladder. A dream ladder? A fire escape? Or an allusion to some notorious ladder such as the one in the Lindbergh case?

Your picture is so packed with movie allusions that by contagion I see a likeness between the blonde with braids and a very young Marilyn Monroe with the same hair-style. And with a sad countenance too. Bonjour *tristresse* ... *Furthermore I keep in mind that some years ago, in an exchange with a critic about Walter Lippmann*, you raised the surprising question: does anyone remember *The Constant Nymph*? I don't know if you were referring to the once-popular novel by Margaret Kennedy of 1924, or to its 1933 movie adaptation by Basil Dean, with Victoria Hopper in the role of Teresa Sanger, the fifteen-year-old constant nymph. Is she, then, the girl on the ladder? Or does the family Sanger play some part in your painting?

R.B.K. The girl with braids *is* from *The Constant Nymph* and I should love to follow her up the ladder to her Alpine hayloft. Long before Marilyn Monroe. Joan Fontaine, I think. The picture augurs the arriving storm in Europe, preceded by refugee movie people in Hollywood, etc. You may be right about Victoria

Randolph Bourne in Irving Place (detail), 1963

41

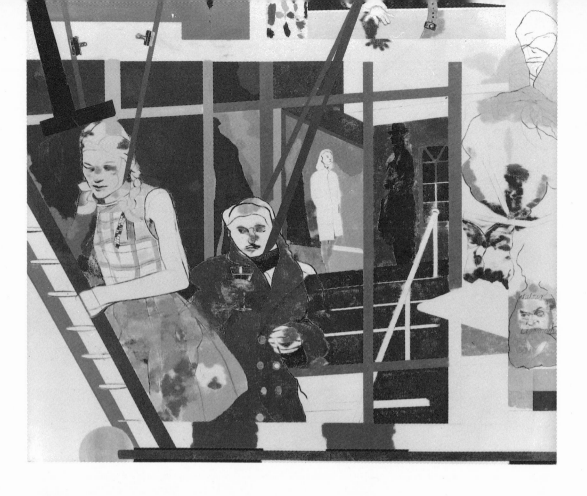

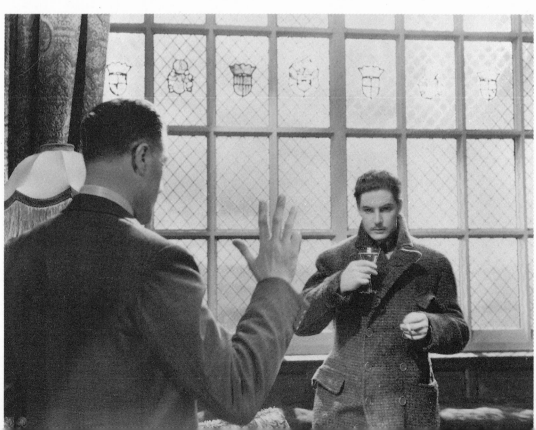

Walter Lippmann, 1965–6

* *The Constant Nymph* was remade by
Edmund Goulding in 1943, starring Joan
Fontaine and Charles Boyer.

Hopper, I may be wrong about Joan Fontaine. But that's good deconstruction, no? Good Midrash.*

J.R. The columnist and social analyst Walter Lippmann, the detached voyeur perhaps in his detached column on the right, could probably analyse and connect the different scenes; and moreover, as a disciple of William James, he would catch the drift of this painted stream of 'iconsciousness'. But what attracts my attention more are the green strips which seem to hold up the heads of the nymphet of the ladder and Robert Donat's double as if they were puppets. Or are these green lines only holding the composition up? But please don't tell me too much.

R.B.K. Puppets maybe, but OK, I won't tell any more than I did in the Phaidon preface.

J.R. Let's quote then the last lines of that preface:

> When movies were first shown, the form was so new and unusual that most people found it difficult to understand what was happening, so they were helped by a narrator who stood beside the piano.

Robert Donat in The 39 Steps *(1935)*

43

J.R. Another strip, yellow this time, goes from the hair of the naked girl to the hands – and vice versa – of the big-nippled madam in *The Ohio Gang* (1964). If you think it's appropriate we could consider this yellow strip a kind of Ariadne's thread to go into the labyrinth of *The Ohio Gang*. Could this golden thread lead us somewhere? Could we learn something – structural or thematic – from this yellow?

R.B.K. I attach here a fragment of Midrash on *The Ohio Gang*.

Last night, I stayed up late to watch Ford's great *She Wore a Yellow Ribbon* (a holy ikon since boyhood). The ribbon signifies that the girl pledges herself, without divulging to whom, to one of two men (John Agar and Harry Carey Jr in the movie). In the painting-dream, I've conjured two very unalike suitors, both imprecating the young girl. The standing man is my comrade of many years, Robert Creeley, whose poetry I had just discovered when I made this picture. The seated man strongly suggests an actor I knew briefly in the late 1940s when we lived in a slum rooming house on East 16th Street.

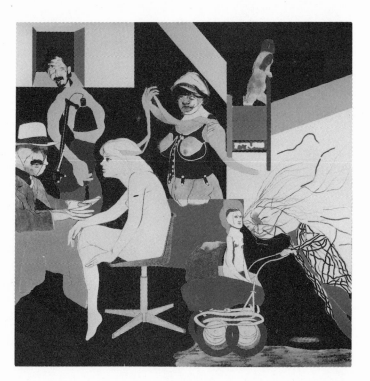

The Ohio Gang, 1964

PORTRAITS

The first student I got to know there was Ron Kitaj. We got on
immediately. Also, his painting straightaway fascinated me. I could
tell he knew more about painting than anybody else. He's about
four years older than I am, which when you're twenty-two is a lot
of difference, in experience anyway. He was a much more serious
student than anybody else there. He has a marvellous dry humour
that really appeals, but in those days he was much grimmer than he
is now, and he was a rather formidable person. He used to put up
a kind of front against people as though he couldn't tolerate fools. I
got on with him because we had a few things in common. Literature
we would talk about; he was interested in Orwell, and I remember
talking to him about *The Road to Wigan Pier* which I knew very well
as a book from a long time ago. It was written in the year I was
born, and my father was always mentioning it; he'd say it was
written in the year you were born, and this is what it was like. Ron
was a great influence on me, far more than any other factor; not
just stylistically – he was a great influence stylistically on a lot of
people, and certainly on me – but in his seriousness too.

David Hockney by David Hockney

J.R. David Hockney is one of your 'brothers' (as you call your
closest friends) and you have known him since the first days of
your postgraduate course at the Royal College of Art in London.
You have portrayed him several times, at least since the beginning
of the seventies. But your most ambitious portrait of David
Hockney (in my opinion one of your best works) was started in
1976 as a full frontal nude and has been concluded recently in a
very sophisticated manner – neo-Cubist or rather 'simultaneist'.
As in other paintings of yours very long in the making, your pal
is in a palimpsest. Luckily we have photos of the original portrait:
the socks gave it a charming touch of comedy, and I imagine
that an X-ray picture of this portrait could also be very revealing.

What in the painter David Hockney interests you most now,
and in his recent works what similarities do you find with your
own?

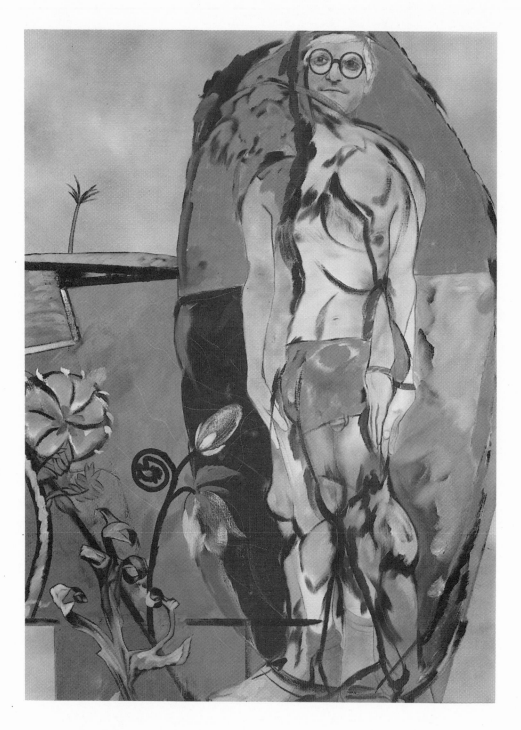

The Neo-Cubist, 1976–87

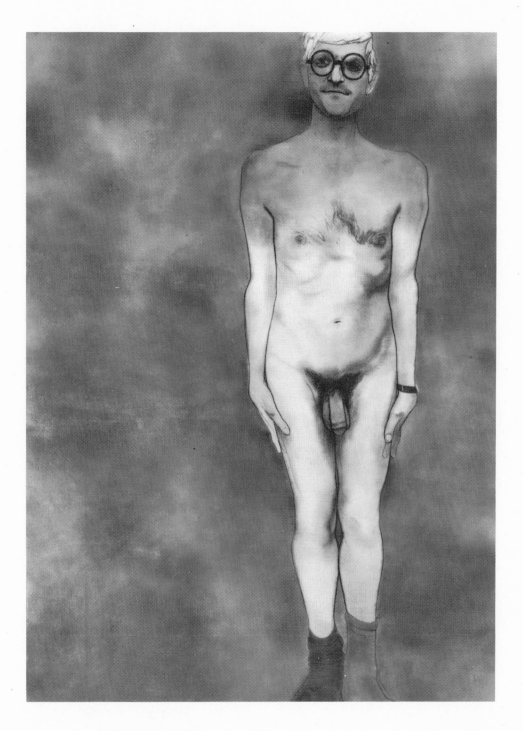

David Hockney, 1976

R.B.K. His mind is a Space-Traveller. It travels far away from my own homely precincts and then it will alight again, as it used to more often when we were young, in my own backyard. What I am saying is, I can't join him on his trips to the moons of technology, to the theoretical-spatial moons represented by the advanced machinery he loves to conduct him. Nor can I follow him (or my wife Sandra) joyously into the great opera houses because opera puts me to sleep. Nevertheless, his mind fascinates me wherever it goes – like watching Nijinsky staying up in the air a little longer than anyone else. His neo-Picassoism, the child of his middle age, touches my own life, though. My exemplar is late Cézanne, my companion of every day. Hockney's companion is late Picasso. Picasso's admitted master was Cézanne, so we are, the four of us, bound together for life. Hockney is the greatest *natural* draughtsman alive. My own climb (like Cézanne, as opposed to Degas) is harder and longer. If I had Hockney's energy, I would be Rembrandt, not poor Kitaj. *But*, as Pound said of Eliot: 'Tom is a crocodile. If he was a gazelle it would have killed him.'

David at Berkeley, 1968

Francis Bacon, c. 1965

F.B.: But I think that artists can in fact help one another. They can clarify the situation to one another. I've always thought of friendship as where two people really tear one another apart and perhaps in that way learn something from one another.

D.S.: Have you ever got anything from what's called destructive criticism made by critics?

F.B.: I think that destructive criticism, especially by other artists, is certainly the most helpful criticism... When people praise you, well, it's very pleasant to be praised, but it doesn't actually help you.

David Sylvester, Interviews with Francis Bacon

J.R. I know Francis Bacon is one of your inspirators. You've known him for nearly thirty years now and your admiration for him has never failed. As is well known, Francis Bacon paints his portraits from memory and photographs and I suppose he doesn't like to sit for another painter. When you portrayed him in *Synchromy with F.B. – General of Hot Desire*, did you use photos of him?

R.B.K. Yes, he gave me the photos I used for the portraits and also I took some snapshots of him.

J.R. Have you often discussed your craft with him?

R.B.K. We discuss, but not often. I only see him now and then.

J.R. Is it the tragic solitude and the convulsed beauty – to use Breton's expression – of his figures that appeals to you most?

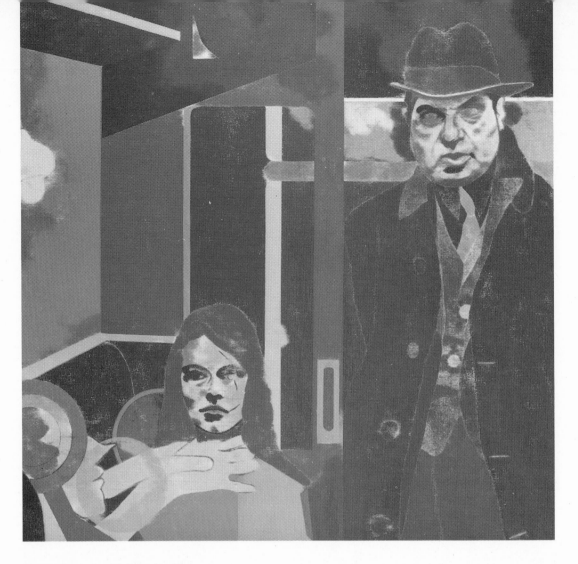

Francis Bacon (detail from *Synchromy with F.B.*), 1968–9

R.B.K. Bacon and Balthus are my favourite living painters. Neither are *great* artists of the first order like Picasso, Matisse, Cézanne, Degas. But they are the best since the deaths of Picasso and Giacometti in my universe. Breton's words are OK but not quite as I think of Bacon. I like Nietzsche's definition of art best: art is the desire to be different, the desire to be elsewhere. *That*'s what I like most about Bacon. He contrived better than anyone to be elsewhere. His success is exciting and narrow and unique. But I pass Bacon's little studio each day and the living fact of him, his art, inspires me.

J.R. You first met Frank Auerbach in the early sixties, while you were teaching at Camberwell School of Art, but your close friendship dates from 1971, when you began to see him regularly. At suppers, isn't that so? And in the autumn of 1987 you flew with him to Germany, to the opening of his exhibition there. That was the first time he had returned to Germany since childhood, I believe. Can you tell me your impressions of that trip?

Frank Auerbach (photograph by Kitaj), *c.* 1984

R.B.K. I wanted to look at Auerbach's face when he stepped off the little private plane on to the old Heimat after fifty years! He looked ... *OK*. Then he hung his show in Hamburg which looked wonderful. I ran off to prowl the red-light district, St Pauli. At the end of the evening I saw a man creeping towards a brothel. Did you see the movie *The Elephant Man*? This poor deformed creature reminded me of that horror. What possible confrontation could he have with the girls? I was tired and shattered. The next morning on a long walk through Hamburg with the Auerbachs, I told them what I'd seen. We flew back in the sun to England. Now I've begun a painting of the man I saw that night. I'm sure to fail.

J.R. I know you admire Auerbach deeply and share with him several devotions. First of all, this integrity to devote yourselves wholly to Art. Could I say that both of you enter into Art as monks go into the church? Is there no salvation outside Art?

R.B.K. Yes, there is something devotional about any good artist. We are both somewhat monkish (stay-at-home) as you suggest, although I'm more restless than he is and I go looking for trouble outside the Art church. But we are devoted to some of the same masters like Matisse and Rembrandt – quite often from books on the studio floor. We are both rather movie-mad and have passed that on to our sons. There is salvation outside art. In fact I believe that the best art is an apotheosis of what inspires it, from both outside itself and inside its maker. There is also a London in our devotions, I think, including an historical art milieu – London as a place where a vivid, odd, oblique art can be made. Auerbach and Freud particularly have drawn me into the strange glow of that London over the years, and so have others like Hodgkin, Bacon, Kossoff and, well, a dozen or more remarkable painters. But I am closest to Frank, and I see Freud from time to time when I'm awake enough to coincide with his hours. I also like to keep in touch with many other painter friends young and old. Another visual artist who always inspires me is my great friend Lee Friedlander. We see each other about once a year for a few days and when he leaves he has excited me so much that I pretend to be a photographer and take dumb snapshots for a week or so.

Germania (to the Brothel), 1987

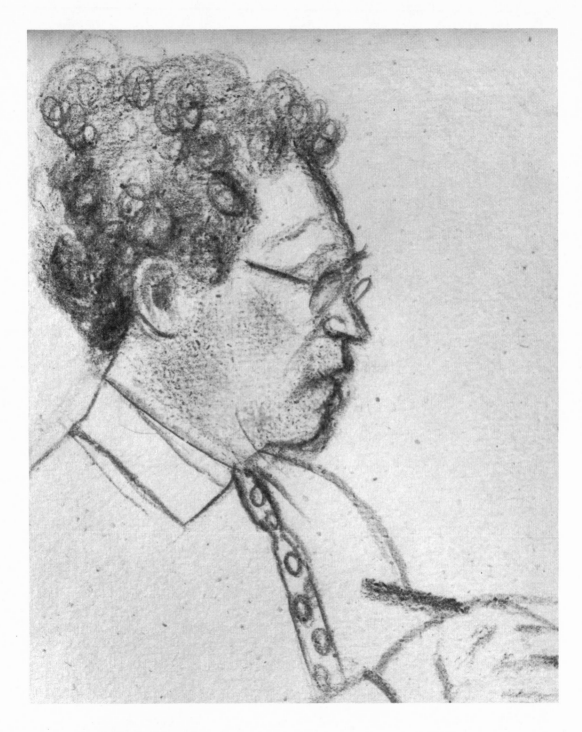

Arikha Sketching, 1982

J.R. Although you first knew him years before, your friendship with the Israeli painter and scholar Avigdor Arikha became closer during your one-year stay (1982–3) in Paris.

R.B.K. Yes. I am closer with him now than with anyone. We speak on the phone every few days, and see each other quite often.

J.R. He was born in Bukovina in 1929. When he was thirteen his draughtsmanship saved his life. His drawings, on scraps of paper, drew the attention of the concentration camp authorities. In this respect he was luckier than the Polish draughtsman and writer Bruno Schulz, who in Drohbicz ghetto, first occupied by the Soviets and next by the Germans, tried to survive making drawings and portraits according to the canons of socialist and 'nazist' realism. But I suppose the two of you didn't talk much about the art for life's sake of those terrible years.

R.B.K. I know something about a few things. He knows everything about everything, almost. I try to pry open my failing intellect to make pictures. He, the superb scholar, paints nudes and vegetables in one sitting. He, who suffered the German hell, wouldn't touch it in art. I, who was warm and safe in America, can't keep away from some oblique engagement with what happened all those years ago. I believe something awful will happen again. When I am in Jerusalem with Avigdor, I do not feel optimistic about the future of the Jews. Sometimes we talk on the phone twice a day. We buck each other up when we're depressed.

J.R. You share with Arikha many artistic passions and principles, in particular a passion for observation, for drawing from life.

R.B.K. Yes, we truly share many things. I wish we could repeat the intimacy of that Paris year. I wish a lot of things.

J.R. Your portrait of Arikha sketching was made *alla prima*, in tune with one of Arikha's principles. Do you agree with this practice of painting in only one sitting without making corrections afterwards?

R.B.K. *All* my sketches are *alla prima*, as opposed to the larger drawings which can take a very long time. It's not for me to agree with this practice of 'one go'. If it's in one's grain it must be done. It is in Arikha's grain ...

A picture is something which requires as much knavery, trickery, and deceit as the perpetration of a crime. Paint falsely, and then add the accent of nature.

A picture is first of all a product of the imagination of the artist; it must never be a copy. If then two or three natural accents can be added, obviously no harm is done. The air we see in the painting of the old masters is never the air we breathe.

<div align="right">Degas's sayings</div>

J.R. Sage Degas. Your master in so many artful stratagems is more than deserving of this palindromic title. In 1980 you painted him on his deathbed, from a photograph – an appropriate way to pay homage to him, if we bear in mind the significant part photography played in the development of his art. Degas above all, with the support of Sandra Fisher, led you to the 'discovery' of pastel, which became of great importance in your artistic production from the moment you visited the Degas exhibition in the Petit Palais in 1974. What was the 'message' of this medium, pastel? What did pastels allow you to do that was not possible through oils?

R.B.K. Pastel is *quicker* than oil, which is not the same thing as 'in a hurry'. Also, drawing on paper suddenly attains colour.

J.R. Was it easy for you to master its technique?

R.B.K. Nothing in art is both good and easy.

J.R. Have you applied Degas's techniques to your pastels? Or have you tried your own experiments?

R.B.K. I have tried to 'layer' the pastel many times over as Degas did. Other innovations of his I have not tried, but yes, maybe I've made a few innovations of my own.

Degas, 1980

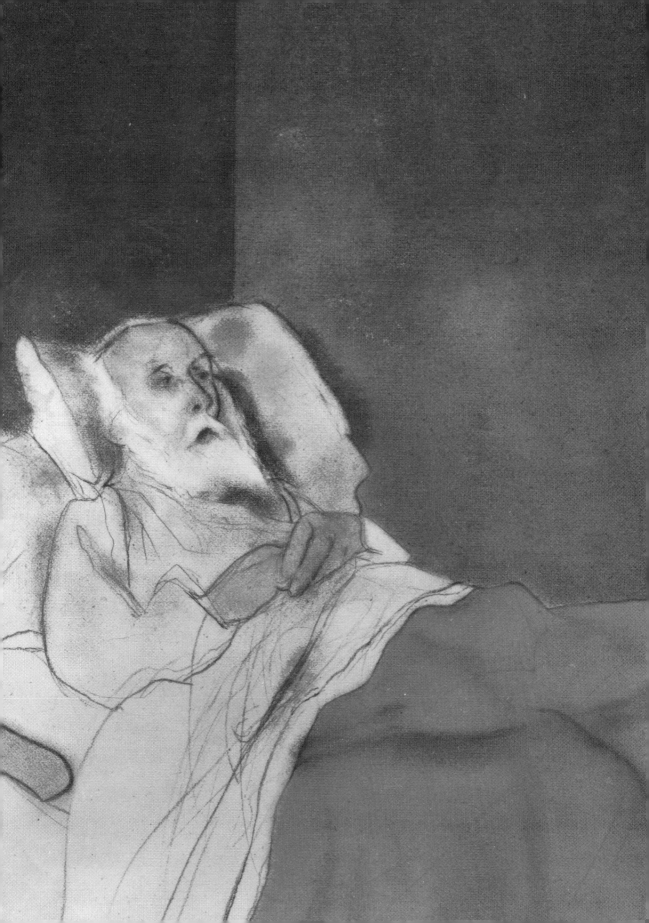

J.R. Paul Valéry, the author of the splendid *Degas Dance Dessin*, would have wholly subscribed to the above Degas quotations. What Valéry called 'literary superstitions' in reference particularly to the novel could be extended to the domain of art. No, we cannot breathe the air of the paintings, but this 'air' helps us to breathe better, and helps each old master's heir to have better inspirations – don't you agree?

R.B.K. Yes, I love that Valéry book on Degas. Did you know M. Teste is Degas?

J.R. Sage Teste ...

In one of your Prefaces, after quoting Picasso saying 'Cézanne! He was my one and only master!', you designated Cézanne your favourite painter. Picasso's proclamation was perhaps excessive. As we know, El Greco was for Picasso at least as decisive a master as Cézanne. A polemical article in the *New York Review of Books*, by John Richardson, 'Picasso's Apocalyptic Whorehouse', which you probably read, insisted on Picasso's deep roots in Spanish art and maintained that El Greco's influence in the formation of Cubism was even more decisive than that of Cézanne. I think Cézanne was the catalyst that allowed Picasso to incorporate El Greco into modernity. But even if Picasso had not known El Greco, which is not the case, he would have received his lessons through Cézanne. Many times lessons are received through intermediary masters.

On several occasions, paraphrasing Cézanne's aspiration to do Poussin over again after nature, you have expressed the wish for doing Cézanne over again after Auschwitz. I wonder if the correct way of putting this would not be rather to redo Cézanne *into* Kitaj – and that would inevitably include Auschwitz, the Gulag, the A-Bomb and the other abominations of your historical time. Recalling Borges's dictum, in 'Kafka and His Precursors', you have pointed out that 'artists tend to *create* their precursors'.

Cézanne is a figure with whom you identify yourself, even to the point where in the introduction to the 1980 exhibition at the National Gallery, 'The Artist's Eye', selected by yourself, you said: 'I, for one, *feel* like a Post-Impressionist.' Couldn't that feeling be illusory at bottom? Surely you remember Borges's story of Pierre Menard, the French author who undertook the impossible task of writing *Don Quixote* over again, word by word? Borges reached the unavoidable conclusion: 'The texts of Cervantes and that of Menard are verbally identical, but the

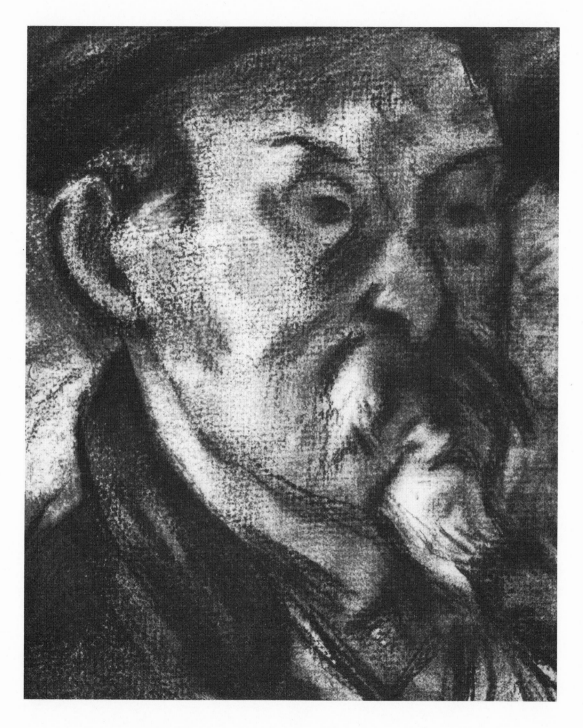

Cézanne c. 1979

second is almost infinitely richer.' The lesson of Pierre Menard still hasn't been sufficiently learned. As Goya said, time also paints. Could you talk about Cézanne's teachings and the way he allows you to master your own tradition?

R.B.K. The Richardson article is superb. He and Marilyn McCully, who did the research on El Greco etc. for Richardson, have published the first volume of a great four-volume life of Picasso. I was born six years after Monet died. Does that not make me a Post-Impressionist? Of course '*into* Kitaj'. There is *no* other way. It is *because* of Goya's truth that time paints that I can circumvent, short-circuit time at will and act as though I am like Picasso or Matisse, who *both* considered Cézanne their master. They painted *while* he was painting what I consider his greatest pictures (after 1900!) – the large *Bather* paintings. Without these, Picasso and Matisse and Cubism and Expressionism and Bonnard and Post-Impressionism are impossible as we know them; Greco or no Greco the demoiselles of the whorehouse in calle d'Avignon and the revolution it started would not exist. Picasso might have given in to his very natural penchant for Symbolism/Surrealism, or Iberianismo. (He is *already* the greatest Surrealist painter, the greatest collagist. Maybe also, with Matisse, he is the greatest twentieth-century sculptor – they are certainly the best draughtsmen.) I understand where they come from, but I do not understand the mystery of their master, how he arrived, and so I am drawn to him as they were, as if the years since 1906 hardly exist. But they do! So I study him every day for his mysteries. If I did not think the mysteries were beautiful, I would not study them. Cézanne belongs with Giotto, late Titian, Michelangelo, Rembrandt, Velázquez, Goya and Van Gogh.

The poet talked with Cézanne and with Verlaine: he overcame the impossible by the urgent need of such a conversation. They spoke sadly.

> Let's talk
> about important trifles,
> about this poor craft of ours.
> Now,
> bad verses
> are trash.
> A good line –
> is worth a lot.
> With a good line
> I, too, would be ready
> to lay
> my guts
> in the gutter.

This was hardly evidence. The verses were good, and the 'poor craft' was poetry and painting.

Viktor Shklovsky, *Mayakovsky and His Circle*

J.R. Most of my artist friends agree with me that relationships with practitioners of arts different from our own are usually more stimulating for personal creativity.

R.B.K. I don't think I can agree with your friends that I get more inspiration from writers than painters.

Art, like the Jewish God, wallows in sacrifice.
And:
In Art ... the creative impulse is essentially fanatic.
And:
... the excesses of the great masters! They pursue an idea to its furthermost limits.

Gustave Flaubert

J.R. You and Philip Roth are both of the same generation and have similar family and childhood backgrounds. The lunches with Philip Roth could irrigate your American roots. The Jewish life in his work is apparently less dramatic than in yours, more farcical. On the other hand, I suppose you are his art tutor. I remember now some Flaubert quotations collected by the narrator of *My Life as a Man*, Peter Tarnopol, which in turn I am going to include here in the margin because I think you could subscribe to them entirely.

Was your portrait of Philip Roth made in one session?

R.B.K. No, about six sessions.

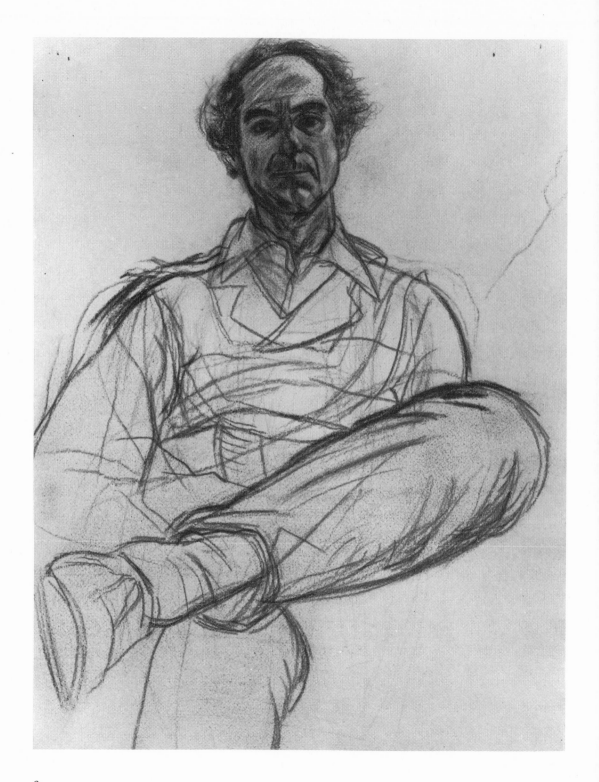

Philip Roth, 1985

Colonel Jonathan Williams
(underdrawing for *Aureolin*), 1964

J.R. Poetry has always taken a prominent part in your paintings (*ut pictura poesis ...*) and your friendship with some of the Black Mountain poets and some American poets of your own generation has been, I presume, an important stimulus for your own creativity.

R.B.K. Of course the poet friends have entered into my life and art – Ashbery, Jonathan Williams, Creeley, Duncan ... and others.

Woke up this mornin',
Cape Canaveral can't get it up ...
Woke up this mornin',
Cape Canaveral can't get it up ...

But sent a cable to Great Venus –
told her, better watch her ass!

Jonathan Williams

J.R. Then let's start with the person who introduced you to post-Eliot/Pound poetry, Jonathan Williams. You first met him at a poetry reading in a Dulwich pub a year or two before portraying him in *Aureolin* (1964) as a sort of cosmonaut or aviator. Maybe when you painted him as Colonel Jonathan Williams you had in mind some verses of his ...

R.B.K. 'Colonel' is an American designation for a Southern Gent, which Jonathan is. He's the Colonel of Poetry, a superb Carolina antidote to Senator Jesse Helms and the powers of darkness.

J.R. In 1965 you illustrated his *Mahler* poems. How a *Maler* felt before Mahler? I imagine you tried to find the soul (Alma Mahler) of music and poetry. Did you create some synesthetic symphony, à la Whistler?

R.B.K. I suppose you could say that, but I would not dare to compare my poor collages of that folio with Whistler's masterful symphonies in paint. I regret my collage period deeply. Thank God it did not last too long.

J.R. I think you had the luck to find in that Dulwich pub the best initiator into the mysteries of contemporary American poetry – a poet himself and a publisher who has been the 'connector', from Connecticut to Cumberland, of distant and often isolated poets. Did he introduce you to other poets, maybe some of his Black Mountain friends?

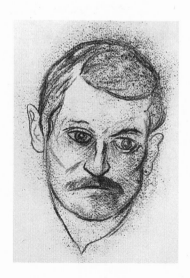

John Ashbery, 1979

R.B.K. He introduced me to their work through his beautiful Jargon Books. Later I met Olson, Creeley, Duncan, Dorn et al. on my own. And later, Jonathan's companion Thomas Meyer entered the scene and began to do some very special books with Sandra. Tom is just about the only younger poet I read. If there are others out there as good as he is, well, I'm missing a great deal, but I miss a lot of things.

J.R. John Ashbery is another of your portrayed poets, although not in a convex mirror. There are, in my opinion, some parallel lines between his poetry and your painting – *ut pictura poesis*. There's a visual and intellectual acuity that interconnects images and missing links, a sense of place and detail, and of the tale which corrects with its internal logic the surrealistic flotsam. Because, as is said in Ashbery's *Houseboat Days*: 'The mind/Is so hospitable, taking in everything ...' In 1976 you did an oil

painting of a dreamy oarswoman for the cover of *Houseboat Days*. Your heroine (inspired by the belle Simone Simon in Allegret's film of 1933, *Lac aux Dames*) pulls a good oar. And creates what Ashbery would call 'a particular mental climate' – something in which Ashbery is also skilled. Have you ever thought of some of the parallels between Ashbery's art and yours?

Houseboat Days (for John Ashbery)
(detail), 1976

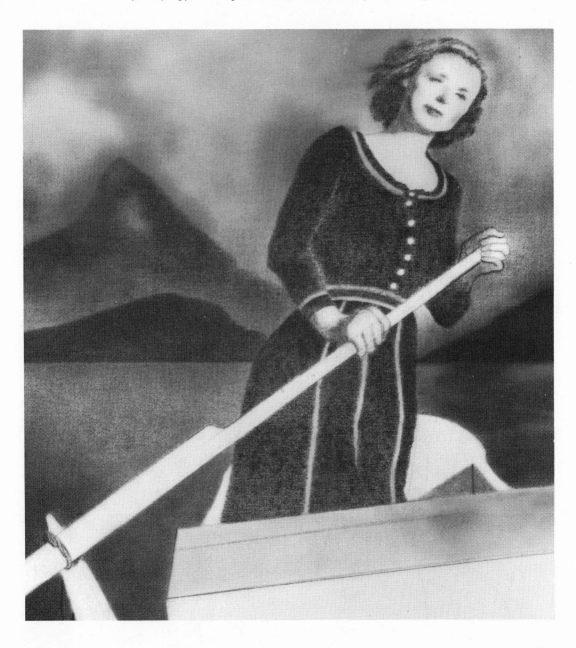

A Visit to London, 1977–9

R.B.K. I did a self-portrait in Paris for a wonderful, round edition of his *Convex Mirror*, published in San Francisco. Yes, of course we remind one another of each other – that is how we were drawn to each other. We have a common cause in Americanized, expatriated Surreal-Symbolism. He lived many years in Paris. His syntax thrills me on the page, connecting unusual, variable worlds, emotions, phrasing, words, etc. Like me, he seems to want to do something anachronistic, undecidable, *different* with every picture.

J.R. In *A Visit to London* you portrayed the two Roberts, Creeley and Duncan. And I want to ask a quite curious question: do you remember some of your conversations during the making of this painting? Or did you use Bacon's method?

R.B.K. *A Visit to London* was painted from life. The Roberts were both staying with us at Elm Park Road in the days before Max. Now we will have no house guests until he is older. No, I don't remember what we talked about.

J.R. Besides the fact that they happened to be at your place at the same time, was there any poetic or artistic reason for joining together these two quite different poet-friends?

R.B.K. Creeley and Duncan are very different poets. Creeley's poetry is spare, 'skinny', tense, often about love, about women. Someone said reading Creeley was like walking through a minefield. Duncan is America's greatest poet-scholar, dense, oblique, difficult, gay, alchemical, *but* they are very, very old friends, going back forty years to Majorca and Black Mountain, where they were protégés of the great American erudite Charles Olson. There was *every* reason to celebrate them together in a painting. They are like Picasso and Braque, something like that – very often coupled in the history of modern poetry.

J.R. Robert Duncan is your most frequently portrayed poet, especially during 1982, in Paris, where you made at least nine portraits of him. These later portraits contrast with your first portrait of him, in 1968, I think. Your friendship began a year before, while you were staying at Berkeley as a Visiting Professor.

R.B.K. Some of the Duncan portraits were published in New York in a book called *A Visit to Paris*, with his poetry about being drawn by me. I also wrote an introduction for that. Duncan is unique. Anyone who meets him is entranced. He rarely stops

Duncan at Berkeley, 1968

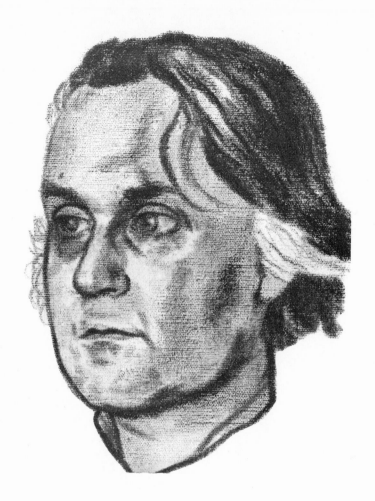

talking in a high-pitched voice on every subject, with an occult erudition that knocks you out. He is a master of poetry, history, art, Americana, homosexuality and an encyclopedia of the arcane. He is the great gossip gospeller of arcane knowledge. Borges might have invented him. He is very, very ill now, we all fear. That Paris visit, staying with me, was his last fling in the world he scattered himself through and upon. Now he is quiet, back in that incredible dark Symbolist house in San Francisco he shares with his beloved Jess.

Being together in Paris concluded our real-life friendship, I guess. I speak with him on the phone but I'm afraid it is ghostlike. He tells me he has not written anything for years. Oh, what a poet, scholar, man, older brother . . . I hope I can see him again.*

*Postscript: I never will.

68

This pen is where the writing flows in sight the measuring eye follows line by line, mouth set in the mind's movement throughout attentive, tentative – let the numbers fall into the hands one drawing the letters one by one holds the count at bay, the other keeps the time of an inner wave in sway.

From *Illustrative Lines* by Robert Duncan

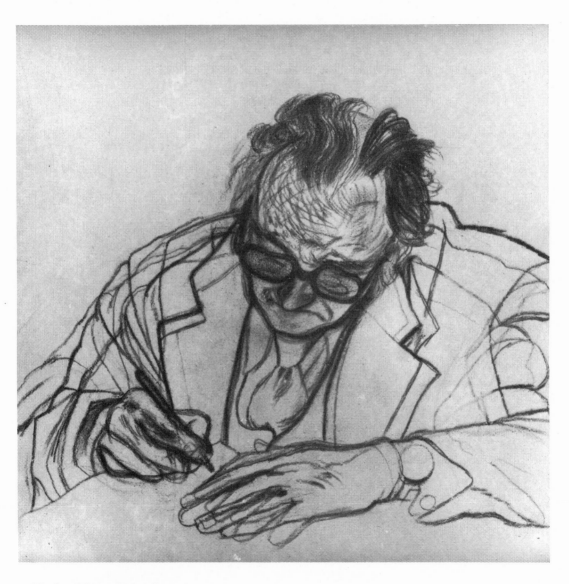

The Poet Writing (Robert Duncan),
1982

Anne on Drancy Station (Anne Atík), 1985

Sandy Wilson, 1980–84

Richard Wollheim, 1978

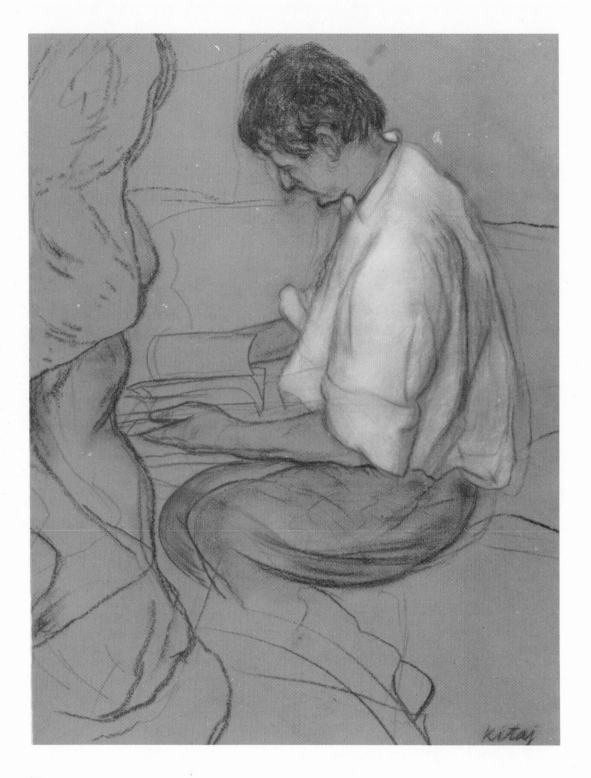

72

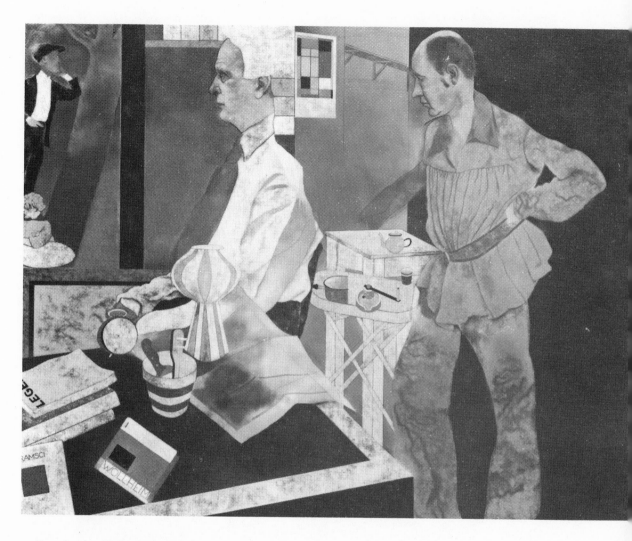

*From London (James Joll and John
Golding)*, 1975–6

Lucian Freud, 1990–91

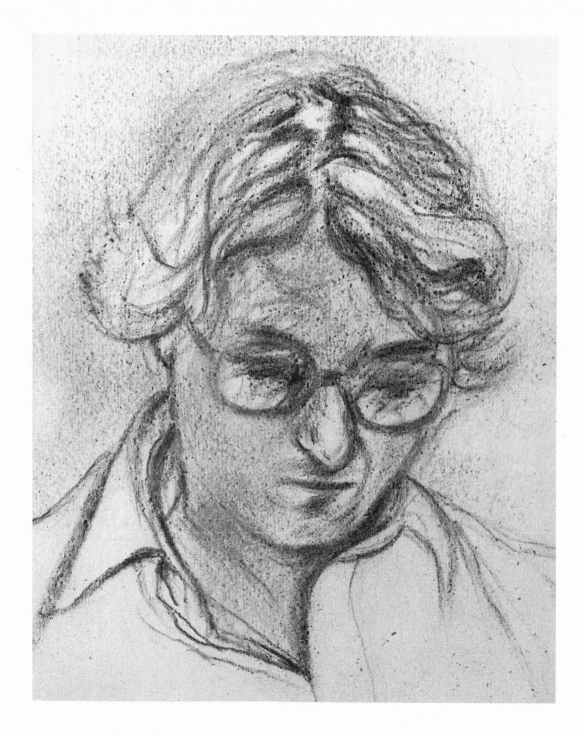

Frederic Tuten, 1982

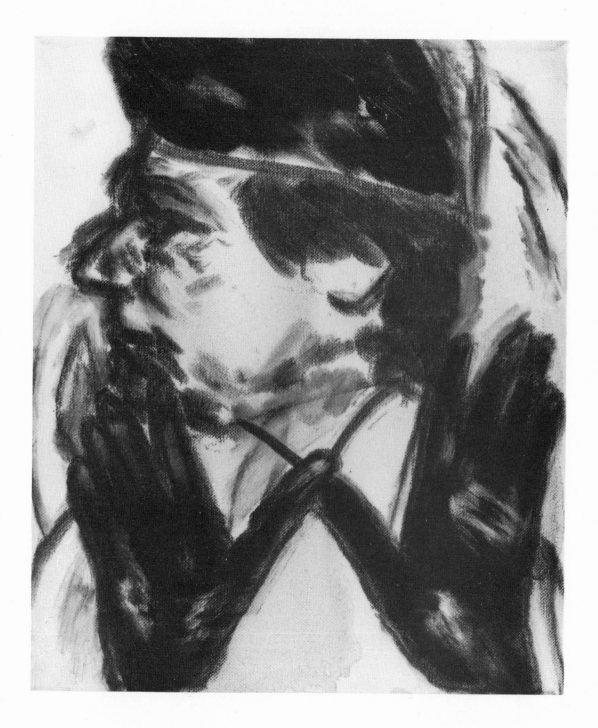

David Plante, 1992

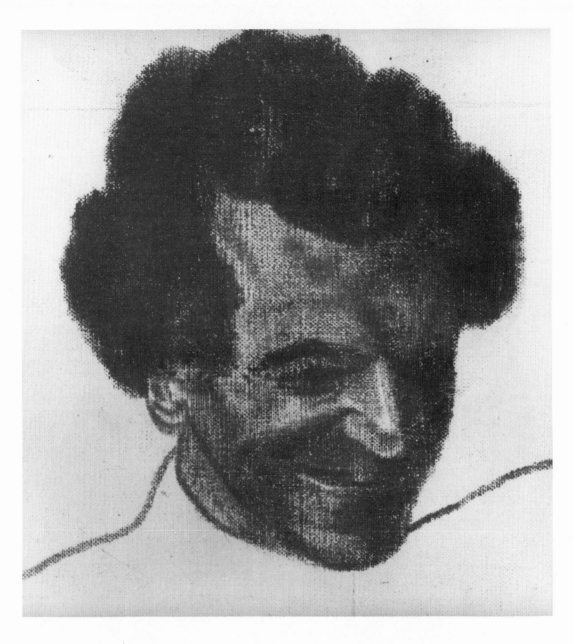

John Wieners, 1968

Basil Bunting, c. 1971

76

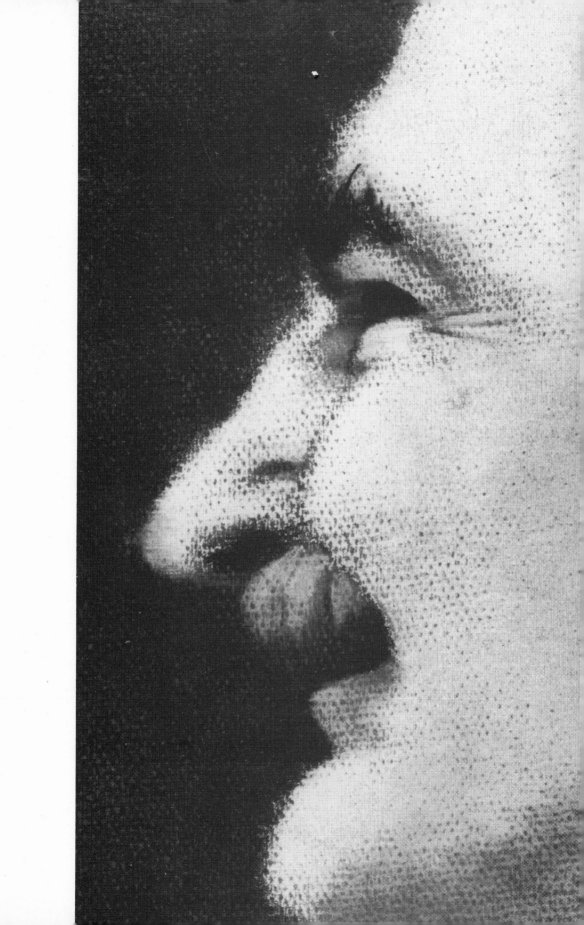

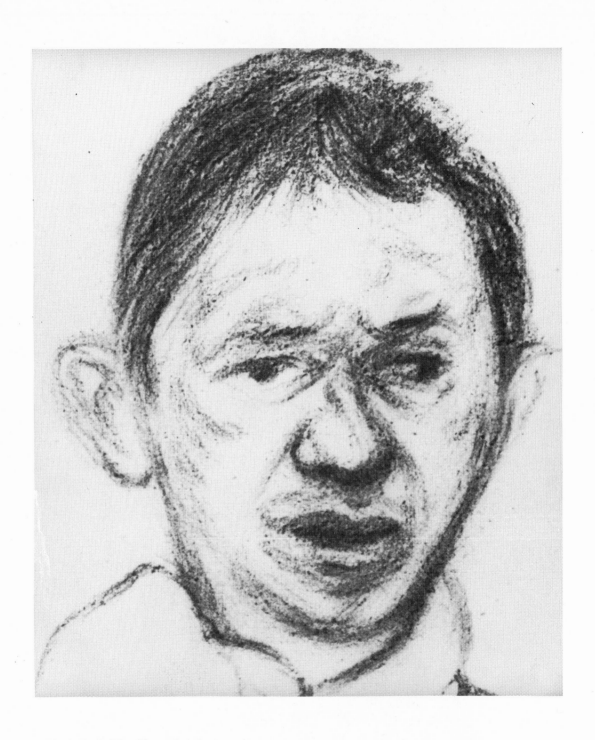

Tim in Paris (Tim Hyman), 1982

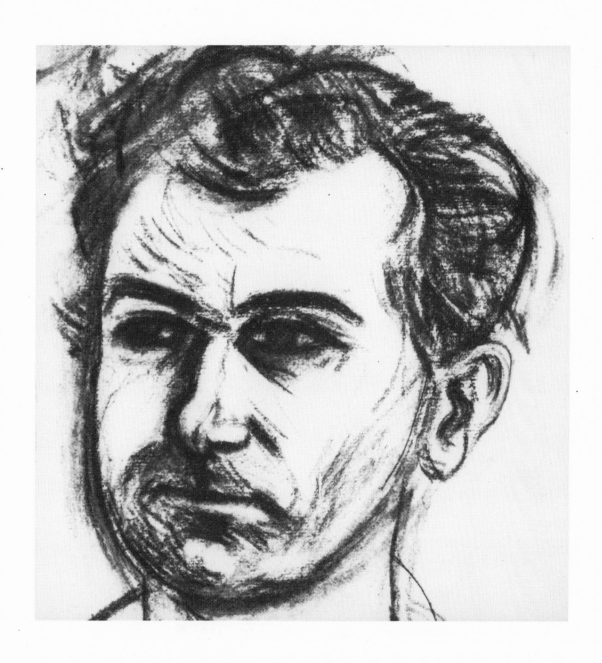

Sacha and Gabriel (detail of Gabriel
Josipovici), 1981

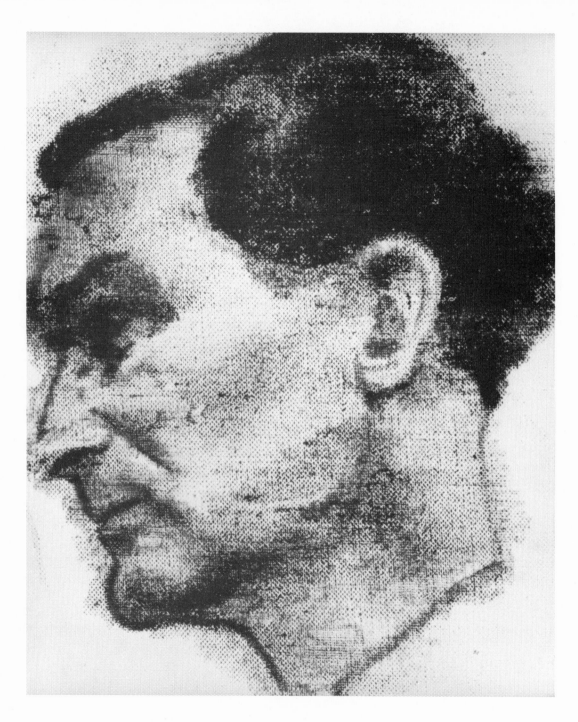

Michael Hamburger, 1969

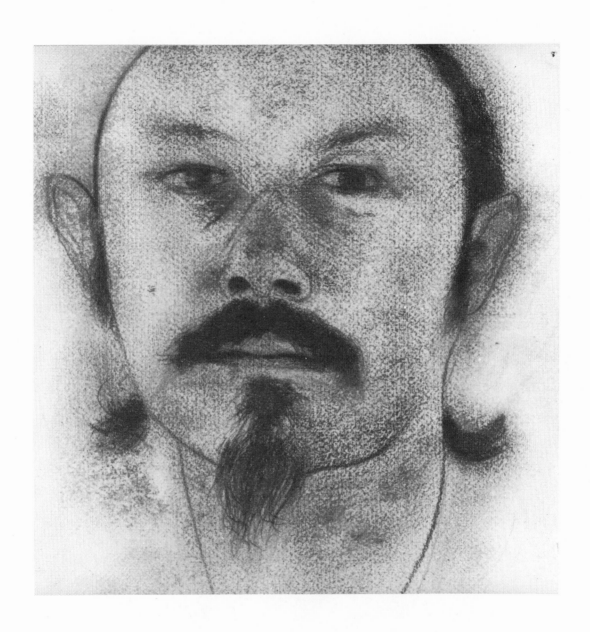

Paul Blackburn, 1980

Ed Dorn, 1967

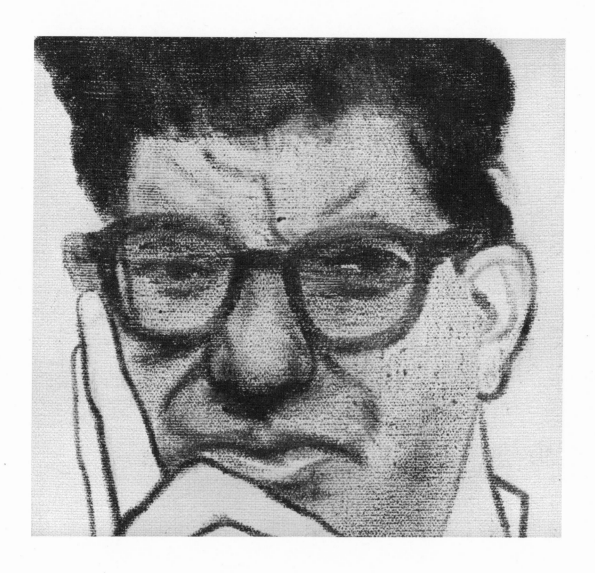

Morton Feldman, 1967

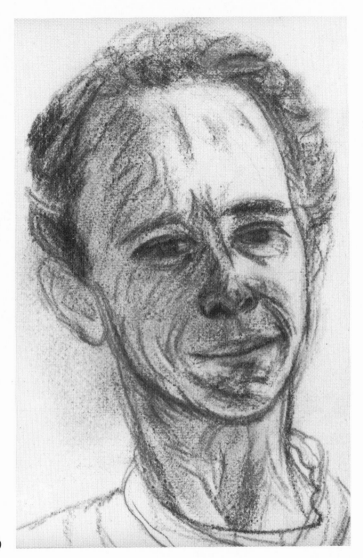

Joel Grey, 1989

J.R. Your face will be the best epilogue to this collection of friends. Therefore I include here portraits of you by some of them.

Kitaj in London (by Frank
Auerbach), 1980

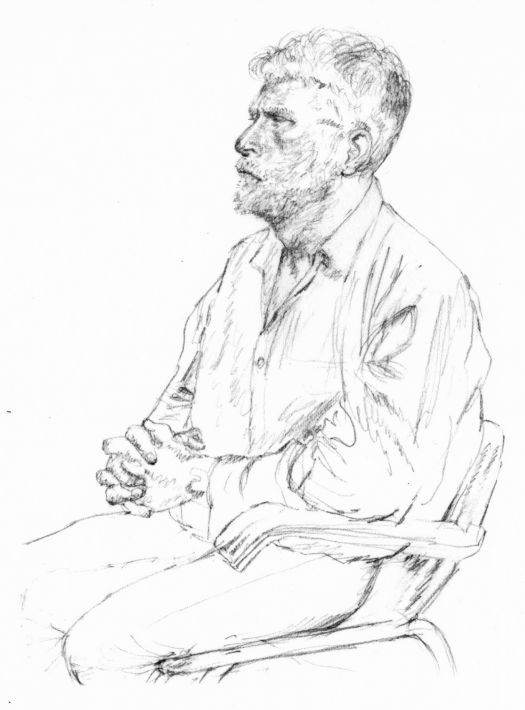

R.B. Kitaj (by Avigdor Arikha),
1983

86

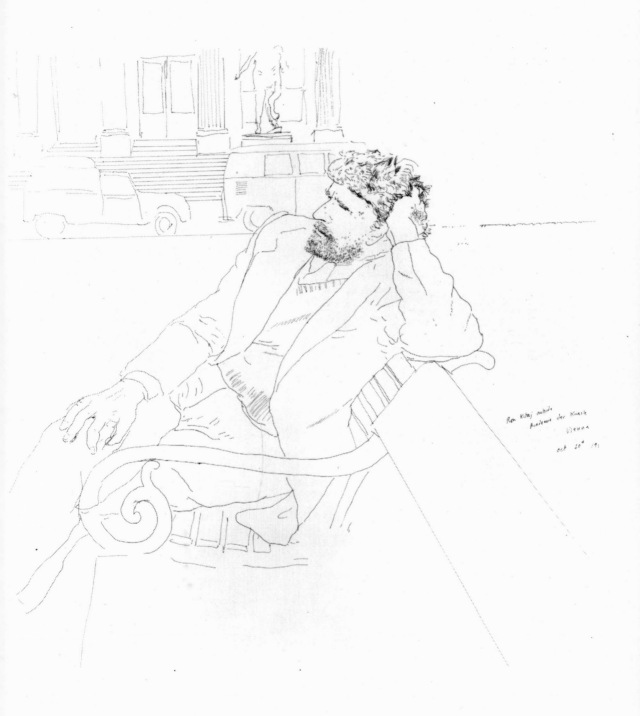

Kitaj in Vienna (by David Hockney),
1974

Kitaj in London (photograph by
David Hockney), 1980

SELF-PORTRAITS

Un hombre se propone la tarea de dibujar el mundo. A lo largo de los años puebla un espacio con imágenes de provincias, de reinos, de montañas, de bahías, de naves, de islas, de peces, de habitaciones, de instrumentos, de astros, de caballos y de personas. Poco antes de morir, descubre que ese paciente laberinto de líneas traza la imagen de su cara.

Jorge Luis Borges, El Hacedor

J.R. Besides the fact that the artist is (usually) his most available model and that in every artist there is something of a Narcissus, I suppose what drives the true artist to face his face in a self-portrait is primarily the yearning for knowledge: know thyself – the first step to any deep understanding of human nature. So all the great portrait painters have also been great self-portraitists. Other motives and obsessions may act too, for instance masochistic impulses or a Saturnian preoccupation with time: the face is a clock that ages ...

You have portrayed yourself quite often, particularly in recent years – maybe this is because maturity allows us to examine ourselves without pose and with repose.

In other chapters we have seen different self-portraits of yours: sometimes you are accompanied, as in the 'goyesco' *The Green Blanket*, and sometimes you impersonate difficult characters – *Self-Portrait as a Woman* – or even make discreet chameleon appearances à la Hitchcock – *Smyrna Greek* (*Nikos*), or the recent *Germania* (*To the Brothel*). But here I would like to examine portraits in which you face your face alone.

And since objects can also be the measure of man, and especially in this time of 'chosification', I choose first your *Self-Portrait* of 1965. A piece of modernist wit? Wittgenstein comes now to my rescue: *Ich bin meine Welt.* I am my world ... Every painting is at bottom a portrait of the artist who made it. And now I recall the best Borges self-portrait, which also portrays every *hacedor* or maker.

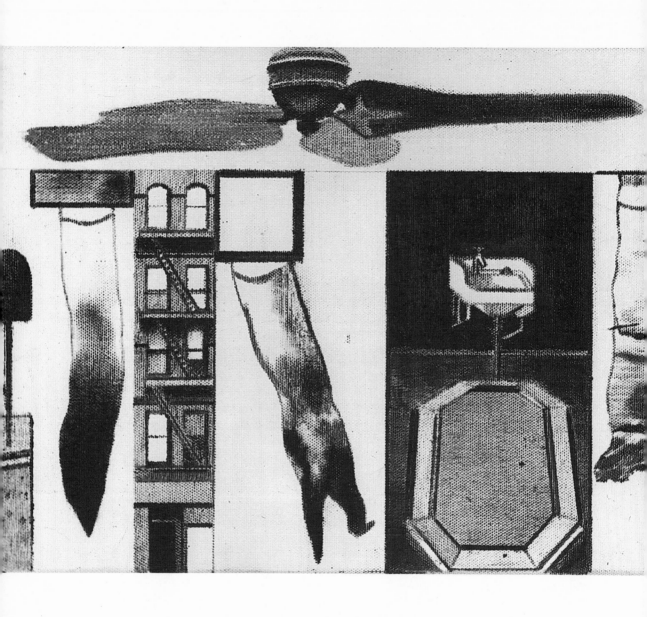

Self-Portrait, 1965

90

Self-Portrait (for Ashbery), 1982

R.B.K. *Ich bin meine Welt,* but I can't honestly recognize the purpose behind the 1965 *Self-Portrait.* I believe it represents a mood I was in. I can't say for certain what was in my mind. Those three shapes which look like condoms are, in fact, fabric samples which have been burnt, charred, to test their resistance to fire – ardour? – cooled by the fan above. The tenement and the sink may allude to whoring. I don't remember.

J.R. Did you use a convex mirror in your *Self-Portrait (for Ashbery)*? And do you usually make use of mirrors to portray yourself? A mirror on the left of your easel, following the Rembrandt method?

Alas, after a certain age every man is responsible for his face.

Albert Camus, The Fall

R.B.K. No convex mirror, but I do use a mirror, mostly on the right or held in my left hand.

J.R. Self-portraits are as revealing as dreams, and we could say, paraphrasing Delmore Schwartz's title, that in self-portraits begin responsibilities ... It is enlightening to observe how an artist views himself. Your mature self-portraits reveal a mellow sense of humour which does not exclude the force – and farce – of gravity. I am particularly thinking of your *Cold in Paris* self-portrait and the other Parisian ones after Matteo. And Rembrandt. Matisse is another master, invoked by you in your Parisian *Self-Portrait* (*Greta Prozor*).

Self-Portrait (*Cold in Paris*), 1983

Kitaj in Paris, 1982

Kitaj in Paris (after Matteo), 1982

Self-Portrait (Greta Prozor), 1983

At fifty, everyone has the face he deserves.

George Orwell, Notebook

R.B.K. In the mirror, over my shoulder, was a poster of the Matisse portrait of Greta Prozor just acquired by the Beaubourg.

J.R. When scrutinizing yourself in a self-portrait have you ever discovered something you don't like to show? Do you keep some self-portraits secret?

R.B.K. No, no secrets.

J.R. Nobody can portray the *same* face twice. The self flows continually, as the great artists of the psyche reveal in their successive self-portraits. Henry James spoke, in *The Ambassadors*, I think, of the terrible *fluidity* of self-revelation. Each self-portrait could also be a kind of *instantané* beyond the instant, an intent to fix that fluidity. Are you interested in seizing the flow and the flower of the day?

R.B.K. Yes.

95

DRAWN CHARACTERS

J.R. In the literary creation of characters, pictorial terms are often used – such as 'portrait', characters 'well or badly drawn' – and I suppose that the reverse could also be possible. But a literary character exists through his words, actions and thoughts and, above all, through time. Do you think it is possible to attain the complex *density* of a novelistic personage on the canvas?

R.B.K. Your question is momentous and mountainous ... Cézanne's great mountain is not inapposite here. Of the three or four ways you mention in which literary characters 'exist', action and time can arguably be said to be available to a painter making a portrait of a mountain and especially many portraits of the same mountain. Did Borges say if you repeat a memory often enough it becomes a legend? The 'real' Mont Sainte-Victoire *became* a legend! If I were to draw a character, I would expect also to endow it with your third element – thought. Sweet silent thought. Even sweet silent words are not out of the question: in the painting *Self-Portrait as a Woman* I've given the mouth words to speak.

But all this self-justification aside, I have yet to achieve the degree of complexity I would like. I hope the way lies ahead for me. Meanwhile, the best painters can be said to have created characters. Just think of any favourite picture of someone who never 'existed' except in the painter's mind and then on canvas. From Michelangelo to Picasso – saints, sinners, fools, angels, gods.

My pictures are full of characters I make up. I suppose complexity in a drawn character will be remembered through being *seen*, so it enters the social memory like a character in Dickens or Kafka or Chekhov, but by a different path. In a painting, the character need not unfold in an instant, like a vision. It takes *time* to look, to unfold, to change, to repeat, to fulfil ... and so on.

Daumier's *Ratapoil* is my pre-eminent precursor in all this ... and such thugs as Borges, Kafka and Chirico have given their unholy permissions to mark my playing cards anew, switch decks, destroy evidence, etc.

The only reason for the existence of a novel is that it does attempt to represent life. When it relinquishes this attempt, the same attempt that we see on the canvas of the painter, it will have arrived at a very strange pass. It is not expected of the picture that it will make itself humble in order to be forgiven; and the analogy between the art of the painter and the art of the novelist is, so far as I am able to see, complete. Their inspiration is the same, their process (allowing for the different quality of the vehicle) is the same, their success is the same. They may learn from each other, they may explain and sustain each other. Their cause is the same, and the honour of one is the honour of another.

Henry James, The Art of Fiction

J.R. Your models lead me to respond with some very lucid lines by Henry James, in *The Art of Fiction*, about the analogies between novel and painting. The art of fiction, yes, and the fictions of art.

As the first of your drawn characters I would like to choose your *Self-Portrait as a Woman*: the self is the main drag and the first fiction. 'That ghost who is our self,' said Monsieur Teste, very buddhistically. And we know, at least since Rimbaud, I *is* an other. I suppose that you have represented in this self-portrait your feminine, inner side? Or perhaps something even deeper? After all, anima is an anagram of mania.

R.B.K. As you know, one of my animated manias is to write a preface, or your better term, epilogue, for many of my pictures, so *Self-Portrait as a Woman* will get the 'treatment'. But in the interim I can say that the picture was meant to show one of those ladies the Germans used to parade in their streets with a placard saying 'I slept with a Jew'. These written epilogues or prose poems will take maybe all my life to compose, but your analysis is interesting. There is surely something even deeper here, as you say.

J.R. You have exposed yourself as a stigmatized woman through the astigmatic 'fanaziticism'. In descent, exposure ...

R.B.K. Updike says, 'Shame is not for writers,' and my dear Philip Roth says, 'Fiction has an obligation to be about those things that we're too ashamed to talk about with those we trust the most.'

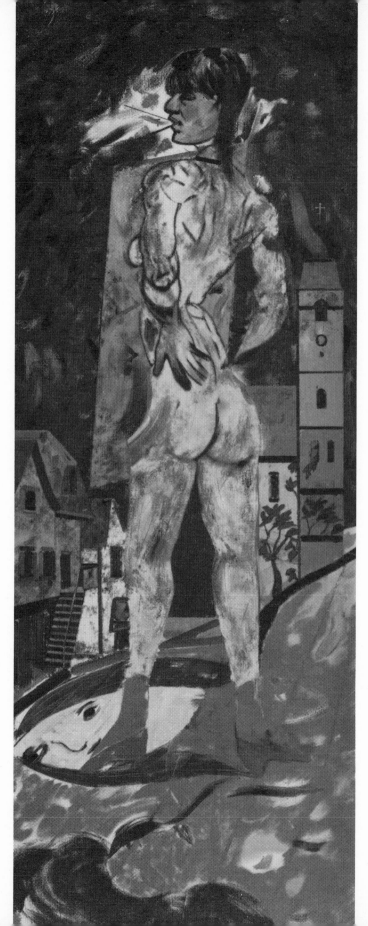

Self-Portrait as a Woman, 1984

98

J.R. You have recreated yourself, in a way not very dissimilar from many cosmogonic myths (including Jewish ones), as androgynous. This theme could lead us very far – or mislead us – through alchemy and cabbala, for example. I would just like to mention that the German mystic Jakob Böhme saw Adam in Paradise as a '*männliche Jungfrau*', a manly girl.

When a moment ago you talked about the silent words of your *Self-Portrait as a Woman*, I remembered that some years ago a Portuguese poet asked me to help him distribute a home movie of García Lorca which he owned. He said it might be the only extant film of García Lorca. He was walking in the streets of Buenos Aires and talking silently, but, the Portuguese poet emphasized, a lip-reader could determine what the author of the *Romancero gitano* was saying. Could you put words into your alter ego mouth?

R.B.K. She is saying I slept with a Jew ... and some other things.

J.R. In connection with painting as invention or even fiction, I suppose you could appeal to the liar's paradox and say, 'We artists are all liars.'

R.B.K. And besides, there is Picasso's beautiful statement: 'The artist must know the manner whereby to convince others of the truthfulness of his lies.'

J.R. To which could be added, like a pendant, the following Wallace Stevens adage, from his *Adagia*: 'The final belief is to believe in a fiction, which you know to be a fiction, there being nothing else. The exquisite truth is to know that it is a fiction and that you believe in it willingly.'

To continue with your imaginary characters, I would choose now a wandering tramp called *Bill*. His first performance was in *Bill at Sunset* and he reappears, with emblematic significance, in the background of the double portrait *Kenneth Anger and Michael Powell*, also of 1973. Will he act soon in another work of yours? How do you see him exactly? Don't you find something of Santa Claus, or perhaps even Falstaffian, in his appearance?

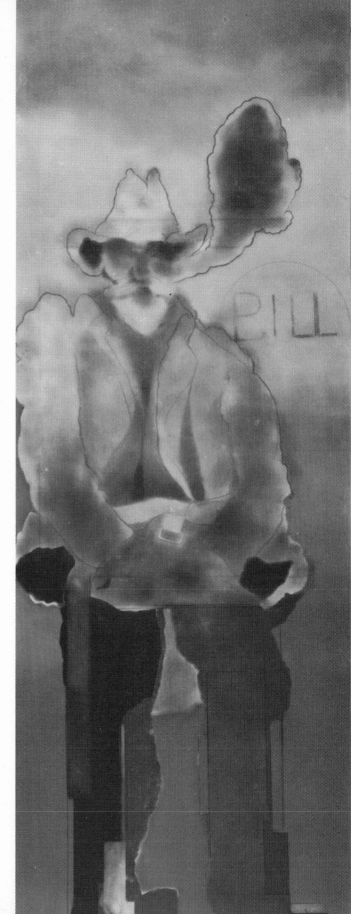

Bill at Sunset, 1973

R.B.K. I don't know if Bill will appear again. My mind has been simmering since then and new ideas form each day. I *don't* see him exactly. He misleads me in his short chimerical life.

J.R. Joe Singer is the character who has appeared most often in your works: *Bad Faith (Riga) (Joe Singer Taking Leave of His Fiancée)*, *The Listener (Joe Singer in Hiding)*, *Study for the Jewish School (Joe Singer as a Boy)* and *The Jewish School (Drawing a Golem)*, all from 1980. And his name appears in one of the bookshop signs of *Cecil Court, London WC2 (The Refugees)*, 1983–4. Apparently 1980 was Joe Singer's year. Will he show up soon or be in hiding for a while?

Study for the Jewish School (Joe Singer as a Boy), 1980

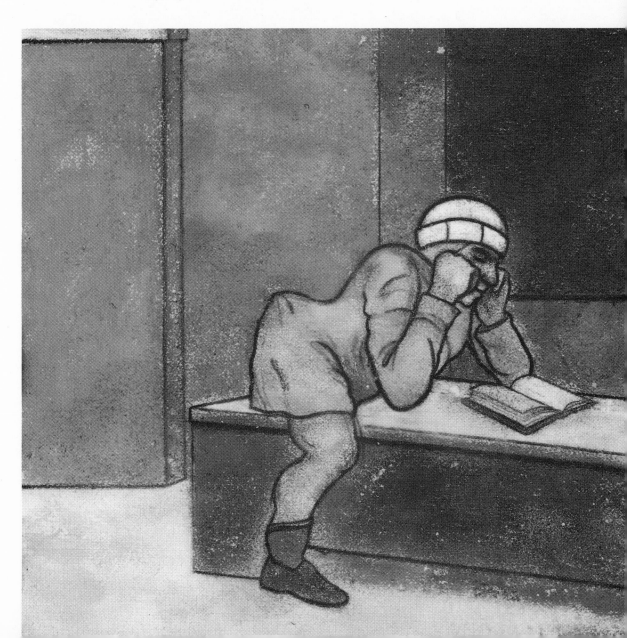

R.B.K. Joe recently made two appearances. I've just finished [early '87] two oil paintings: *Germania (Joe Singer's Last Room)* and *The Caféist*. He survived the war (in his last room), thank God, and he is shown as an older man – now perhaps, the caféist near the rue Blondel where he and I have been following our lifelong addiction to les girls whenever we get to Paris. As older men, our addiction is largely to the peculiar romance of such ancient districts, almost divorced from modern life but not from modern art.

Germania (Joe Singer's Last Room),
1987

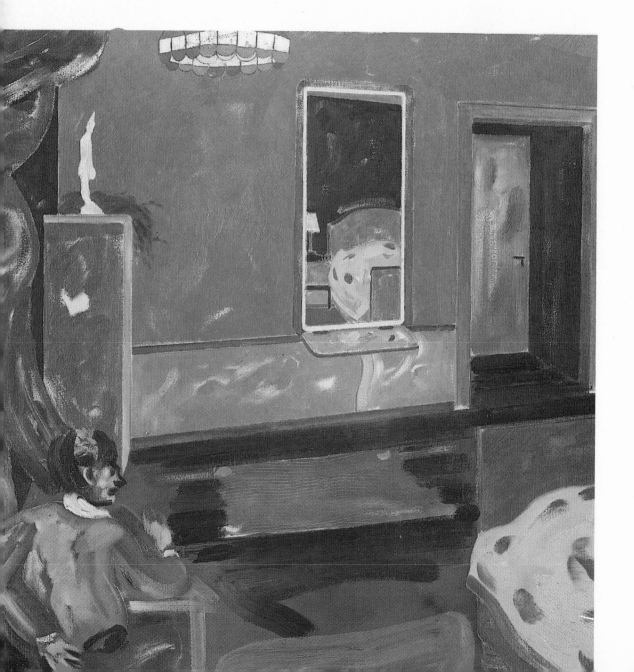

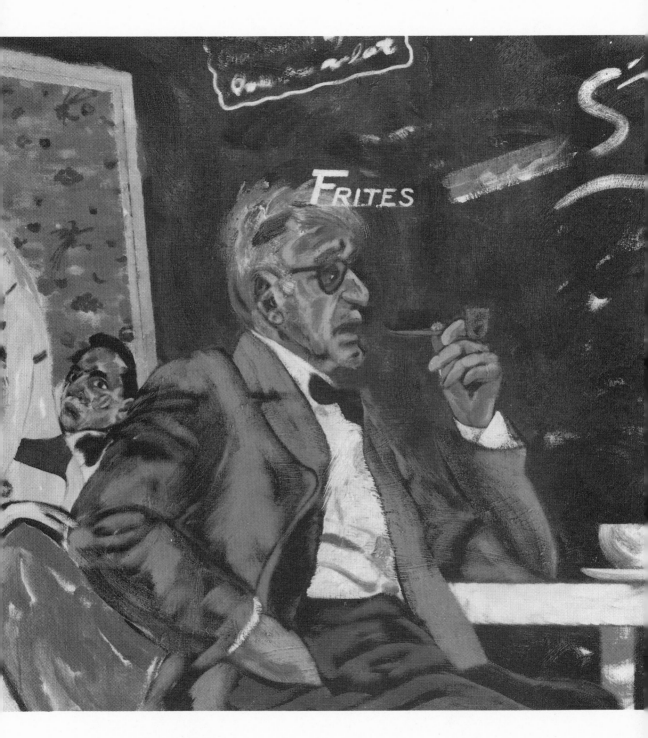

The Caféist, 1980–87

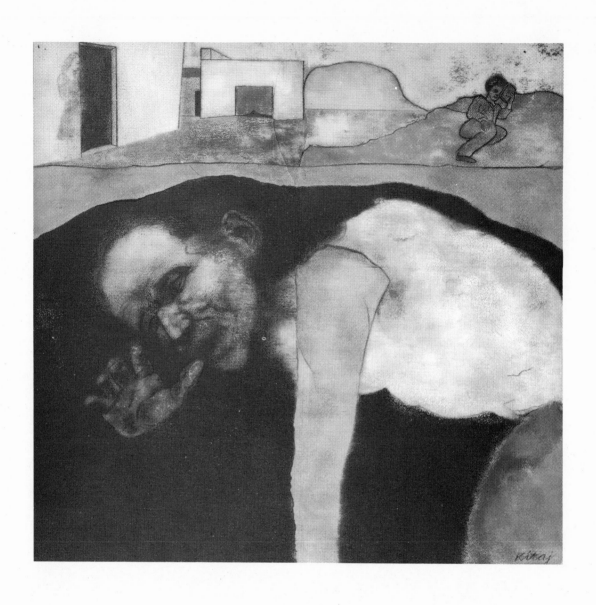

The Listener
(*Joe Singer in Hiding*), 1980

J.R. Joe Singer is *your* Jew, your particular Jew, and universal too, because he is a partner of many parts and, besides being a *persona*, he is an impersonator of the Jew living perilously by force. A metaphysical figure whose beginning is scarcely physical, since he is based on vague childhood remembrances of yours and, more concretely, on an old photograph: a fellow named Joe Singer in his Cleveland apartment, in the late 1930s, with a group of friends, among them your mother and your future stepfather, Dr Walter Kitaj.

An imagined nostalgia permeates the creation of this imago: Joe Singer is your agent, the Jew you send in your place to those dangerous moments of the past in which you couldn't be present. He could also be a father image of all your Diasporist predecessors. He is a versatile figure, changing face in each painting, isn't that so?

R.B.K. Everything you say is good and true. Changing face in each painting is what I want my art to do, so I don't get too bored. Many of the things you mention are attributes which interest me for the art of painting: nostalgia, dangerous moments, etc.

Photograph of Joe Singer and
Sam Weiss, *c.* late 1930s

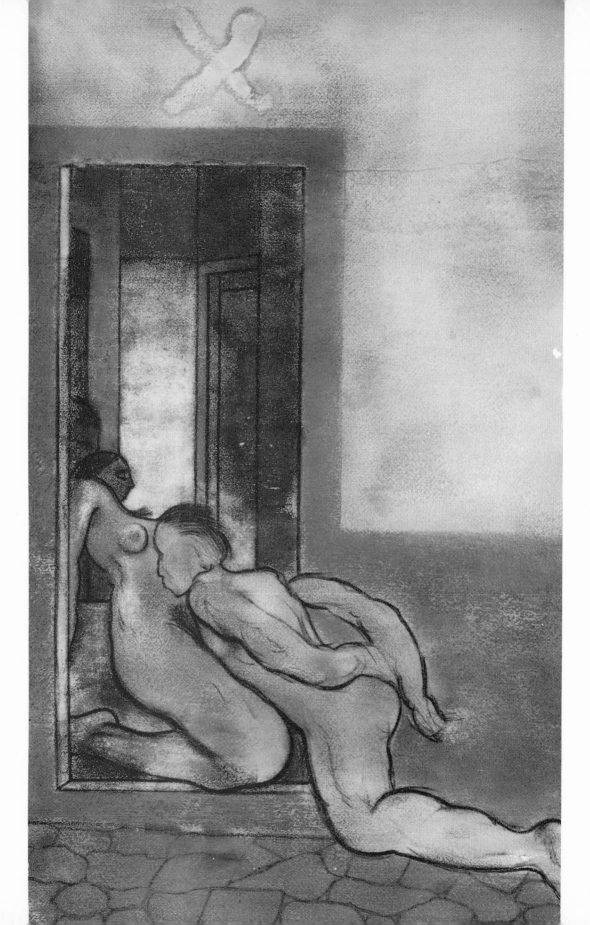

Bad Faith (Riga) (Joe Singer Taking
Leave of His Fiancée), 1980

J.R. The name of Riga in a painting from your 'Bad Faith' series suggests an endless and sinister rigadoon, a dance of death – the one of History – around the Latvian capital, always going from hand to hand, like a false coin, from Polish to Swedish to Russian to German to Russian … And the Jews of Latvia caught in all those hands. Does your *Bad Faith (Riga) (Joe Singer Taking Leave of His Fiancée)* refer to the Nazi occupation of Riga or the Soviet one?

R.B.K. I have been obsessed with Nazism. Stalinism stinks but was not on my mind here. My experience of art suggests that if I paint through an obsession I begin to ease off and save myself for newer forms of obsessive art.

J.R. But apart from History, with a capital H for horror, the history of art also intervenes in your painting, as can be seen in the contorted figure of Joe Singer taking leave of his fiancée, which was modelled on Rodin's *L'Amour ou l'idole éternelle*. Sculpture has often inspired painting and occasionally it appears in some works of yours, as in your 1965 *Pogany I, II*, based on Brancusi's *Mademoiselle Pogany*. In this Joe Singer painting, are the Rodin figures only for their expressive force or for other more obscure reasons?

R.B.K. If I write its epilogue, other reasons may emerge. Time is on my side? Meanwhile I should say that (as you know) I paint in a library in which the history of art and other histories intervene every day in my painting practice. So, you see, Rodin would be to hand. He would help me to paint.

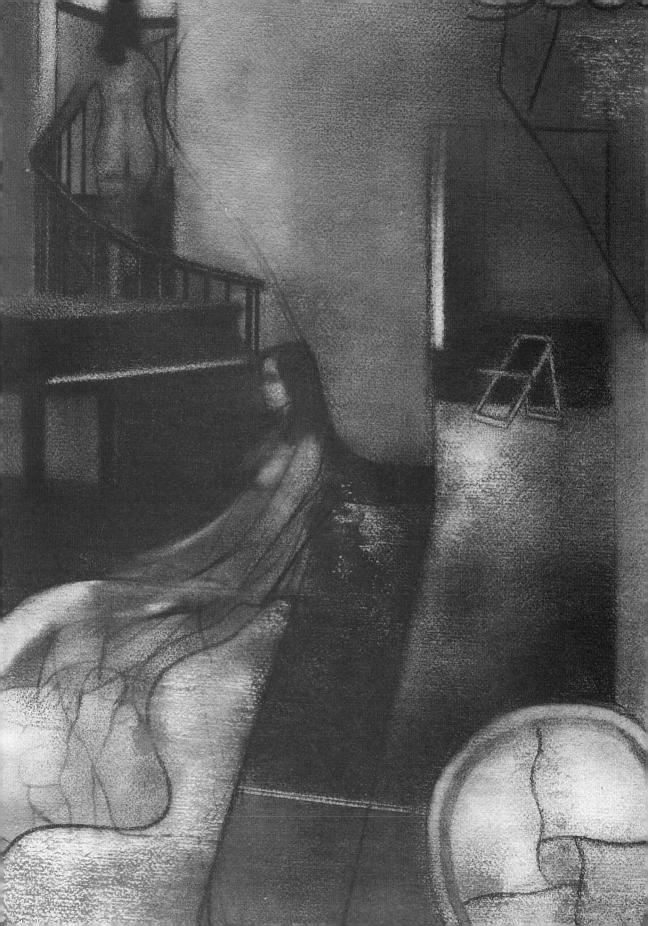

WAKING DREAMS

I dream when I am awake.

Pedro Calderón de la Barca, *La Vida es Sueño*

Klee is perhaps the only one who has treated dreams with the respect they deserve, as the most inviolable thing which takes place in the human being.

Elias Canetti, Die Provinz des Mensche

J.R. Looking at some of your more amazing paintings – a maze, but not without a plan – brings to mind one of my favourite Klee aphorisms: Enter a painting as into a dream ... I am particularly thinking now of *The Philosopher-Queen* and *4 a.m.* Since you have repeatedly acknowledged the influence of Surrealism, I would like you to try to evaluate the importance, in your daily artistic activity, of that underground work that Freud has called the 'work of the dream'. Could the making of a painting sometimes be – to follow the game of correspondences – the magic of images on the other side of the dream/mirror? Do you usually keep vivid images of your dreams? Do you have an eidetic memory?

R.B.K. It seems to me there's an Eidetiker lurking inside each interesting painter, no? He's the guy who gets the vision-idea out of his head and into the world. I'm one of those who make pictures with the help of my Eidetiker, who is too often asleep. If a painting is entered as into a dream, I very often wish to sleepwalk into a painting (of mine) as on to a stage.

I've never been an orthodox Surrealist or an orthodox anything. I'm an unorthodox Diasporist. Picasso was the best Surrealist for me. He was also a Diasporist. I guess he invented again and again for our century the logic of non-logic; he kept on re-inventing it (even in Cubism), which orthodox Surrealists

The Philosopher-Queen, 1978–9

109

did not. Yes, some of my pictures have been dreams, or rather daydreams, because I don't remember the dreams of sleep very well. Certainly, when Breton and Freud and my Muse urged me as a young man to descend into my (hellish) self in quest of secrets, I ran there hungrily.

Some of us seem to need an absurdist hell to invent or realize. What the Surrealists called 'the certainty of chance' must be attractive for many painters. Dreams have a bad name in painting, like pretty fishing ports and circus clowns; maybe they're due for a comeback. I like the idea (Freudian?) that repressed *wishes* attach themselves to dreams. I have some new ideas about these wishes which I will try to work out in my daydream art. My days interest me more than my sleep, and a wakeful 'stream of consciousness', coined by the American William James and done to a turn by the great modern penmen, fired my youth.

I also think paintings can be sequels to dreams.

There will be no end to the troubles of states, or indeed, my dear Glaucon, of humanity itself, till philosopers become kings in this world, or till those we now call kings and rulers really and truly become philosophers.

Plato, The Republic, *Book 5*

The Philosopher-Queen. I think there was someone, a king, called the philosopher-king? That inspired my title. I don't remember if the title came first or after the pastel was done.

J.R. Your title alludes to Plato's utopia of philosopher-kings and draws together the mythical, the mystic, the symbolic and the literal lines of the picture. What is this pastel's past?

R.B.K. I read *The Republic* forty years ago but I have a lousy memory. This daydream is set in the Greenwich Village flat where we lived for a year in 1979 and has no more meaning than a dream has. Sandra, who appears twice, as you can see, and I were almost happy there on that stage.

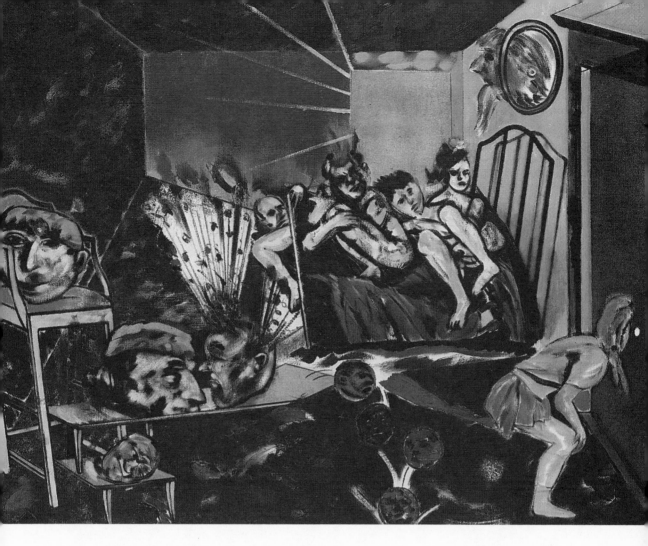

4 a.m., 1985

J.R. *4 a.m.* looks to me like a strange sabbat, perhaps a psychedelic sabbat. I recall one of Walter Benjamin's impressions, collected in his writings on hashish and mescaline, *Über Haschisch*, in which he describes the disorientation of being alone in his own room under the effect of hashish. He remarks that for a moment it seemed his room was full of people. The crowded room of your painting is the stage for a bizarre dream-*drame* ... The man squatting on the bed reminds me of the monkey in Fuseli's *The Nightmare* and also the gargoyle-bather in the top left corner of your *London, England (Bathers)*. And the exploding heads lead me to your sulphurous *Saragossa Self-Portrait*. Could *4 a.m.* be one of the rooms that open on to the fearsome corridor of that Saragossa painting? And is the peeping girl in the miniskirt the Queen of Sabbat?

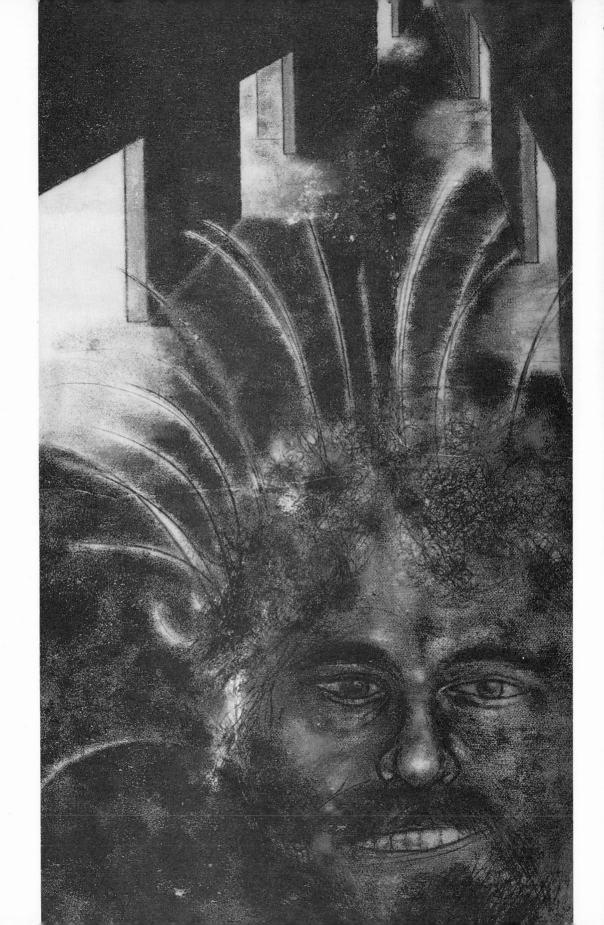

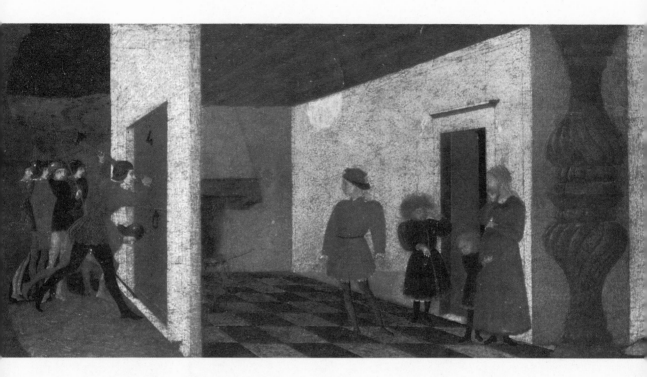

Miracle of the Desecrated Host by
Paolo Uccello in the Ducal
Palace, Urbino
(photograph: Scala)

R.B.K. Shabbat is the Hebrew pronunciation (as opposed to
the English sabbath). And of course shabbat begins at sunset on
Friday and lasts until sunset on Saturday. Poor Benjamin is also
appropriate here. One of the main sources for *4 a.m.* is an
Uccello panel showing men trying to break down a door to kill
a frightened family of Jews in a room, the inside of which Uccello
also shows. I've crowded the room like Benjamin's hashish vision.
The odd chair on the left is a traditional circumcision chair.
The little girl is peeping through the spyhole, reporting the
progress of the men battering the door down. This will be
explained by me later in an epilogue on the often debated subject
of whether or not the Jews could have escaped. For the moment,
I accept your idea that *4 a.m.* is one of the rooms in *Saragossa*.
Even that is appropriate because the *Saragossa* picture is in the
Israel Museum in Jerusalem, surrounded by ghosts, survivors
and the besieged!

J.R. The Uccello connection modifies my vision of *4 a.m.* (why
this hour?) but reinforces its nightmarish atmosphere – that of

Saragossa Self-Portrait, 1980 History.

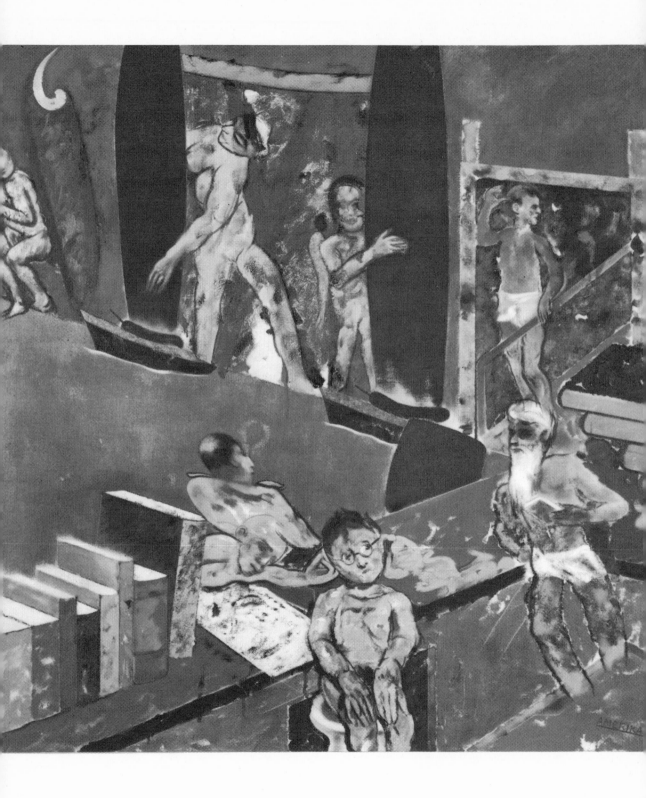

J.R. Your bathers in *London, England (Bathers)*, unlike Cézanne's, are in an oneiric setting and they seem to be trapped in a sinking place. There is something pathetic and even bathetic (see the bather seated on the bowl) in the painting. Does it present a pessimistic view of London, England, and the Old World in general?

R.B.K. Well, I'm an old pessimist but this odd picture was painted that wonderful year in Paris, '82–3, and I was looking back at the English Isle – water all round, you see – in that difficult, oblique mode I adopt too often for my own taste and the tastes of countless critics of mine. I was wondering as I have done a dozen times abroad whether I would return to London or not. I was reading about the crazy little Falklands war against what an old favourite of mine, W. H. Hudson, called 'The Purple Land That England Lost'. And in the end I left Paris, France, and returned to London, England, as usual because there seems to be a little less wrong with London than other places I've known.

J.R. You portrayed yourself as an old man running around – perhaps an alter (old) ego in a Noah's archetype. Does the Amerika arrow point the way out?

R.B.K. The Amerika arrow points to the object of my homesickness, never really consummated ...
 Child and Mother (Daymare): Daydream but also Daymare. Same rooms as *Philosopher-Queen* in New York. This pastel has an elaborate but secret explanation, and so it has a secret life.

J.R. Dream is an anagram of *madre* and of *drame*. Daymare (*des mères*): the mother is a chimera (or better yet in French a *chimère*) in the child brain, an 'infantasy' – a creation of his in-fancy. In the new title, *Child and Mother* (formerly *Mother and Child*), child precedes mother and perhaps proceeds with his re-creation of her. I suppose that to identify the child (a real child? an imaginary one?) would be to meddle in the private life of your pastel.

R.B.K. The child stands for my daughter (but doesn't look like her), whose secret life (Queen) Sandra was trying to be philosophical about in that flat.

J.R. I don't know if the reproduction here shows the whole picture or only a detail, but the mother appears only in part.

Child and Mother (Daymare), 1978

R.B.K. That is the whole picture, not a detail. The mother is only in part because she was cut off in real life (twice). Let it be. Try to find the source for this mother in Picasso's great *La Vida*, which is in my hometown museum (Cleveland). Look at it in a Picasso book and you may see the contour of the mother.

Mother and Child (Tempest), 1986

J.R. The quick march and resolute air of your Great Mother bears a resemblance to *Dulle Griet* or 'Mad Meg' (I prefer the French nickname: 'Margot l'Enragée'), the visionary walker in the Bruegel masterpiece of that title. But she comes out of the dreamscape of Giorgione's *Tempest*, as we can see from the columns and the tree on the left.

R.B.K. You're right about *Dulle Griet*. But my figure is not meant to be a virago at large upon the world like Mad Meg, but just a nice mother looking after her child with only the tempest to threaten (from Giorgione, of course). Bruegel died without divulging Dulle Griet's secret to the world, but my secret is easier. The mother is from an image of Bergman climbing the volcano in boyfriend Rossellini's *Stromboli*. The image has *only* a visual meaning. From a vast archive and library I've always used, certain images (some are film frames) press against my psyche again and again. This Bergman (so like Dulle Griet) is one of them. I can hardly explain why – the posture, the way the dress hangs, the forward motion, its generalized disposition.

Some of the monsters there may be related to humans, some to animals ... There are also the Monocles, and Arimaspes, and the Cyclopes. And also the Scinopodes who, although they have only one foot, run faster than the wind and, when they lie down, shade themselves like plants, with their raised feet. There are headless ones with their eyes on their shoulders and holes in their chest for noses and mouths, and hair like animals. There are others, near the source of the River Ganges, that live on nothing but the smell of fruit; if they travel, they carry this fruit with them, for they die if they smell a strange odour.

Honorius of Autun, Of the Image of the World

J.R. The fascination with monsters is one of the constants of the history of art, from Bosch to Picasso. Do you feel free from freaks or does '*el sueño de la razón*', as Goya would say, also disturb your works sometimes?

R.B.K. No, I don't feel free from freaks. Do you know Tod Browning's great film, *Freaks*?

J.R. Yes. The year of *Freaks*, 1932 (by the way, the year of your birth), was a vintage year for monsterpieces: Dreyer's *Vampyr*, Florey's *Murder in the Rue Morgue*, Freund's *The Mummy*, Kenton's *The Island of Dr Moreau*, Halperin's *White Zombie* and Mamoulian's *Dr Jekyll and Mr Hyde*.

R.B.K. And of course the wondrous Buñuel on Extremadura. I forgot the name but not the pictures.

J.R. Yes, also of 1932, *Las Hurdes – Land Without Bread*.

R.B.K. Norman Douglas said he would climb an Alp in search of an extraordinary *Dorftrottel*.

J.R. Also extraordinary are your monsters: *New York Madman*, in the vein of Goya, and *Sixth Avenue Madman*; *Bather (Psychotic Boy)* and the hat-boy from *Value, Price and Profit*. And the

double-faced priest in a deckchair – a double image of a moral
malformation? More caricatural and Hydelike is the ape
practising the art of Apelles. But then that high Alp you just
mentioned – in German the word means an incubus or
nightmare.

New York Madman, 1978

Sixth Avenue Madman (detail), 1979

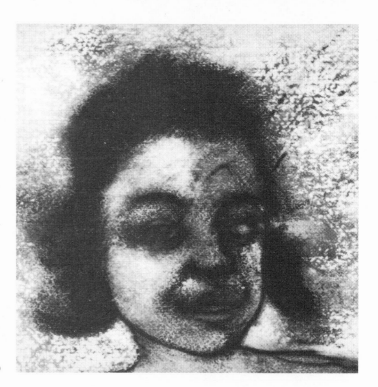

Bather (*Psychotic Boy*) (detail), 1980

120

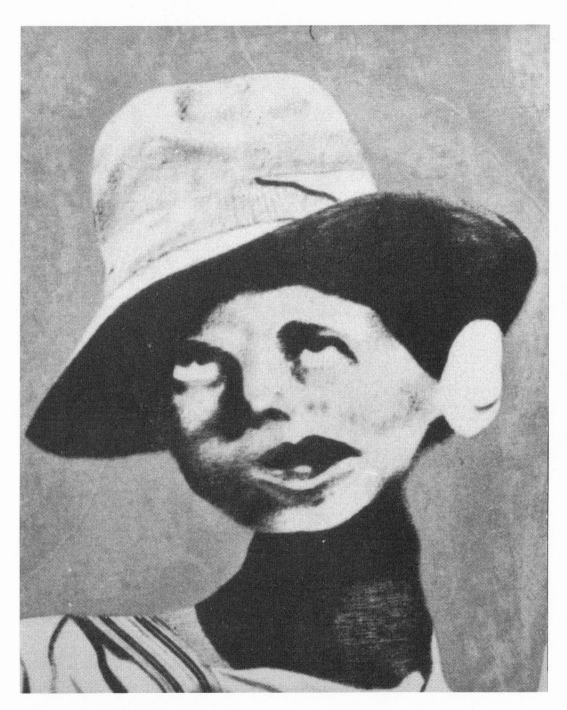

Hat-Boy (detail of *Value, Price and Profit*), 1963

Painting, 1983–5

Bather (*Torsion*), 1978

Priest and Deckchair (detail), 1961

R.B.K. As to Goya's '*el sueño de la razón*', I repainted it some years ago. It's a little pornographic. It's called *The Clerk's Dream*. It was rejected from the then leading salon in England (the John Moores Exhibition) because it was so dirty.

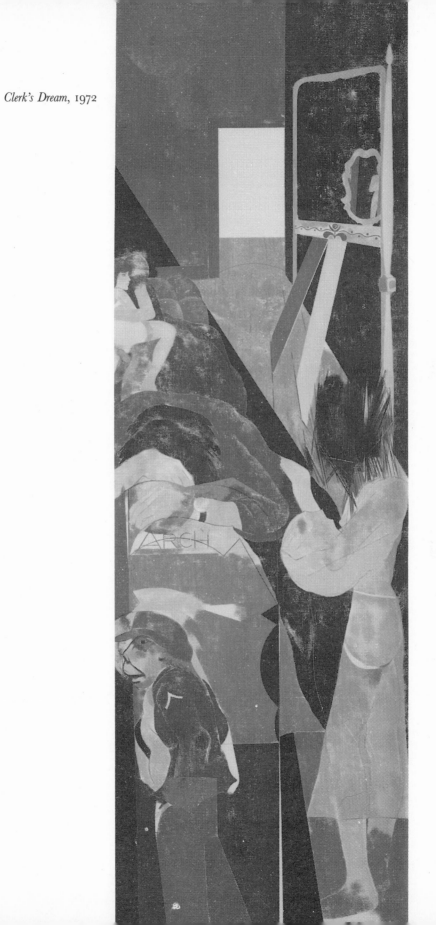

Clerk's Dream, 1972

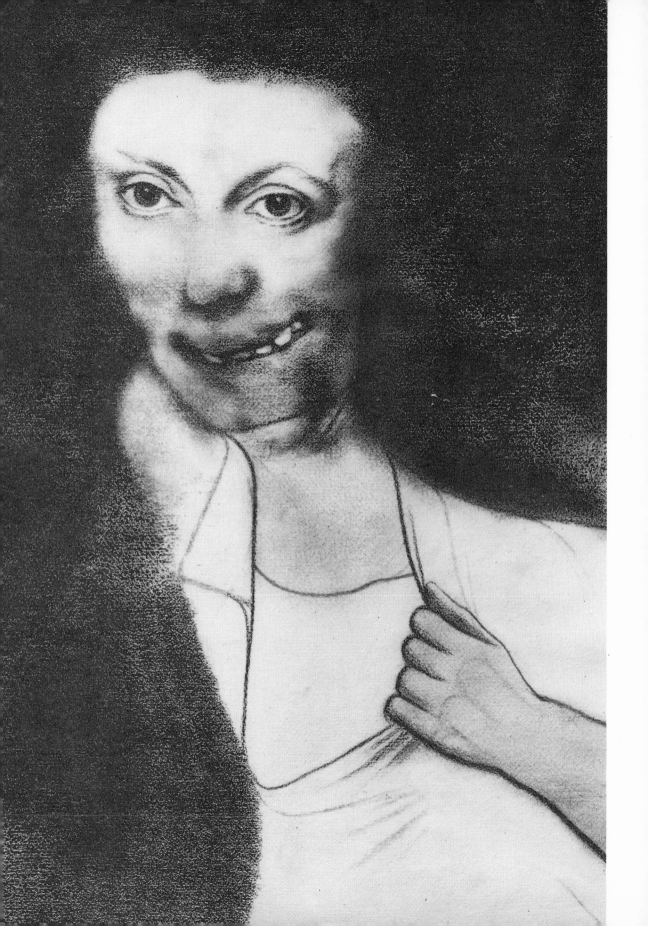

His New Freedom, 1978

J.R. With its atmosphere and setting your painting seems to extend *The Waste Land*'s episode of the 'carbuncular' clerk. Dreams are dreams, as Calderón put it, and perhaps they will never be totally deciphered by rational means. But the recognition of some images, even displaced or distorted ones, could help to outline the story that every dream tries to convey. For example, in his *Capricho*, Goya portrayed himself as the dreamer. Who is your clerk, if I may ask? The woman behind him left me with an impression of *déjà vu* – perhaps she is recycled from other paintings of yours. I hope you will not answer my request for identification with the favourite words of my favourite clerk, Bartleby the Scrivener: 'I would prefer not to.'

Speaking of monsters and recycled images, I would like to mention your masterpiece, or monsterpiece, *His New Freedom*, which I have found unforgettable since I saw it years ago grinning at me from one of the walls of your home. I forgot to mention, concerning *His New Freedom*, that in this painting you created, as Baudelaire said of Goya's monsterpieces, a verisimilar monster. Perhaps more than a portrait, it is a mirror of our distorted times. A fast mirror? I know it is a composite piece, vamped up from Dreyer's *Vampyr*, but I wonder if it is not *also* a metaphorical self-portrait of your 'bad' side – your secret Dorian Gray or Mr Hyde portrait. The most intense monsters – and modern monsterpieces demonstrate it in excess – are in ourselves. Could modern art be considered, at least in part, as 'teratological'?

R.B.K. What a good idea – a teratological modernism. My three favourite living painters of the older generation have brought forth monsters: Bacon, master of freaks; Balthus, of the sinister demon-children, cursed cat-people and wuthering nannies; and De Kooning, of the she-devils. I would welcome your reading of my bad sides, speaking as a confessional painter in an era which has largely discouraged dissent from the holy of holies – the autonomous art object. Don't get me wrong – I cherish that tradition, but I don't want to be tyrannized by it. When it comes to halting at the sacred framing edge, I prefer not to (I too have loved Melville's Bartleby since my teens). I prefer that the picture leads beyond itself, descending as you suggest into ourselves, bad sides, secret lives and all – whence the picture comes after all. So many good painters are scared of 'illustration'. I don't know why confessional poetry is tolerated but confessional painting is either rare or not read as such in modern art discourse. Well, I intend to pursue my demons.

WHOROSCOPE

Out, ye Whores, to work, to work, ye Whores, go spin.
William Herbert, 1st Earl of Pembroke (in Aubrey's *Brief Lives*)

It was on the street, the previous midsummer's night, the sun being then in the Crab, that she met Murphy.
Samuel Beckett, *Murphy*

J.R. I propose the title of this chapter in homage to Celia Kelly in Beckett's novel *Murphy*. In the hard lottery of harlotry the horoscope can turn out to be a horrorscope: the Grim Ripper can appear on any night-time corner. This troubled atmosphere of fear and danger also pervades some of your pictures, such as *Streetwalkers* or *Little Romance*. Do the streetwalkers in your oil painting *Walter Lippmann* (1966) come from some movie? You have shown me some interesting prostitution scenes by your favourite photographer, Robert Doisneau. Have you been inspired by him or by other night explorers like Brassai?

R.B.K. Yes, I have. I've always loved the Miller–Brassai *Quiet Days in Clichy*. In *Walter Lippmann*, there is, I think, only one streetwalker – oh, yes, the *man* in the shadows is the *other* streetwalker. And yes, the source may be that very early Mai Zetterling Swedish film – I forget the name – *Torment*?

J.R. I haven't seen it, but I suppose you're referring to *Hets* [1944, called *Frenzy* in Britain and *Torment* in the US], directed by Alf Sjöberg, in which the teenage Mai Zetterling appeared and Ingmar Bergman made his début as a screenwriter.

Little Romance, 1969

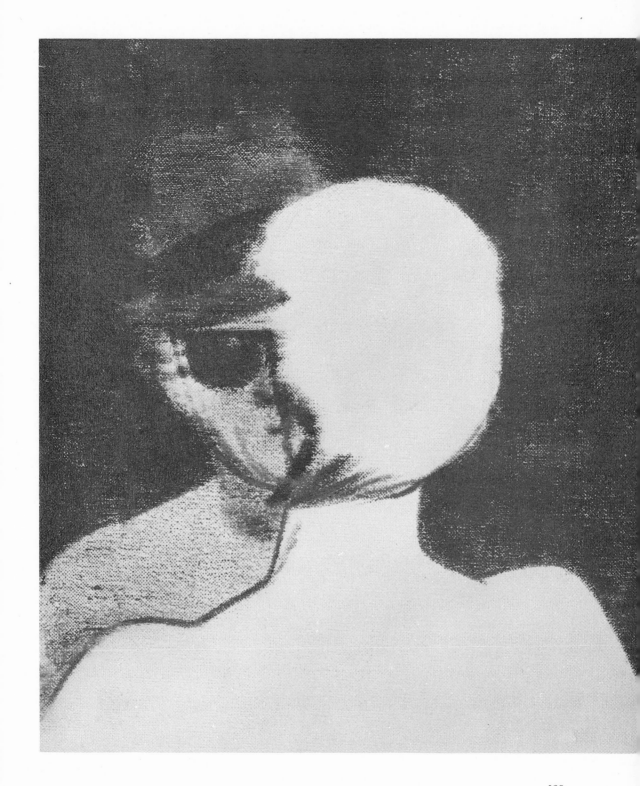

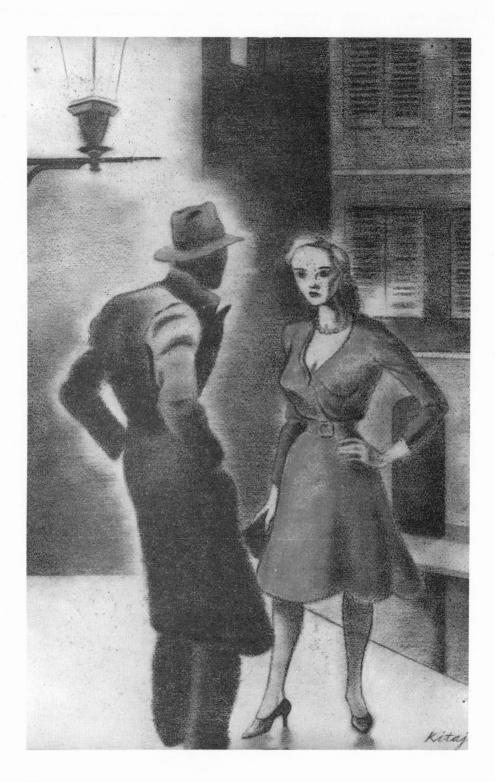

130

The Street (A Life), 1975 R. B. Kitaj's Preface for *The Street (A Life)*, 1975:

Baudelaire said there is no exalted pleasure which cannot be related to prostitution. Now, that's the strong stuff of some very great poetry, but my own exalted pleasures are far less exclusive, while my most exalting sense of a modern art is, I think, an art of Renewal in which one's own changeful poetics, mind-sets, nerve systems, fired by the ups and downs and dreadful secrets of one's modern lives, seize up and become pictures. Of all modernist Sleep-walkers, Benjamin set a renewing pace (for a possible big-city art) quite familiar to me as he prowls those networks of streets he says prostitution opens up 'across the threshold of class'. Strangers are drawn (alone in crowds) into these districts of minor crime where one is allowed but does not belong (like some Diaspora), where danger, in its very excitement, has been known to feed the art of the quiet studio. Among those loveless alleys (where Baudelaire says he found both love and God), which are, like pictures, the same and different across the world, I have always been enchanted by an art-god plying there, as Benjamin, Picasso and Degas were. I don't mean to exalt this little pastel illustration of mine. It's just a memory-aid styled after the jacket of a pulp thriller. Each painter has his own minor deity who looks after the special art interests of his client. In this pastel, mine is talking to the woman in The Street. I think it's not the first time I'd drawn him but he is my own creature, who appears through the ether, like Daumier's Ratapoil, to agitate and excite the stuff of life into pictures recollected in tranquillity. He can act unspeakably but always in the name of my art.

The Room (Rue St Denis), 1982–3 **J.R.** I will now call *The Room (Rue Saint-Denis)* 'A Study in Scarlet', if you permit me to change the title. The name of that street in a red-light district of Paris (one of these '*rues propices*' as it is called in George Bataille's *Madame Edwarda*) not only adds local colour to the picture but explains that empty room. The title is literally an *hors-d'œuvre* but, in a sense, forms part of the painting, don't you think? Do you usually need a title to work on a painting?

R.B.K. Titles are my little damnations. They damn me like the whores I used to follow up creaking stairs in strange districts. I'm always curious where these whores and titles will lead. Both are creatures of fantasy, and art may even arise in their embrace. Of course I don't always follow titles and whores. Sometimes only once or twice a year and even then it's only to take a walk with a title, to paraphrase your friend Klee, or just to prowl at night in those red streets.

Some pictures, perhaps unfinished over years, get new titles when the charms of the older ones fade. For example, I am still working on a painting which began five years ago in Paris as *The Island*, after which it became *The Marriage*, then *Adam and Eve*, and now it is *The Expulsion from Paradise*. The hoary picture leads in this tango. And now [1990] I'm about to paint over it.

J.R. Perhaps your *Expulsion* is not out of place here. I remember Milton in *Paradise Lost* compared Adam, after his first real screw, to Samson rising from the 'harlot-lap' of Dalila. A rise and fall which meant Paradox regained. In the first phase of your painting *The Island* there were no human figures at all, only the earth without form. Have you retraced the Creator's steps?

R.B.K. The Creator in His guise as Mad Scientist. This monster is about to be destroyed in my lab. I've wedged it into a Victorian fireplace in my house so it can't stalk abroad. But this changeling does represent an unusual painting method which comes upon me from time to time whereby I replace the entire concept, leaving some details or vestige of what went before. One recent picture, *The Handshake*, began in 1958 as a portrait of the mad Warburg.

The Island, 1982

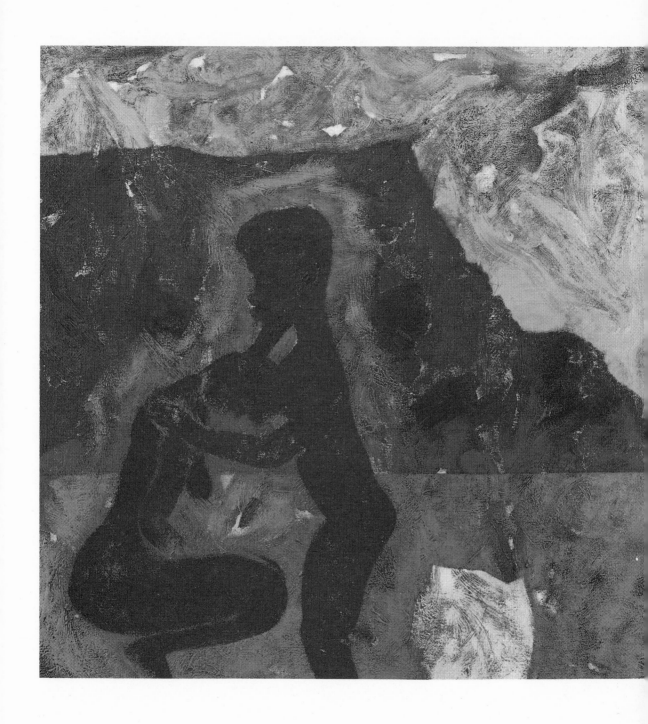

The Expulsion from Paradise, 1982–6

J.R. To return to *The Room* in the rue Saint-Denis (by the way, Denis comes from Dionysus), the red, the bed, the bare walls, the narrowness of the room, really a cell, bring to my mind a cruel observation Bataille made in *Madame Edwarda*: 'The nakedness of the brothel calls for the butcher's knife.' The 'redspread' in this painting is really disturbing. At the same time the aloofness and precision of the composition (you use colours as Borges does adjectives) are a feast for the eyes and a feat which accomplishes brilliantly something I had been looking forward to seeing for a long time: obtaining with a figurative painting all the mystery of colours and richness of textures characteristic of an abstract masterpiece. There is an intermittent glint (concrete/abstract) that doubles the mystery and depth of the painting. This 'Room' in the *rue* of Dionysus could be a good introduction to a theme, let me call it 'brothelhood', that is recurrent in your work. Of course, you have many predecessors in this fascination. Have you pursued your studies of the red-light districts?

R.B.K. Recently I returned to the *rue* and I was amazed that business was booming despite all the AIDS publicity and the plague itself.

J.R. Eros and Thanatos seem determined to embrace again in this *fin de siècle*.

R.B.K. Many individual scenes and incidents of great poignancy caught my eye but not my purse.

J.R. When he's not the peeping Tom or phantom in the vampiric terms of Michael Powell's film, the artist is often the peeper who presses his face to the display windows of life. Not without reason have you identified yourself with the armchair voyeur, one of your most memorable images, in *His Hour*, 1975. Our hour too, because viewers become voyeurs. And you have admirably differentiated the two sites/sights: the real one of the man who is looking, and the unreal one − only outlined − of the sexual act. In voyeurism the mind's eye is the most important. Is this picture inspired by a pornographic photo? Or by some brothel scene *à la* Toulouse-Lautrec or Degas, those supreme voyeurs?

His Hour, 1975

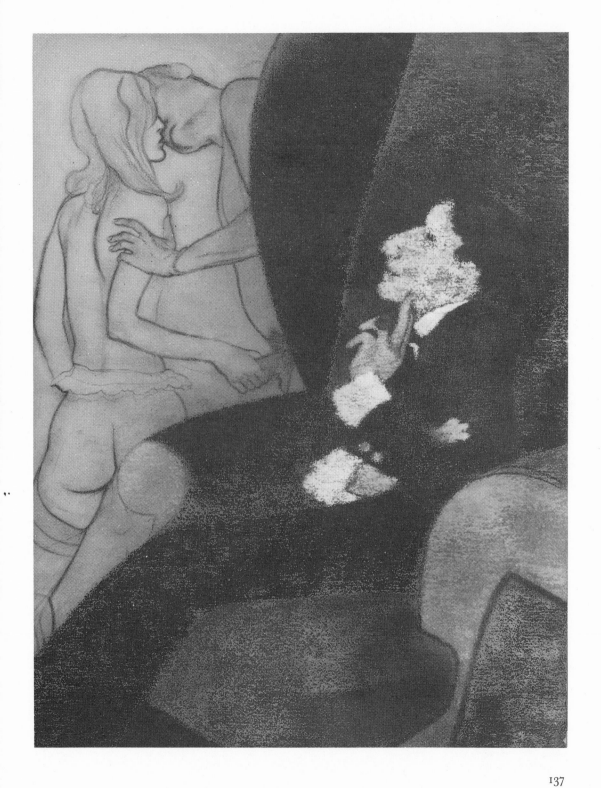

R.B.K. First I want to return to Saint-Denis because I've just found a great passage in a Kahnweiler conversation with Picasso dated 3 July 1952, which I want to quote for you:

> P.: I walked along the rue Saint-Denis the other day. It's marvellous.
> K.: I often walk along there, I find it so wonderful.
> P.: Yes, it's wonderful, the tarts, etc. If you could paint the life of a city, that would be magnificent. But you can't do it alone, you have to be with others, as we used to be in the days of Cubism. You need team work for it.

Julián, isn't that a strange passage? I don't understand it. Do you? My experience is the opposite. I prefer to be quite alone in that city crowd. I rarely go to those places with friends. And then I translate what I see in the studio in solitude. As to your question – yes, the pastel *His Hour* was suggested by plain pornography, which I prefer to 'erotic art'.

*Phaidon, Oxford, 1985. **J.R.** Marco Livingstone, in his introduction to *R. B. Kitaj*,* revealed that the voyeur of *His Hour* was derived from a still of Meyerhold's 1915 film adaptation of *The Picture of Dorian Gray*.

R.B.K. The seated man in *His Hour* comes, I believe, from a frame of Meyerhold himself acting the role.

J.R. One of the most original scenes of voyeurism, framed as a movie picture, is *This Knot of Life*, 1975. The voyeur, unnoticed, contemplates from the landing of the staircase the black and white picture. To become the invisible man, the last goal of a voyeur – and now the fitting title of Ralph Ellison's novel comes to my mind because of some black and white associations. But the strongest literary allusions in your work are usually in the titles. Where does this knot come from? I recollect now, just in case, 'this knot intrinsicate of life', from Cleopatra's last speech to the asp in *Antony and Cleopatra*. Evidently we can see the knot of the bodies with the naked eye.

Watching (detail of *This Knot of Life*), 1975

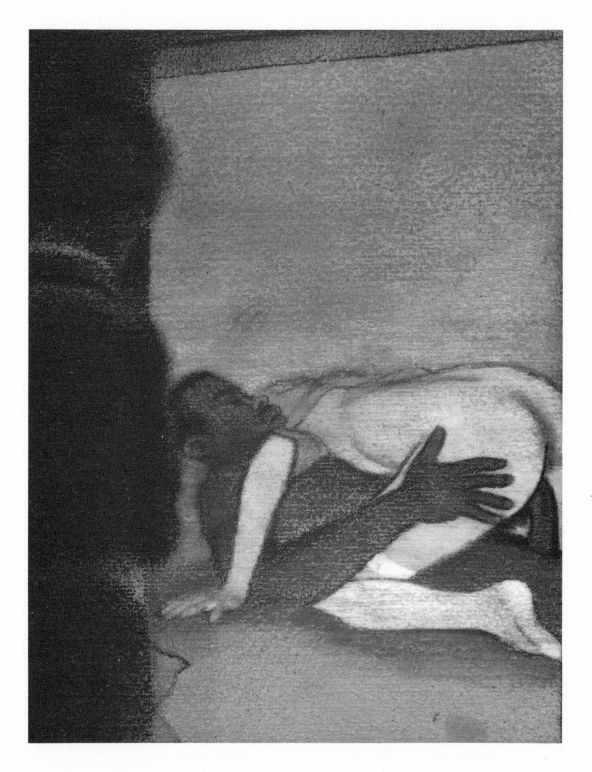

Communist and Socialist, 1975

R.B.K. *This Knot of Life* was the title I stole from a novel by M. P. Shiel, an English stylist and fabulist much loved by my friend Duncan. I had a collection of Shiel's rare books which I sold recently in one of my periodic purges when I want to change my life and its contents. Kenneth Anger was also a great fan of Shiel. Sadly (or maybe happily) my erotic work and my drawings of the nude are less open to iconographic interpretation and discourse.

J.R. In Catalonia, I think, in 1975, you surprised those comrades-in-arms, Communist and Socialist, resolving their ideological differences in bed. You told me, I remember, that you drew them separately from life and afterwards you brought them together into action/painting – what art hath joined together ... I hope it is not a question of what politicians call a union against nature, but rather what in France is now called cohabitation. Does this intimate scene have some allegoric intention? You don't indicate who is the Socialist and who the Communist. That is something the viewer must deduce. In the erotic communion every body – and almost every cell – is communist. The separation between yours and mine disappears. Anyhow, in your *Communist and Socialist* I guess – ladies first – she is the Communist.

R.B.K. Let's keep 'em guessing, OK?

J.R. The lonely bar-girl in *Indigo* (1968) suggests the blues and, I presume, the setting is American. New York? The girl reminds me of *New York Nocturne*. That *Nocturne* – which sends us back to the pastel master – seems illuminated by Degas light.

R.B.K. *Indigo is* a memory of New York, of a girl (not a *bar*-girl) who drove me crazy for six months in Manhattan in 1965, another of my lousiest painting years. There's a fantastic letter Van Gogh wrote to Bernard on the arcane subject of whether or not Degas achieved erections. Vincent thought Degas saved his energies for painting. The letter *was* written from the most famous loony bin in art history, but still ...

Indigo, 1968

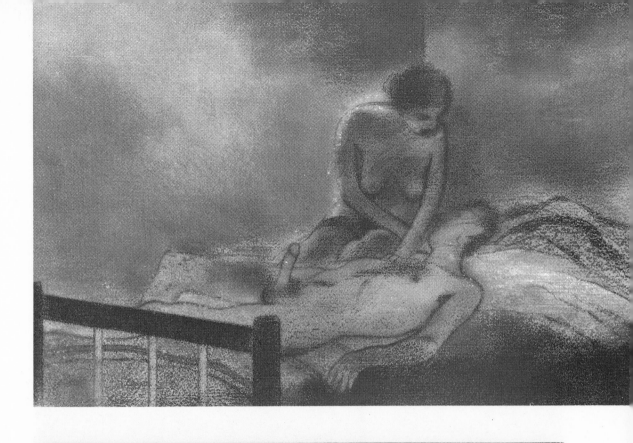

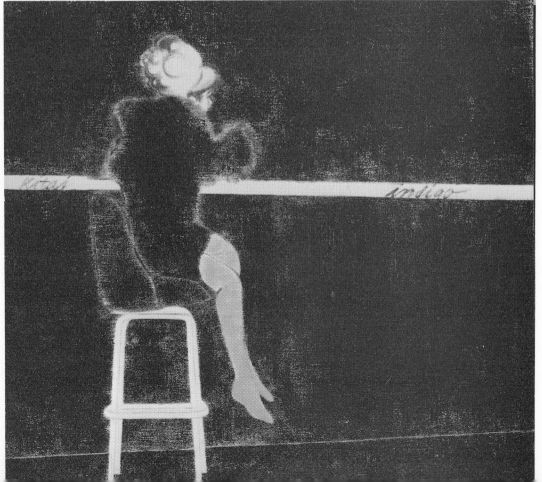

New York Nocturne, 1978

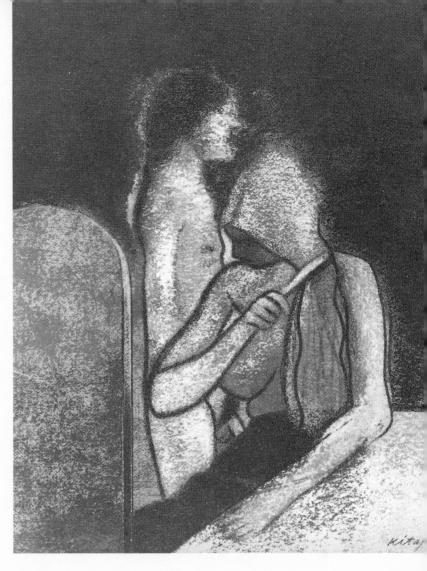

Tonight the Ballet, 1975

J.R. In my view *Tonight the Ballet* (1975) is another homage to Degas, although your ballet scene is by comparison carnal. Also from the same year is the pastel *Waiting*. Where is the girl waiting? In Paris? You seem to have studied her posture carefully. From life? Perhaps you employed a professional model or some art student. The pencil or the brush can sometimes be a magic wand. And the erotic phantasms of the painter also meddle in the composition. I am thinking now of the 1979 charcoal *Marynka and Janet*, and also *The Red and the Black* of a year later, the pastel and charcoal of two girls lying together in an exposed pose suggestive of pornographic photos.

R.B.K. Yes, these were all drawn in my studio from live models.

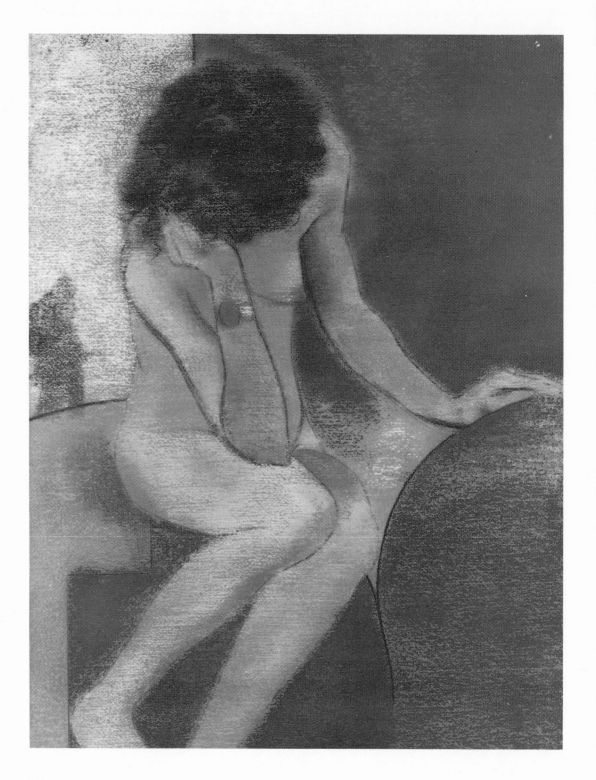

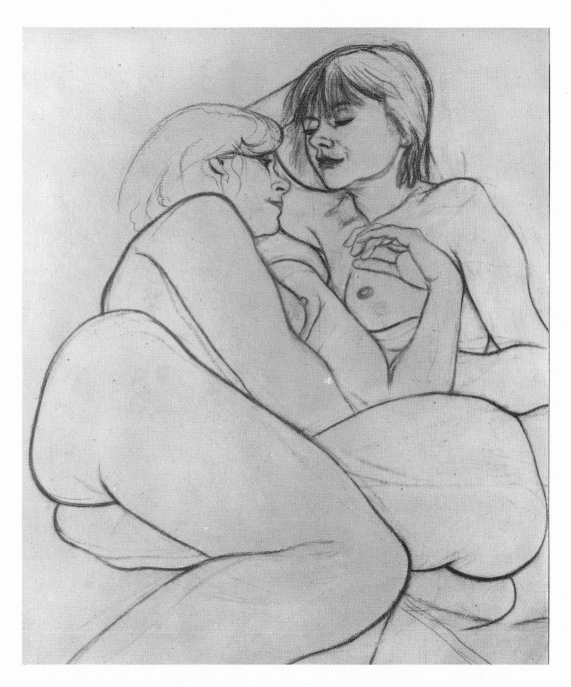

Marynka and Janet, 1979

Waiting, 1975

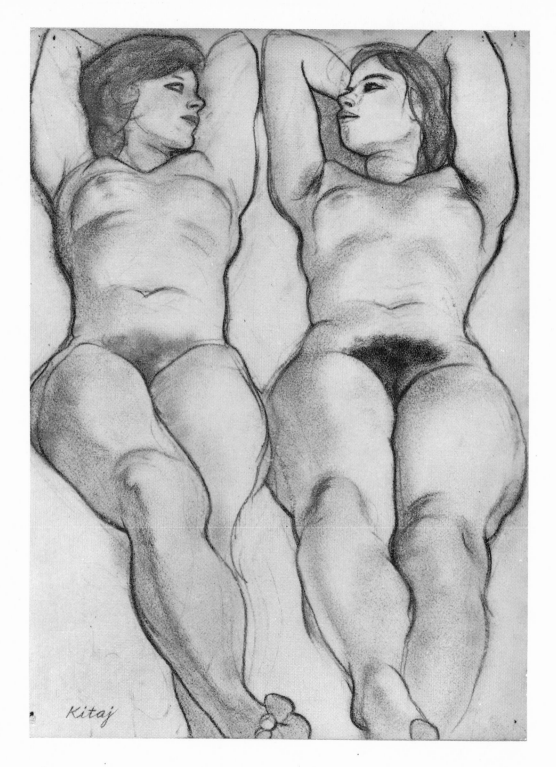

Kitaj

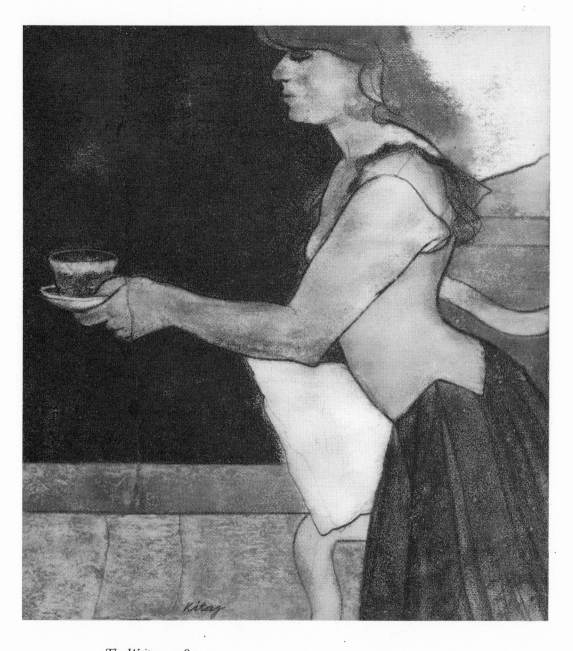

The Waitress, 1980

The Red and the Black, 1980

J.R. Your *The Waitress* is clearly reminiscent of several of Degas's maids. Maybe she is out of place in this chapter, but I remember that two years later, in 1982, you wrote to me from Paris, after saying that you were working quietly there: 'I speak to nobody except waiters and whores.' I replied something like you were a true philosopher because waiters and whores were the real Peripatetics of Paris. *The Pimp* (1982) was drawn, I think, in Paris. Are these two pictures also studies from life?

R.B.K. Yes.

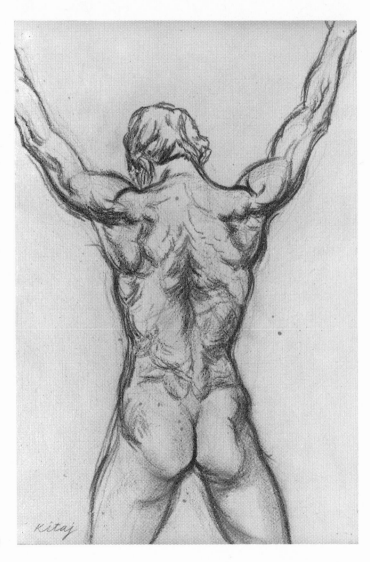

The Pimp, 1982

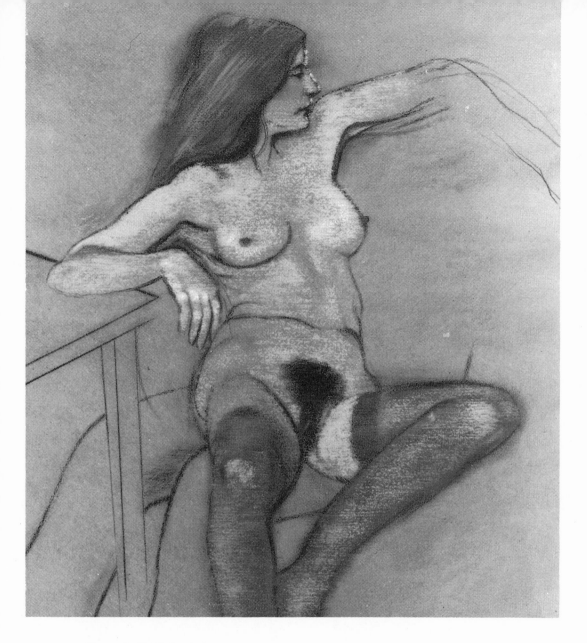

Femme du Peuple I, 1974

J.R. Apropos *Femme du Peuple I* (1974), you have given the title of *Sailor's Girl* to a detail of the face of this 'woman of the people'. Was she one of your port portraits, portrayed from memory?

R.B.K. She was drawn from life and imagined in a sailor's lap.

J.R. Perhaps now's the time to record some of your memories of ports and happy havens from your days as a sailor. You went to Havana first, I think, in 1950. For a boy of seventeen was it really heaven? I suppose you visited the ship's friends in calle de la Amistad and environs.

R.B.K. I lost my virginity in one of those houses in Batista's Havana, and, as the saying goes, I never looked back (until recently in my pictures). She looked like the B-movie actress Yvonne de Carlo. I would like to begin a painting to be called *The First Time*. After that, my life included whoring like some painters include gambling. In the hiring hall of the National Maritime Union on 17th Street, I would choose ships of the 'Romance Run' (Santos, Monte, Rio and Buenos Aires). We would bring nylons and other special presents for special girls when the ships returned from New York. As the ship approached port in South America, I swear you could smell coffee, perfume and sex. A port like Bahia had a church and a cathouse for every day of the year. It got into my blood, that prowling, and like Benjamin, it combines beautifully with learning strange cities, their bookshops, the art they contain, their cafés and food, their sense of the past, their dangers. I lose myself in hell and paradise before my time. Sometimes, like Flaubert, I'm ashamed but not for long.

J.R. Walter Benjamin in a beautiful sketch in *One-Way Street* saw sailors as inhabitants of a unique composite city where a Port Said bar faces a Hamburg brothel and the Castello dell'Ovo of Naples is in the plaza de Cataluña of Barcelona. How is your sea city and its main street? Do you recall many port scenes and did you have the opportunity to transfer some of them to your paintings?

R.B.K. *One-Way Street* contains some of my favourite Benjamin. I discovered him in 1965, before he was in vogue. His hopeless pursuit of Marxism bored me. His hopeless pursuit of Asja Lacis is a little less boring, but my painting muse got alerted to the kind of stuff in *One-Way Street* you describe because his prowling was so similar to my own, as I've already said. At this late date, I can only hope to recover my ports in the painting art. And maybe I can attempt some new voyages in my art, God willing. Yes, there are a lot of things past I hope to fix in remembrance and to make new in pictures.

J.R. All the sexual metaphors, even the less flagrant ones, play with fire. In *Sleeping Fires* the blurred man in the background might be about to poke the fire or, who knows, he is looking for the line of fire. The title comes from a poem?

R.B.K. Maybe from George Gissing, who married a whore. A title of one of that poor man's novels? I can't find it.

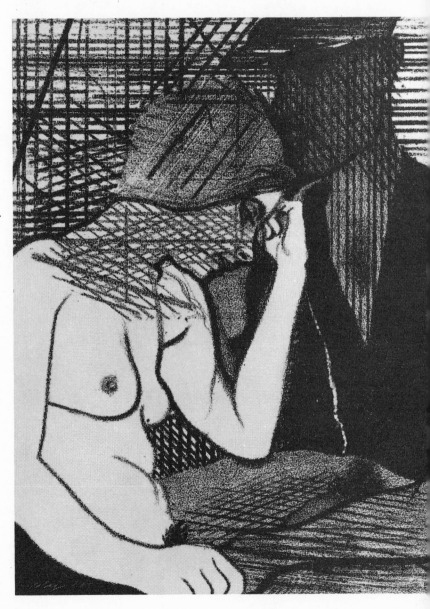

Sleeping Fires, 1975

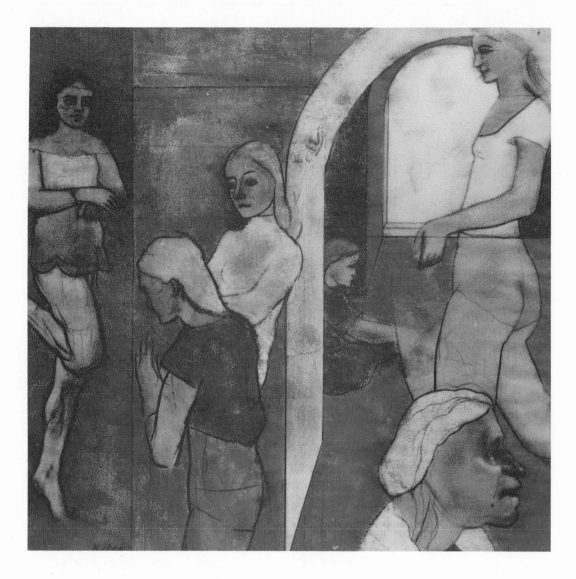

Sighs from Hell, 1979

J.R. I am curious also about the origin of the title *Sighs from Hell* (1979). The five girls in the picture are your *Demoiselles d'Avignon*. In the brothel parlour of Picasso's painting, the preparatory sketches reveal that originally a sailor was going to intrude. In your painting the quite intriguing and androgynous head of a middle-aged person appears. What is the role of this *persona*?

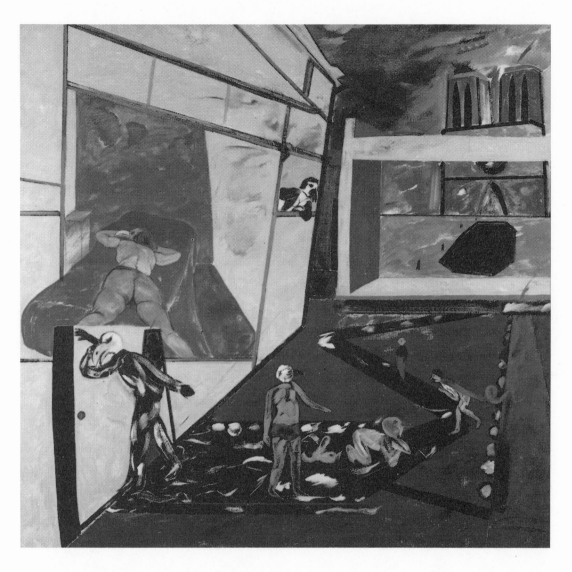

Notre Dame de Paris, 1984–6

R.B.K. *Sighs from Hell.* Milton, I think. The picture is of what used to be a favourite brothel – on the Elbestrasse in Frankfurt. The woman sweeps the floors there.

J.R. In *Notre Dame de Paris*, we find again, if I'm seeing it correctly, the Saint-Denis room. But not empty now: a 'bird' is on the bed. And two 'gargoyles', or birds of prey, flank our lady of Paris. This is a complex picture that might be clarified or, if you like, simplified by some explanations.

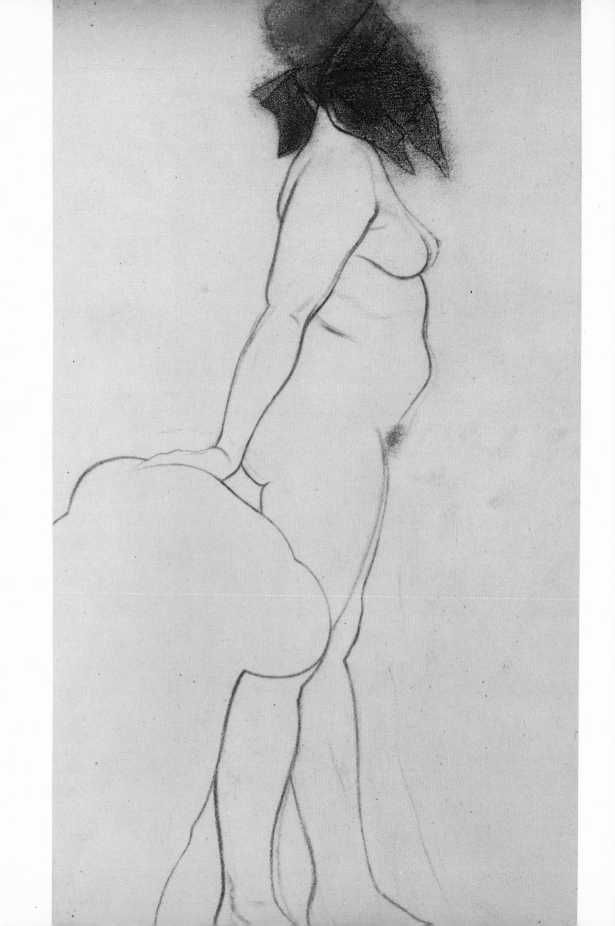

The Mask, 1980 **R.B.K.** The main compositional source is from Fra Angelico. There is a famous Haggadah called the Bird's Head Haggadah, from the Middle Ages, which gives each painted figure a bird's head in order to circumvent the Second Commandment (against idolatrous graven images). In Paris, I had to pass by Notre-Dame to get to the Dames in Saint-Denis. All these saints and sinners mix beautifully as in life.

J.R. The birds of paradise and hell on the same tree, as they appear in some beautiful Spanish Haggadah illuminated manuscripts of the fourteenth century. *Cerca un Uccello in un Bosco*, as the Italians say (literally: seek a bird in a forest), or rather in this case a Fra Angelico in a forest of analogies . . .

Sex is blind but always finds the object of its desire. To get out of this equivocal 'nightmaze' I would like to choose as a kind of sex symbol *The Mask*: a blindfolded woman in the buff – maybe playing blindman's buff? This naked *Maja* could lead us from here to the Spanish labyrinth of the next chapter.

R.B.K. She is Marynka, posing.

SPAIN IN THE HEART

J.R. Memory (or rather its echoes) has no limits. But a
remembrance of a remembrance could expand these boundaries
even further, like the growing circles on the water after the
pebble – the event – has been thrown in. I know Spain was for
you at first a memory of memories – that of your parents' friends
in the liberal milieu of your upbringing. Spain had for you,
since childhood, an almost mythical character. Guernica, for
example, before being a painting, was perhaps for you a name
full of war cries and crimes. Guernica – a *nom de guerre* ...

R.B.K. One summer in the early seventies, when I didn't
know I was a Diasporist painter and it was just dawning on me
to find out what kind of Jew I could be, I was driving my family
away from the caves at Altamira, past Bilbao, when it started
to get dark. We saw a sign saying Guernica and I sped towards
that fateful place. The hotel was full with a wedding and we were
shown to a private flat where we spent the night. In the morning
I took an unremarkable photo of some modern buildings, which
I remark upon now only because it's my only souvenir of a town
whose destruction (or deconstruction?) turned its name into a
painting for my time and my milieu. Paintings are said not to *do*
much except be themselves, but *Guernica* was shown at the
Museum of Modern Art with a commentary next to it when I
was young, which I always thought added to its various powers.

Guernica (photograph by Kitaj),
1975

Each epoch usually has its own Apocalypse. Ours is called *Guernica*. This painting of chaos is in a way a time bomb. It exploded, and unfortunately continues to explode, our time. This grey printed matter that will never be reproduced enough is the stamp of a stampede. And of a stampede in the slaughterhouse of History. Our collective unconscious with its archetypes, the 'nightmaze' of History with its disasters and sordid absurdities, the slaughter of the innocents in a black painting, and besides – because *Guernica* is above all an artistic production – a large part of modern art history, are condensed in a powder flash. A fusion-fission of antagonistic styles. It is precisely this war of forms that allows the painting to articulate the tearing cry of its contents.

The epic and ethical dimension of the great Picasso painting – a moral painting – demands the viewer's aesthetical participation: an ethical attitude.

And we see this painting as the animals trapped in the war of *Guernica* would. War irrationalizes man. He can suffer or inflict war but he will never manage truly to understand it. All animals in the same slaughterhouse. The war of *Guernica*. '*Dans Guernica il y a guerre …* ' It is not impossible that the *guerre* camouflaged in the French pronunciation of Guernica would resound, even unconsciously, in the ears of a painter settled in France for more than thirty years. What's in that name? Obviously, the memory of the Basque town destroyed by the bombers of Franco and Hitler. But after this bombing in reality there will no longer be any local wars or civil wars. And this is reflected prophetically in the great painting-mirror of Picasso. The war of *Guernica* is the war of all of us.

J.R., from 'La guerra del Guernica'

I consider *Guernica* to be a Diasporist painting, at least as much as it is Cubist, Surrealist, Socialist/Antifascist, Picassoist. There was certainly a Spanish Diaspora during the fascist years. It was a Diasporist plight for a Spaniard to have camped across his border, by choice, destiny, anger, fear or expulsion, and to have artfully contrived, in the pre-eminent cosmopolitan milieu, an ultimate Diasporist synthesis. To my mind, the very deeply rooted Cézanne (and therefore no Diasporist) had baked Impressionism into the final syntheses of his great southern Bathing machines, to which Picasso replied as a young relocated Spaniard in the *Desmoiselles*. Only later, when he couldn't or wouldn't return to Spain, I call him a Diasporist of a singular kind (which one hopes to be in any case).

R.B.K., from 'First Diasporist Manifesto'

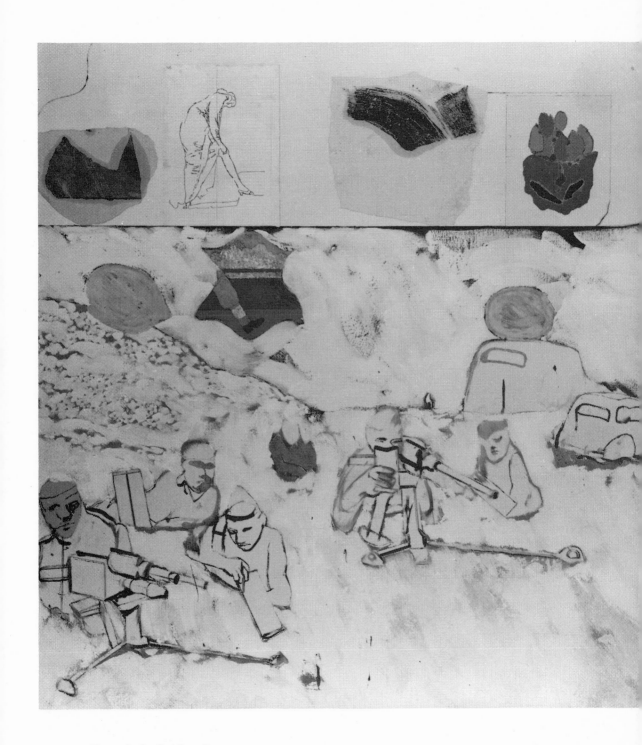

Kennst du das Land?, 1962

J.R. I suppose you also include Goya among your Diasporist artists. His voluntary exile in Bordeaux, because of his old age, turned out to be poignant and exemplary.

R.B.K. Goya belongs to my First Diasporist Manifesto, but he is not there because the drift is modern and twentieth century.

Know you the land where the lemon-trees bloom? In the dark foliage the gold oranges glow; a soft wind hovers from the sky, the myrtle is still and the laurel stands tall – do you know it well? There, there, I would go, O my beloved, with thee!

Goethe's Wilhelm Meister, *in Carlyle's translation*

J.R. And Goya can help us to enter into the land where the demon-trees bloom. And the *granadas* (grenades/pomegranates) too, because we are in the Warland of *Kennst du das Land?* There you have collaged on top like a password or, as we say it in Spanish, like a '*santo y seña*' (saint and sign), a copy of a Goya drawing of a prostitute fixing her stocking. But the spirit of Goya is more present in the figures of the soldiers at their machine-guns, sunk in the snow. They could be at the battle of Teruel where, from the end of 1937 till February of 1938, temperatures were sometimes minus 18 degrees centigrade. Did you look up photos of that war in order to compose your battle painting?

R.B.K. Yes, of course I dipped into my archives for Spanish War stuff. A new buzz-word in New York and trendy circles is 'appropriation'. I'm afraid this old over-the-hill Surrealist has been appropriating like mad for thirty years. I love your '*santo y seña*'. I shall surely appropriate it for the *Kennst du das Land?* preface when I come to write it.

IN CATALONIA

At the side of the sea. My
dream had a house,
at the seaside.

Salvador Espriu, *A la vora del mar*

J.R. Maybe your musing self-portrait in Sant Feliu by the fireside could refresh, or rather warm up, your memory of your Catalan works and days. This painting could also be regarded as an experiment in self-portraiture: a portrait of the artist as – or posing as – an old man. The artist summons up a future of old age – of loneliness near a lonely hearth – through a nostalgia for a place which will not see him grow old. While the artist of the portrait recalls a catalogue of Catalonian memories and impressions (your self-portrait is also a farewell to Catalonia), I shall try to picture the house in Guimerá Street which was a few years ago your home in Sant Feliu de Guíxols, on the Costa Brava.

There you are, thanks to Sandra Fisher, reading for ever in your 'dukedom large enough', as Prospero would say.

UT PICTURA POESIS

Un poème doit être lu dans sa langue originale; il faut apprendre le miró, et lorsqu'on sait (ou que l'on croit savoir) le miró, alors on peut se mettre à la lecture de ses poèmes.

Raymond Queneau, Bâtons, chiffres et lettres

R.B.K. Yes. This is the first portrait of me by Sandra. She painted it from life in my library at Sant Feliu.

J.R. I wonder what book you were reading. A book of poetry? Baudelaire? Your guide to Catalan? Baudelaire and Mallarmé learned English to read Poe, Proust learned it to read Ruskin, Freud learned Spanish to read *Don Quixote*, Unamuno learned Danish to read his brother Kierkegaard. I know that for several years you tried to teach yourself Catalan, probably as much to communicate with your Catalan friends and neighbours as to read Catalan authors. In any case, and since poets must be read

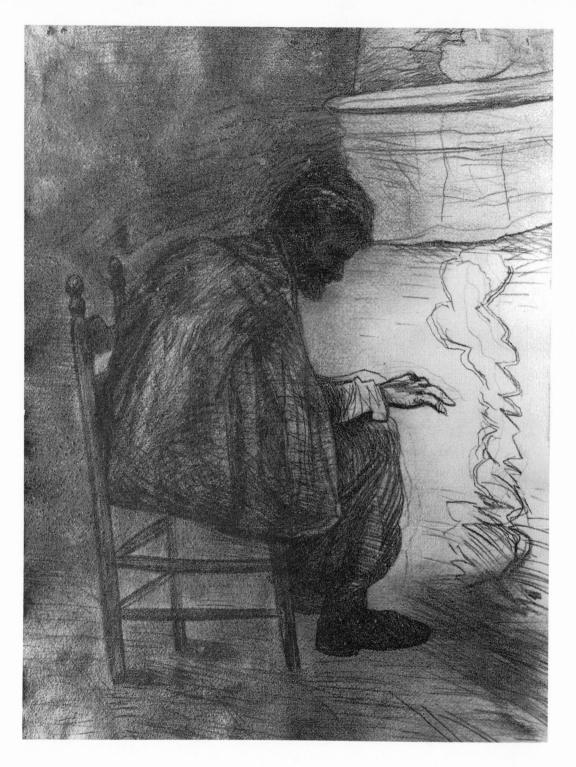

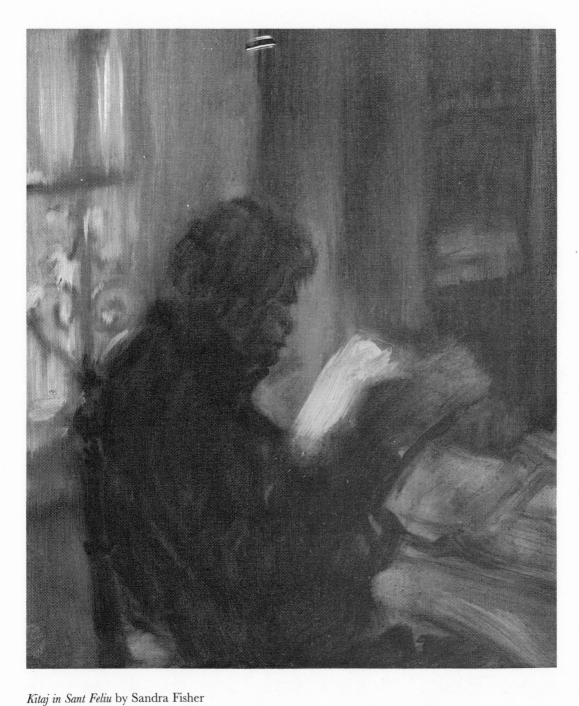

Kitaj in Sant Feliu by Sandra Fisher

Self-Portrait (Sant Feliu), 1982

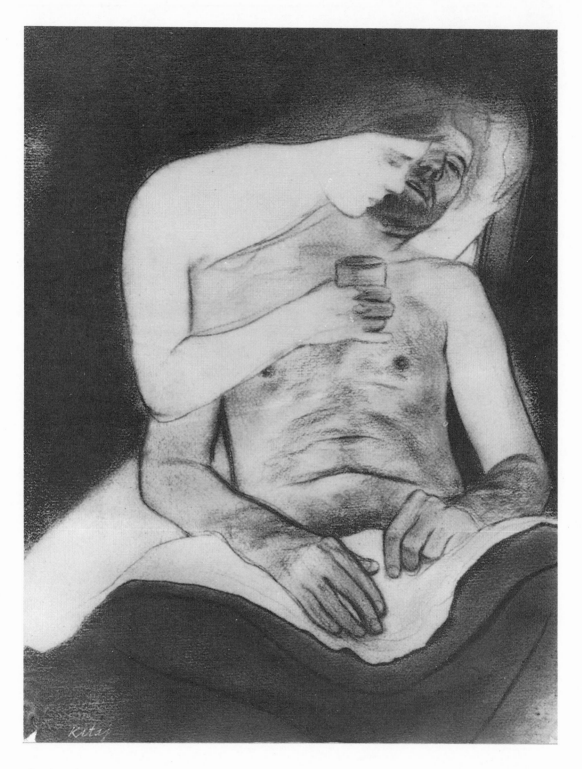

in their original language, two outstanding Catalan poets, J. V. Foix and Salvador Espriu, might interest you, a good reader of poetry, and help you better to know Catalonia's people and their culture. And now a third one comes to mind: Gabriel Ferrater, a solitary voice: '*que és art llarga fer-se decent/ i decent vol dir solitari*': 'It is a difficult art to make oneself honest, and to be honest means to be solitary.'

Perhaps your old friend José Vicente, your mentor in Catalonia, or somebody in your circle of acquaintances in Sant Feliu, talked to you about these poets. Have you read any of them – particularly Espriu, the best known, who was of Jewish descent and refers to Spain as Sepharad?

R.B.K. Espriu, yes. José gave me a little book and I knew of his Jewishness but I touched his work only superficially. Catalan was too difficult for me. Those other Jews – Teresa and her Juan – touched me more.

J.R. Inner Castles in Pain. But we are still in your Sant Feliu abode. *Estando ya mi casa sosegada*, all being then quiet in my house, I'll imagine provisionally that you were reading Juan de la Cruz there. From the library, again through Sandra Fisher's intermediacy, we could go to the bedroom of *The Green Blanket*, where two Spaniards – Goya and his doctor – help us to visit the sick artist in his bed of Spain. The moving *Goya curado por el médico Arrieta* (1820) is the best reference with which to contemplate your cure: you struck Goya's attitude – that of gratitude. But besides being almost an ex-voto, like the Goya self-portrait, your painting is also a love emblem: your healer, Sandra, holds you up, maintains you, and at the same time seems to emanate from you. Two in one.

In a book on Catalonia by an interesting Catalan writer, Josep Plà, I have been looking at a photograph of the seafront of Sant Feliu around the date of your first visit there, in 1953. Do you retain vivid memories of that visit? What was that Sant Feliu like? Do you remember the colours of the hills, and of the sea, that first time you saw Sant Feliu?

R.B.K. Yes, my first visit is very vivid. It was another world, a sleep of dreams. Hard to get to on a rattletrap bus from Barcelona, many hours along a bad coastal road, and then this pretty little town, Spain as it was. I don't have to explain. You know it better than I do. We were two young Americans, my first wife and I, students from Vienna. We took a very grand old house facing the sea for the long cold unheatable winter. It cost

the same as a poor room in New York. Old ladies worked sewing the fishing nets spread outside the door all along the Paseo del Mar, and each afternoon a young man leaned on our wall in the winter sun reading – José Vicente, a Catalan Socialist Dreamer in Francoist Spain almost forgotten by the rest of Europe. I was a naïve young neo-Surrealist and Poundist. With that great sea out my window, I could have – but what's the use? I was not Turner or Courbet. I was a kid, stranded on the strand of Modernismo. Picasso at that age made hundreds of studies of nature as I should have done. But my mind was full of Joyce and Eliot and the Symbolist-Surrealist tradition and your friend Pound. At least Pound had served his (disputed) Classical and Georgian apprenticeship. That would all come much later for me – Giotto, Rembrandt, Cézanne, Goya, Degas, I mean. *Trop tard!* Jesus, I sound like Uncle Vanya! Or maybe I'm wrong. Maybe everything is written and as it should be? Maybe everything we do helps in the invention of oneself. I think Borges said he became lost in the writer where Borges the man was destined 'to perish, definitively'.

J.R. Yes, in 'Borges y yo', from *El hacedor*. But don't forget that true makers can transform old sins into new virtues. That's, in fact, a *virtuoso*.

Coming back to your memories of Sant Feliu, I would like to bring into focus that image of the young reader by your house, a man who is now the Socialist Mayor of Sant Feliu.

R.B.K. José Vicente became an older brother for me, one of many in my life. He was, even then, the spirit of that Catalan place waiting to be rudely awakened. His Socialism was so pure it would melt in the mouth (a Socialism ignored by history). We walked and talked and walked and talked along that wonderful empty coast – to Palamós, to Cabo Creus, to Ullastret, to posh S'Agaró. I tasted antiquity as never before and rarely after. I remember he had never heard of Pound, but he told me about Nonell's circle and of Unamuno, and he knew Barcelona, which I would come to know and love very well. He always spoke of 'our war' as if the other one, in Europe, had been far away. Sant Feliu was and always will be that man for me. And also a small portion of my lost youth when I sat on the rocks in front of my house and read Baudelaire for the first time. And also, of course, the Guimerá house later.

LE CONFITÉOR DE L'ARTISTE

Grand délice que celui de noye son regard dans l'immensité du ciel et de la mer! Solitude, silence, incomparable chasteté de l'azur! une petite voile frissonnante à l'horizon, et qui par sa petitesse et son isolement imite mon irrémédiable existence, mélodie monotone de la houle, toutes ces choses pensent par moi, ou je pense par elles (car dans la grandeur de la rêverie, le moi se perd vite!); elles pensent, dis-je, mais musicalement et pittoresquement, sans arguties, sans syllogismes, sans déductions.

Charles Baudelaire, Le Spleen de Paris

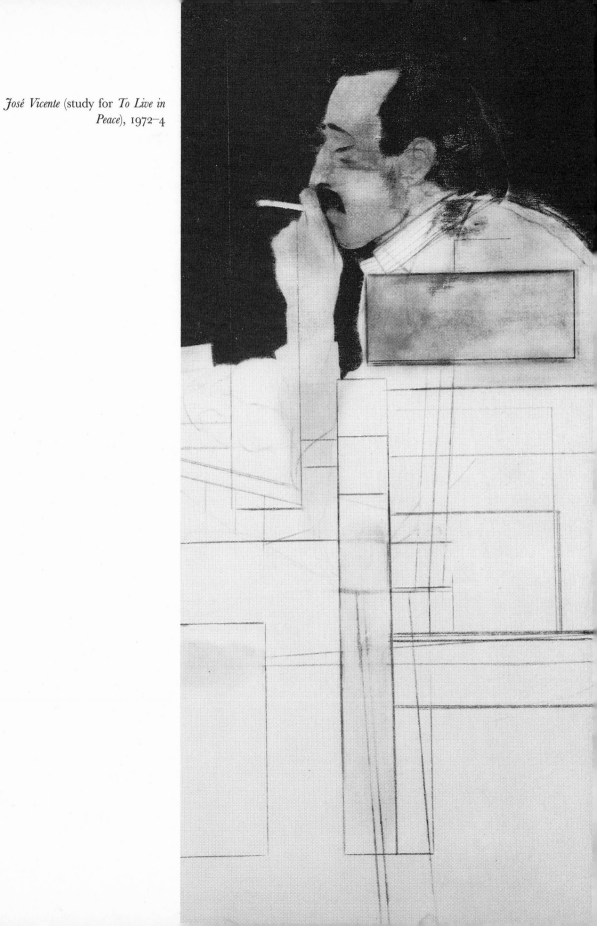

José Vicente (study for *To Live in Peace*), 1972–4

J.R. When I looked at your photograph of Sandra Fisher, José Vicente and the philosopher of art Richard Wollheim, I recalled a passage from Wollheim's *A Family Romance* – his only novel, to my knowledge – in which the narrator reflects on a letter by Rilke which refers to some enchanted geographical zones (as perhaps Catalonia was for you) and to the intimate relations between man and his objects, his possessions (in all senses of the word), especially his house. The artist and his objects. To quote from Espriu again, 'By the sea I had a house, a slow dream . . .' Sant Feliu still forms part of your geography of emotions (the only true paradises are the lost ones), and your house there, in calle Guimerá, must be the happy centre.

R.B.K. Should I have kept the beautiful old town house in calle Guimerá? We talk about it all the time, Sandra and I. It was a creature of only one decade of our lives. (The *entire* working life of Van Gogh!) It was born and died for us in the 1970s. I should say it died for *me*. Why I decided I did not need it in my life any more is a why wrapped in many tearful, nostalgic, sundrenched, rainy, forward-looking enigmas. I regret it; I'm glad it's in a very Catalan past tense. When I first lived in Sant Feliu in the winter and spring of 1952–3 I pretended I was Hemingway. I was only twenty-one and had retired from the outside world to paint an allegorical picture which now exists only in a few small fragments. I would go out on fishing boats. I would fantasize myself fighting at the Jarama, spilling Fascist blood, and I would sport a sharp knife on my belt. Twenty years later I wanted to pretend to live like a painter sort of Unamuno in my tall, dusty, dark house with the lovely courtyard. Guimerá would be my Salamanca where I could escape the boring scene of 'progressive' art and bury myself in what I thought might be more unusual art ideas, away in my Catalan sanctuary, hidden, an ideated life pursued during my children's school holidays. I think the game worked now and then. I made some nice drawings and pastels in that courtyard. Eventually I gave the house up because we hardly used it any more. My children grew older, and I grew very restless. Speaking basic Catalan became a chore. I was at the start of a new Diasporist lifework and Sant Feliu had entered into a boring period I didn't much like. The fantasy house became an enchanted island in a tourist town, a museum-piece stuck among fancy shops, ugly modern hotels, nightclubs and beach trade. The Med-Holiday aura defeated my spirit. No place for Unamuno! Except for the Mayor, my dear comrade José Vicente, idealistic as ever, and his family, everything I had loved was gone or tarnished beyond my old-fashioned dreamlife.

J.R. Your 1978 Sant Feliu summer seems to have been a very productive one. You must have worked hard there in your patio. Besides the beautiful portraits of your beautiful daughter and your son Lem, you made other pastels: *Catalan Cap*, *Emblem* (of Fascism, with a Mussolinian figure upside down? Of bad faith?), *Yellow Apron*, *Washing Cork* (*Ramón*). The last two depict workers in the cork industry, the principal business in the area before the tourist invasion.

R.B.K. You are right about *Emblem*. I think I used that title because the image is so well known it is emblematic. Ramón is from life and also not. My house was almost next door to the old cork factory which José managed, so I could observe and sketch Ramón at work. The pastel was done in the patio.

Catalan Cap, 1978

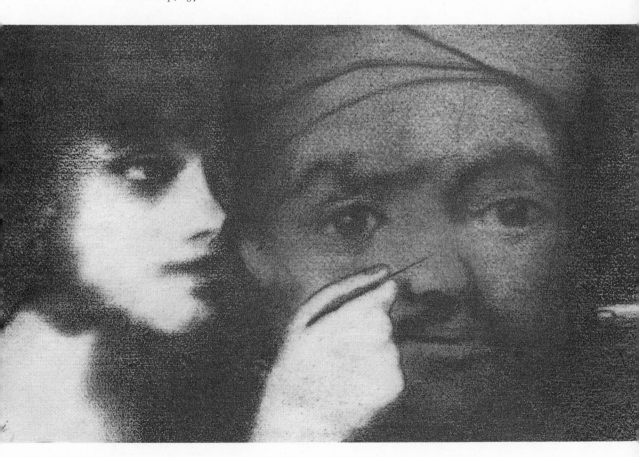

Emblem, 1978

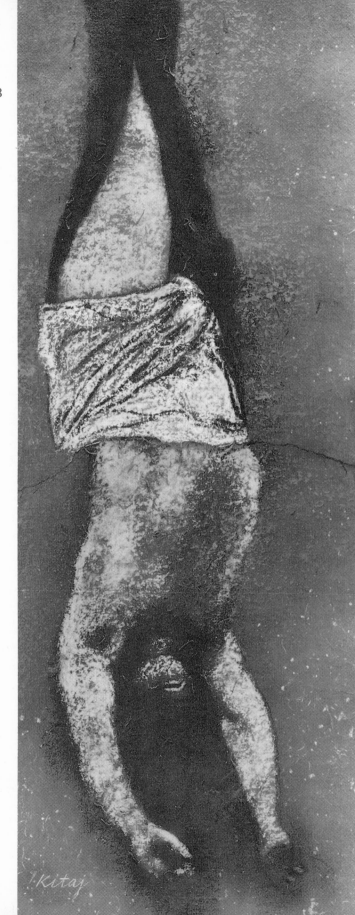

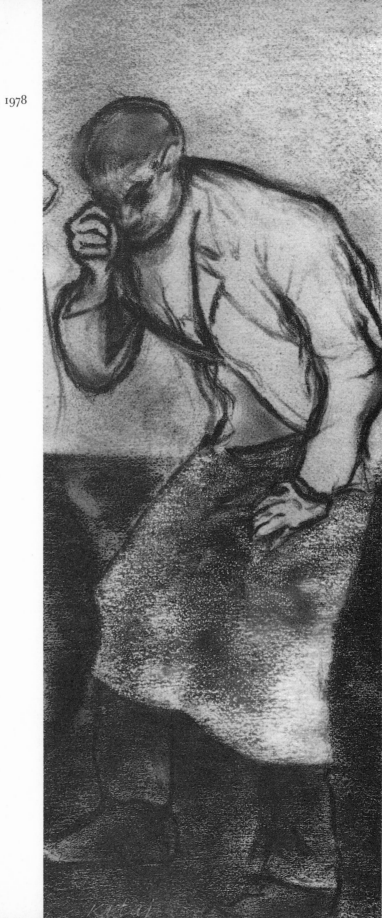

Washing Cork (Ramón), 1978

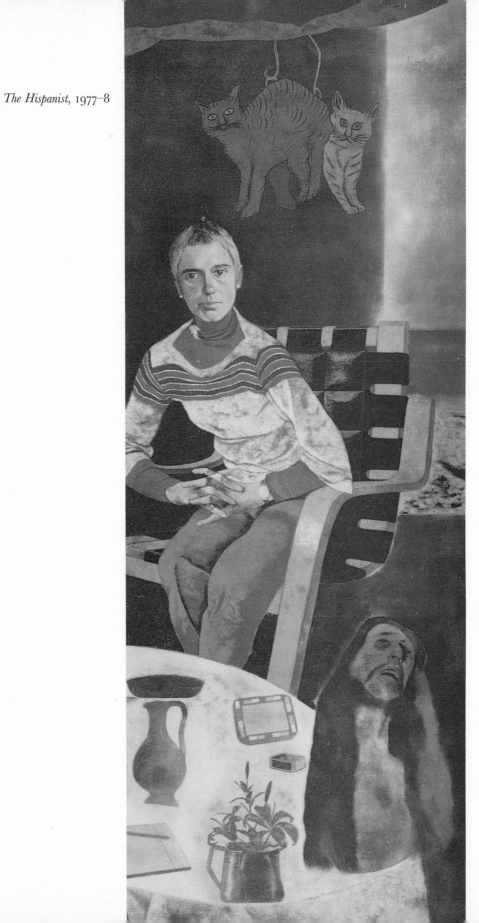

The Hispanist, 1977–8

J.R. From the same period, 1977–8, is the portrait of your Catalan friend, a resident in London, the Hispanist Nissa Torrents. It is a big oil canvas nearly two and a half metres high (exactly the same size, long and lean, as *The Arabist, The Orientalist* and *Smyrna Greek*), and I presume you painted it in London. Did she pose at your studio? – she is sitting in a chair of yours designed by Alvar Aalto. She seems a bit tense, perhaps expectant. I don't know her, but the melancholic self-concentrated expression on her face seems to me one of your finest psychological achievements. But I suppose her pose is relaxed because you are old friends. Where did you first meet her, in Catalonia?

R.B.K. I met Nissa in London, but she was born and raised in the calle Balmes in Barcelona. She and her English husband have a little house inland, near Llagostera. She teaches in the Spanish department at the University of London.

J.R. *The Hispanist* is not exactly a '*portrait d'apparat*' but the objects on the table have an evocative purpose, haven't they? Especially the half-Christ. Is he Catalan, as well as the landscape in the background? And the swinging cats?

R.B.K. Yes, Catalan objects and landscape. The swinging cats *may* have been painted by Picasso to hang over the café Quatre Gats, but no one is certain.

J.R. The agonizing Christ could be related to the 1976 *Catalan Christ (Pretending to be Dead)*. It's the same size as *The Hispanist* but horizontal. He lies against a Costa Brava landscape (Sant Feliu?) and on his coffin are some objects – a dicebox, a board game, some pottery, an apple on a book taken from the Zurbarán portrait of Gonzalo de Illescas – which seem to allude to the leisure time of holidays. Is this placid Christ with cap a memento (mori) from your holidays in Catalonia, and especially during Holy Week?

R.B.K. Yes.

J.R. A convivial and cordial atmosphere comes out of *To Live in Peace (The Singers)*, one of your happiest paintings, full of felicities, which has been compared to Renoir's *The Luncheon of the Boating Party*. And again the Sant Feliu landscape, I presume, places the scene.

Catalan Christ (Pretending to be Dead),
1976

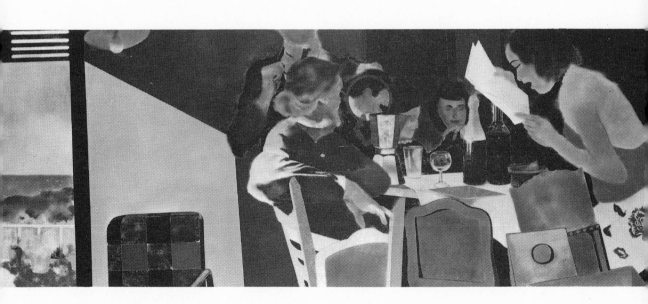

The Singers (To Live in Peace),
1973-4

R.B.K. Yes, the landscape on the left is what you see from José's window, high on a hill above Sant Feliu.

J.R. He's the man whose head is in a circle, isn't he?

R.B.K. Yes, José is in a circle. The others are his mother, wife, sister. The singers are his oldest friend, the painter and amateur tenor Albertí, and a (Swiss?) girlfriend of his. It was an Easter lunch.

J.R. Yes, in 1972, I think. And the girl singer *was* Swiss, José Vicente informed me. He even told me that during that Easter lunch some of Villa-Lobos's *Bachianas* and pieces from *Don Giovanni* were sung. *Viva la libertà!* Those words couldn't have resounded too well because then Spain was still waiting for its freedom. We say in Spanish '*tener la fiesta en paz*', to have the feast in peace. But in Franco's Spain the winners of the war kept the 'peace' *and* the feast. Your premonitory painting shows the determination of the people of Spain to sing their own pieces in peace. And you have been lucky enough to see it fulfilled.

In *Where the Railroad Leaves the Sea*, one of your most ambiguous paintings, I think the Sant Feliu setting is important and might provide a clue to the painting's enigmatic kiss. Is it one of farewell? Of meeting? Or lust? Or rapacity? You have probably travelled in that old narrow-gauge train which used to go along the coast, from Gerona to Sant Feliu. Sant Feliu station appears stylized in your painting with Picabia-like artefacts and the aerial roof – which reminds me of the structures of another painting of the same year, *Apotheosis of Groundlessness* – open to the expectant sea. A sort of port of trains. A kiss at the quays ... What is the key? I read somewhere that it depicts a scene of prostitution. To me the woman has a manner that evokes the movie stars of the 1930s. One of your most perceptive critics, Marco Livingstone, saw it as an intense and poignant love scene in which the man is depicted as literally 'giving himself' to the woman. Who knows? But it is also possible to deduce the opposite: the man is not giving himself at all, at least not entirely, because his right arm, with which he embraces the woman, is detached from his body. Is it a kind of metaphorical prosthesis? When love is adulterated, or vitiated, we offer an artificial embrace.

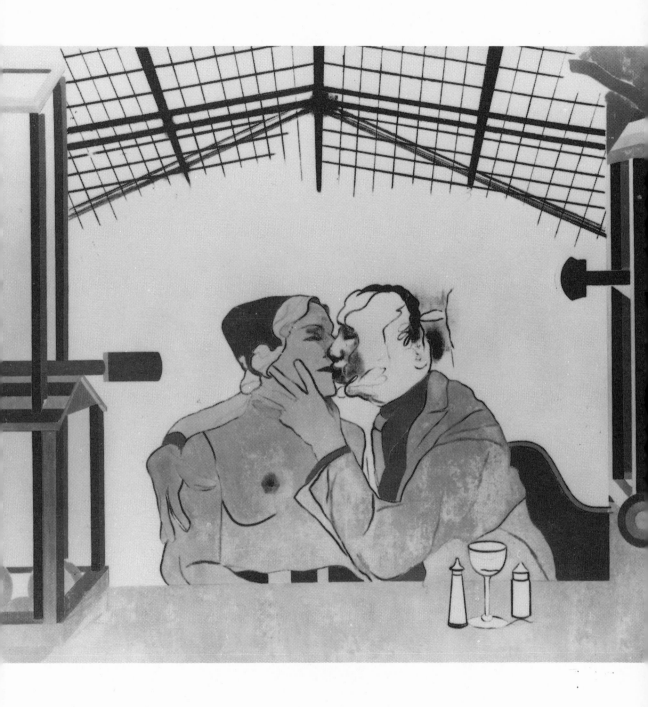

Where the Railroad Leaves the Sea,
1964

In Catalonia, 1975 **R.B.K.** This is one of only very few oil paintings I have kept from the early days. Until recently, it always hung over my fireplace. For the last year it has been in storage, hidden in my genizah with its secrets. Its secret life will be partly revealed when I write about it sooner or later. Now I can say that it *was* inspired by the little defunct station of course, and its melancholia. They just kiss – no fascism intended. Give me time to illustrate my youthful picture with a little tail-piece, although your interpretation is admirable and readable.

J.R. When you painted the kiss at Sant Feliu railway station in 1964, Franco's regime had a decade left. At the end of 1975 – the year of your almost emblematic *In Catalonia* – after Franco's death, Catalonia and the rest of Spain started with *seny* (good sense) to recover their liberties. Your *Communist and Socialist* (1979), which depicted your friend the Socialist José Vicente exchanging views with a Communist friend, is perhaps the result of the discussions that occurred with the change of the regime. I suppose you witnessed that Catalan rebirth with a healthy envy, didn't you?

R.B.K. I was thrilled for them! To have their culture and country back again! It was a strange transition in many ways. Even before the old fart died, there were books in shop windows about Mao, Lenin, Marx, Ché, Fidel, etc. It was a *tired* transition after forty long years. Progress had begun, I think (McDonald's in the Ramblas??). There was 'art' – those unbelievably poor-quality minimalist sculptures everywhere, along every highway. Tired internationalism at its worst, the political and artistic internationalism of left-wing bourgeois youth and Yuppie bureaucrats in a disastrous mixture, which, I'm afraid, from what I hear, continues today, judging by the speed with which Barcelona and other cities take up fashionable·art. I prefer Romero de Torres to Dokumenta, but both are low-grade ore. But *ideas* plus skill in art is rare everywhere. Israel and Catalonia are alike where art is concerned. They are both too young and borrow terrible junk from tired, fake-glamorous avant-gardism instead of watering their own roots. Jeremiah has spoken! I respect López García – no Picasso, no great ideas, but maybe the best you have at a poor moment?

J.R. Could you talk about the winter you spent in 1953 at Sant Feliu and, more specifically, about the 'large allegorical painting (now destroyed)' that you had been working on during that winter? There is a long American tradition in allegory – a

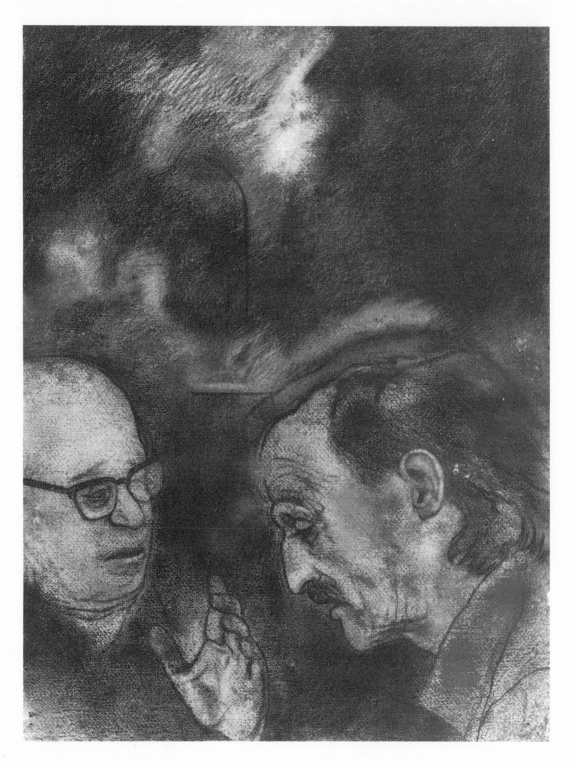

puritanical tradition, perhaps: Melville, Hawthorne, Faulkner. Was your allegorical painting in that tradition? What was its theme? Could you describe this vanished work?

R.B.K. I can't claim that great American tradition for my allegory because I hardly remember the damned painting. I started it almost forty years ago – in New York, I think – and carried it with me for some years in the Joycean tradition, before I cut it up in the Burroughs tradition.

There was a profile of Pound in it and, for the first and last time, from the seaside house in Sant Feliu, I wrote a letter to the great madman at St Elizabeth's Hospital in Washington. Pound answered my youthful nonsense! I sat on my Baudelaire rock facing the grey Mediterranean and read the letter over and over. I had the letter until the late sixties, but haven't been able to find it since. It must be buried in a book in my storage. I don't remember what I wrote to him, but I must have asked him for a sign or a gesture like from a Pope, because he answered: 'What for – an amulet?' He also wrote me: 'Pay more attention to external phenomena!' What great advice. I should have been painting that sea, that town, those people ...

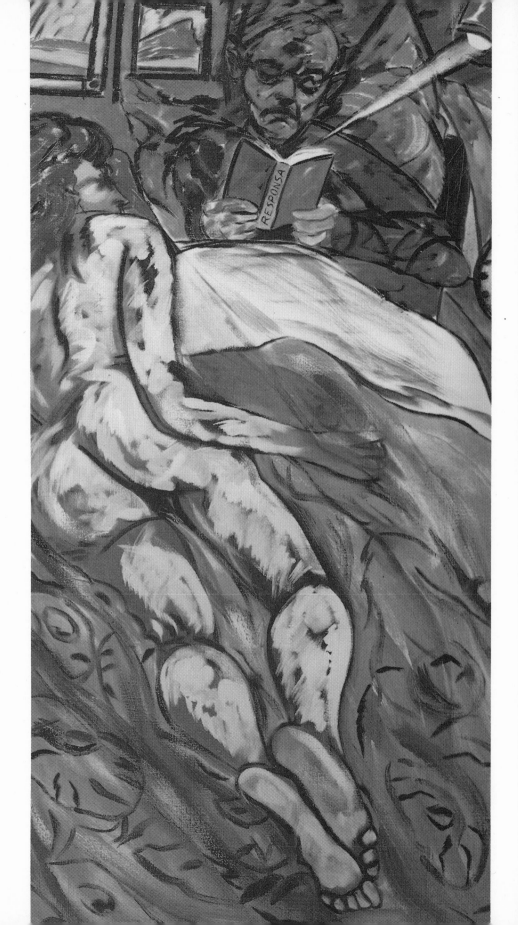

THE GRAND JEWRY

Before dying, Rabbi Shlomo Jaim said to his sons: 'Don't think that
your father was a tzadik, a "rebe", a "good Jew". But in any case I
was not a hypocrite. I tried to be a Jew.'

Martin Buber, *Die Erzählungen der Chassidim*

J.R. The title of this chapter refers to the large community of
Jews, from schoolchildren to writers such as Walter Benjamin,
that lives in your paintings. Perhaps we could begin with *Reading
in Bed* to get your first replies – or *responsa*. Are the formal
aspects of religion, the questions of ritual and observance, of
interest to you?

R.B.K. The formal aspects of religion, questions of ritual and
observance, can't be avoided when one embarks, as I have (even
with my paintbrushes), on a journey into Jewish destiny. The
religion seems to touch everywhere and everyone – even those
who are trying to escape it. I get easily bored in Schul because
I was not brought up in the tradition and I hardly ever go.
Perhaps He will forgive me, I don't know. But the magnitude of
millennial Judaism is entrancing, and its procession of books
and commentaries, the sheer sense of life in Jewish history, as
well as the Tragic Sense, the astounding and deathly Jew-hatred
underlining that historical life, keeps me fascinated by much of
it, including religious law and also reforms of the law. All my
life I've roamed and picked and chosen in the Yeatsian rag and
bone shop for the sake of my art and heart. And so, in the
vibrant gloom of that endless yawning shop I began some years
ago to stumble into its Jewish byways and, like Professor
Schechter in the genizah at Cairo, I turn over scraps of stuff I
never dreamed would interest me or my pictures – the sacred

Reading in Bed, 1985–6
Books, fragmented Halacha, Midrash and Responsa, Messianic

183

and Wisdom literature and so on, whatever my poor mind can respond to in translations done into English by scholars who'd be petrified by the uses their holy stuff is put to by a greatly flawed Diasporist painter in his corrupted secularist art.

What holds me in its grip, so that I can't escape its still stinking breath, is the epochal murder of the European Jews. And so, some of my art-life these days concerns the theological 'explanations' of that event, and there are quite a few bright people who've pulled that cork: the Death of God, the Eclipse of God (Buber), Where Was He, and so on. That's not what you asked but it's the way I cleave to religious questions, which will never get resolved as long as I can't find my own answers or half-answers, which quest brings me back to painting, either as salvation or something else. Like your Shlomo Jaim, I also try to be a Jew. I hope my art will look like a Midrash on my life. Each man's life is surely akin to a 'revelation', and an exegetical art would seem to befit revelation. There are 613 Commandments or Mitzvot, which intrigue me because I want to be a good boy and do unto others, etc., and I want to do good art. So I figure if I study those Commandments and even follow a few of them, maybe my art and I will be affected. Maimonides said that a man who performed in accordance with only one out of the 613 deserved salvation – *if* he did so not out of self-interest. Emil Fackenheim added a 614th a few years ago which forbids Jews 'to hand Hitler yet another, posthumous victory' – lest they perish. Very complex, this, fraught with interest, contradiction and food for my own art.

Who will show a child, as it really is?
Who will place it in its constellation
and put the measure of distance in its
hand?

Rainer Maria Rilke, Duino Elegies

J.R. In *Germania* (*The Tunnel*) you have portrayed yourself as the man who gropes with a walking-stick (a seer, or a blind man?) behind a child holding a book. Is it your son Max, besides being the reborn Jewish nation after the Holocaust? What most puzzles me – and fascinates me – is that the child seems to be the guide in this subterranean labyrinth.

R.B.K. The stick of a man made ill by history. Max leads, yes; we have to learn. I will follow his lead to a certain extent with my poor knowledge of the events of our shared history, his and mine.

J.R. The fireballs between the man and the child, are they *Sefirot*?

Germania (The Tunnel), 1985

*Cecil Court, London WC2 (The
Refugees)*, 1983–4

R.B.K. *Sefirot*, yes. 'And a little child shall lead them' – Isaiah? Micah? – often quoted in Messianic literature. Your Rilke quote is excellent. I am hobbled, even maimed by history. Max runs ahead and, Aged Parent that I am, I must catch up with him and try to explain what it means to be a Jew. I must place him in his constellation.

J.R. I would like to quote from your preface to *Cecil Court*, which you consider one of your most ambitious paintings – and most ambiguous, I will add, because of its strange atmosphere. There's a kind of 'dreamagical realism' which has the intensity of Balthus's *La Rue* or *Le Passage du Commerce-Saint-André*, and the 'indensity' of Paul Celan's expatriated alleys.

> One of the first friends to see this painting (a 75-year-old refugee) said the people in it looked *meshugge*. They were largely cast from the beautiful craziness of Yiddish Theatre, which I knew only at second hand from my maternal grandparents, but fell upon in Kafka, who gives over a hundred loving pages of his diaries to a grand passion for these shabby troupes, despised by aesthetes and Hebraists who were revolted by them ... I would stage some of the syntactical strategies and mysteries and lunacies of Yiddish Theatre in a London refuge, Cecil Court, the book alley I'd prowled all my life in England, which fed so much into my dubious pictures from its shops and their refugee booksellers, especially the late Mr Seligmann (holding flowers at left), who sold me many art books and prints.
>
> R. B. Kitaj (from the 'Prefaces' in Marco Livingstone's *R. B. Kitaj*)

Curiously, the man who is sweeping the floor, in the background, looks quite like your favourite anti-Semite (more expert in semiotic than in Semitic matters), the signmaker Ezra Pound. Who is he, if I may ask? And besides the bookseller Mr Seligmann, who are the other Cecil Court refugees? Marco Livingstone has identified the principal *dramatis personae*: your stepfather Dr Kitaj, at the far right, next to a bookshop significantly called Joe Singer, and yourself in the foreground – 'the artist dressed in the clothes which he had at his recent wedding' – lying on a Le Corbusier *chaise longue*.

R.B.K. The man sweeping the street is sweeping up the mess of broken glass from the shattered windows of Kristallnacht – a reminder of those shopkeepers the morning after. His knickerbocker trousers were common dress for Walter Kitaj in that same period – I even inherited a pair when he came to

The Jew, Etc., 1975

The Jewish Rider, 1984–5

America, and I used to play American football in them. So, the young student Kitaj, from his time at the University of Vienna, his later self in exile, and R.B.K. (ex-University of Vienna) all appear on this painted stage. The baby at the centre is a reminder of the one and a half million murdered Jewish children I've read about in books bought in Cecil Court.

J.R. I presume that the shop signs in the background marked *Gordin* and *Löwy* stand for the Yiddish playwright Jacob Gordin and the actor Löwy, a friend of Kafka, whom you have portrayed in his role of Hamlet.

R.B.K. Yes.

J.R. Your train travellers are cinematic – emotion pictures, archetypes of the escape. Did you have some still or film image in mind when you made these works? Could the traveller with the hearing-aid be a sort of image of yourself projected backwards into an imaginary past? Your escapegoat?

R.B.K. Yes, good, my escapegoat. The Jewish Rider comes, of course, from Rembrandt's *Polish Rider* I've always loved in the Frick. Revisionist historians now say it's not by Rembrandt. Revisionist historians now say there was no Holocaust.

NUDES

J.R. I would like you to talk about your passion for drawing the human form. Could you describe the nature of the encounter with your models?

R.B.K. Drawing someone in my room, closed off from the world, is a nervous encounter, fraught with psychical and historical baggage. The history, even of the minutes before the expected one arrives, plays its part because, in my experience, a quiet desperation has often to be overcome by a kind of politeness that attempts to mask interrupted life. Then the looking begins. Seeing what is, after all, innumerable in the human form becomes a failing power but one which revives and revives, I find to my astonishment, with drawing. Manet told it another way to his friend Antonin Proust: 'There is only one truth, and that is to put down at once what you see. When it comes off, it comes off. When it doesn't, start again. All the rest is nonsense.'

Sickert, who didn't care for Manet, also stressed the failure coefficient in drawing, proposing to achieve the expression of form by one's own individual quality of error (one's own personal bias), a correct record (after nature) not being within human power. In other words, drawing becomes as infinite in its effect as natural life itself is, but the wilful application and sustained concentration which one must find within one's power removes drawing practice from, for instance, reverie.

In my room I get to stare, which is not done in polite society.

Sometimes sexually interested but rarely aroused, I can scrutinize at my leisure. The guy who said (I think it was Pieper?) that leisure is the basis of culture must have known about drawing because the looking to see and the limning on the paper's grain of what you think you see, at speed but without haste, and the beautiful expanse of time, its very quietude, are a cultural privilege. It's an education and has also been called a moral act in the sense that you must face decisions and their consequences. What results, if it results in an art, reveals a particular kind of human intelligence. An unfriendly critic wrote that Degas is 'continually uncertain about proportions'. Nothing, Degas replied, could better describe his state of mind while drawing.

I never know how to start and really don't know how to finish, and within that span of ignorance lies the intelligence and exaltation of drawing. You can see that palpable mystery best in the drawing of the supreme old men – Rembrandt, Cézanne, Degas, and above all in the Michelangelo crucifixion drawings of his last days. I may be wrong, but I tell young artists that, aside from sketching quickly, it's kind of dumb and arrogant to get the configuration down too soon and then have to defend those lines as though you knew exactly what you saw and the registration was 'accurate'. This would be like consummating a marriage once and for all so that the art of it would come to an end. Those hill-form nerve systems called Montagne Sainte-Victoire, the put-upon Degas girls after 1900, and the blur of Christ's body in those supreme little Michelangelo sheets tell of an accuracy beyond the crisis of decision, a calm without rest, gone through to the world's body, a proper study of mankind. The trouble is, you have to know, as Whistler used to say, which end of the brush to put in your mouth. I get less and less sure as I grow older.

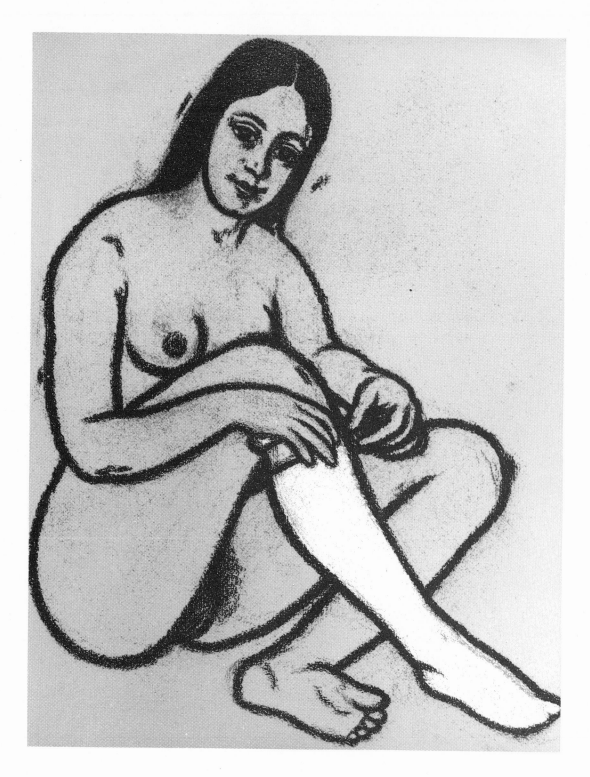

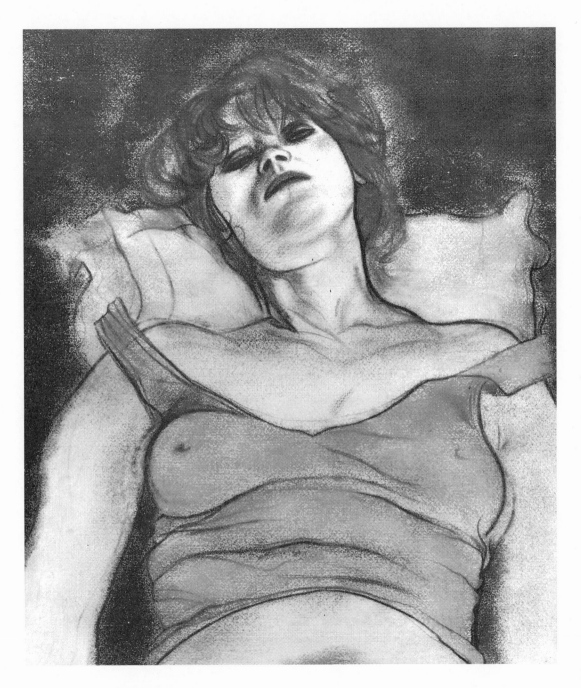

Mary-Ann, 1980

Thérèse, 1978

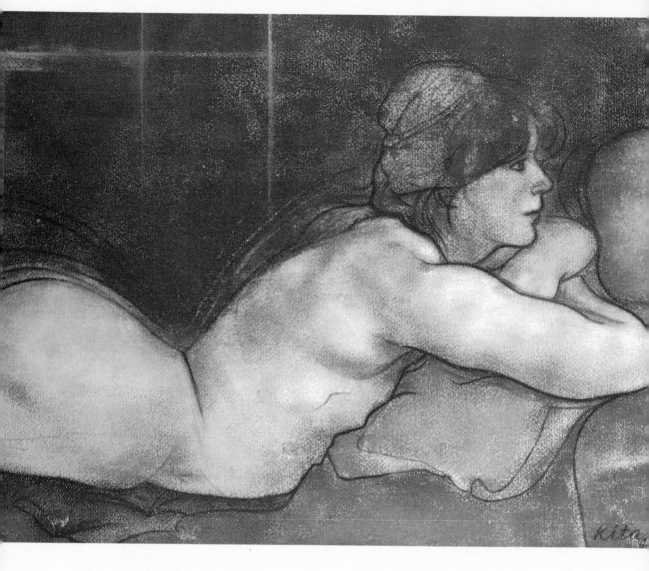

Mary-Ann on Her Stomach (face right),
1980

Marynka Smoking, 1980

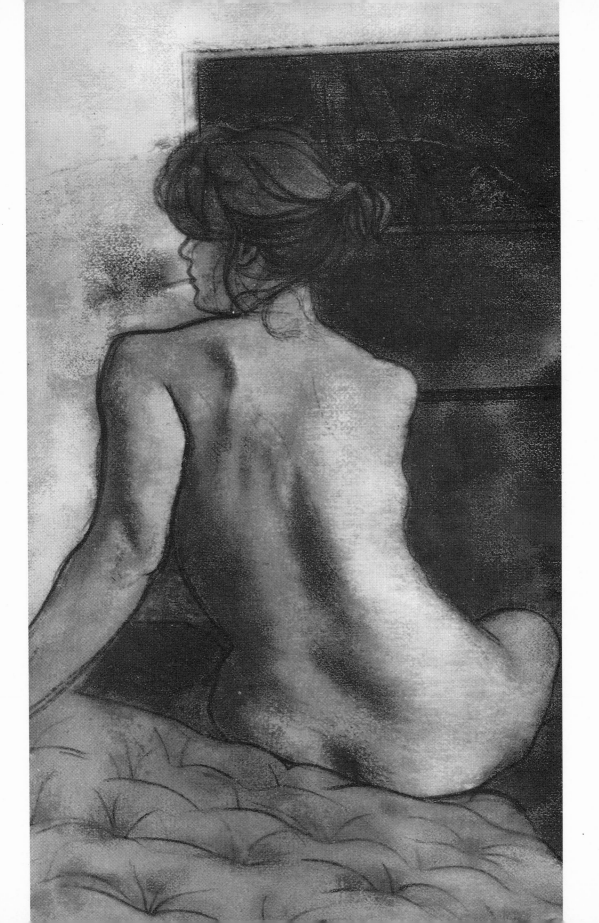

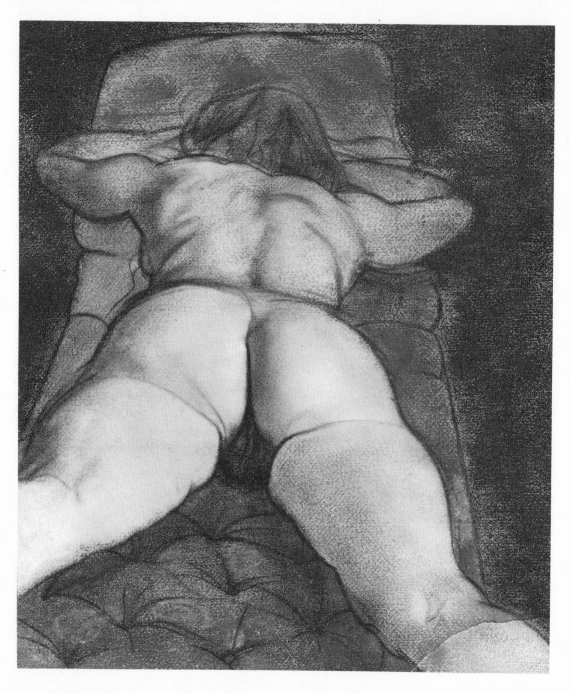

Marynka on Her Stomach, 1979

Ilan (Leaning), 1982

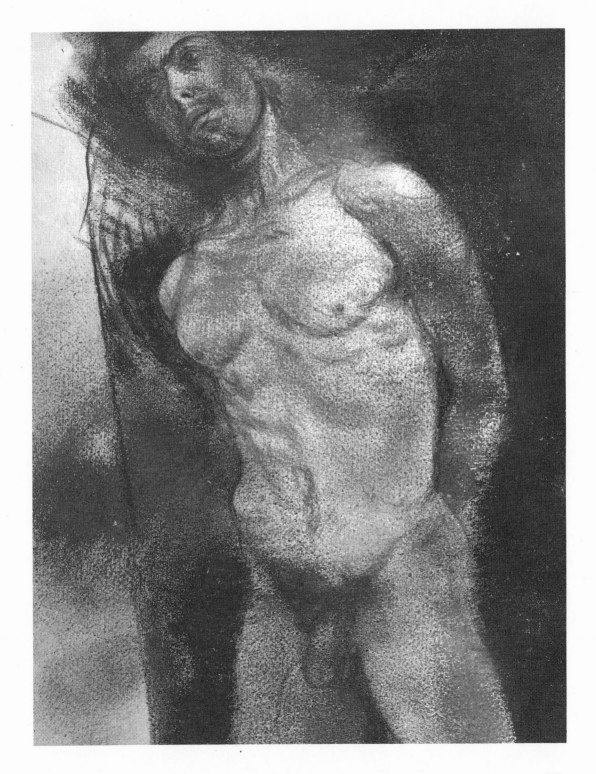

Young Man by a Lake, 1979

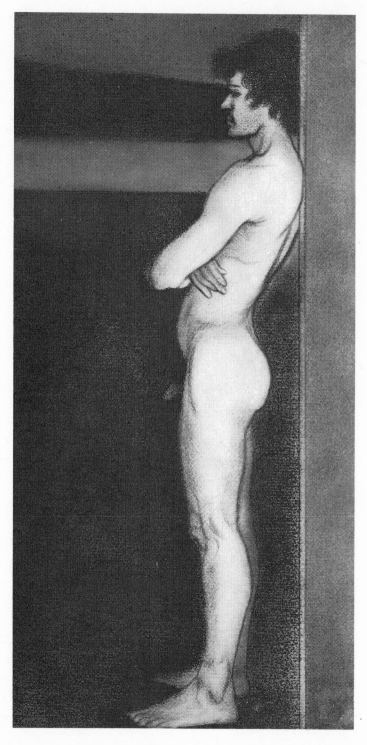

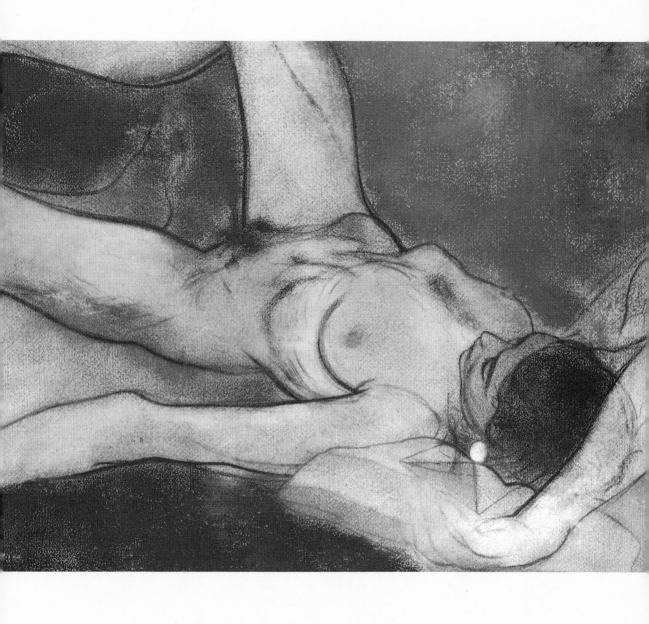

Annabel on Her Back, 1980

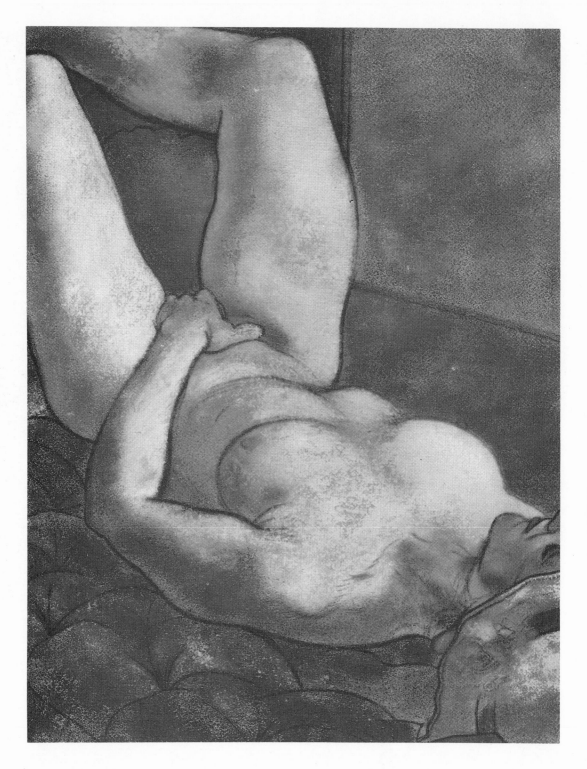

The Yellow Hat, 1980

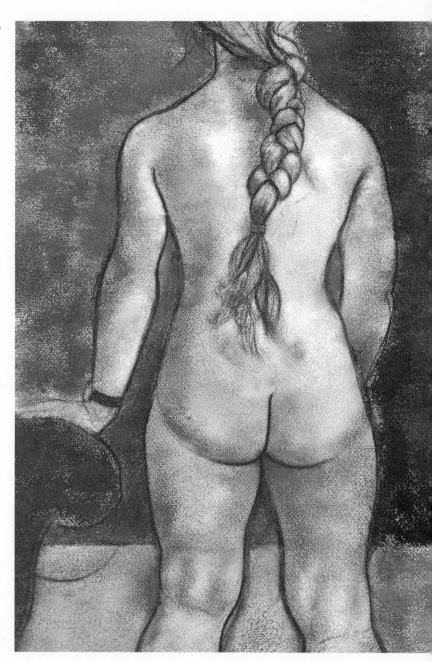

Miranda's Back, 1980

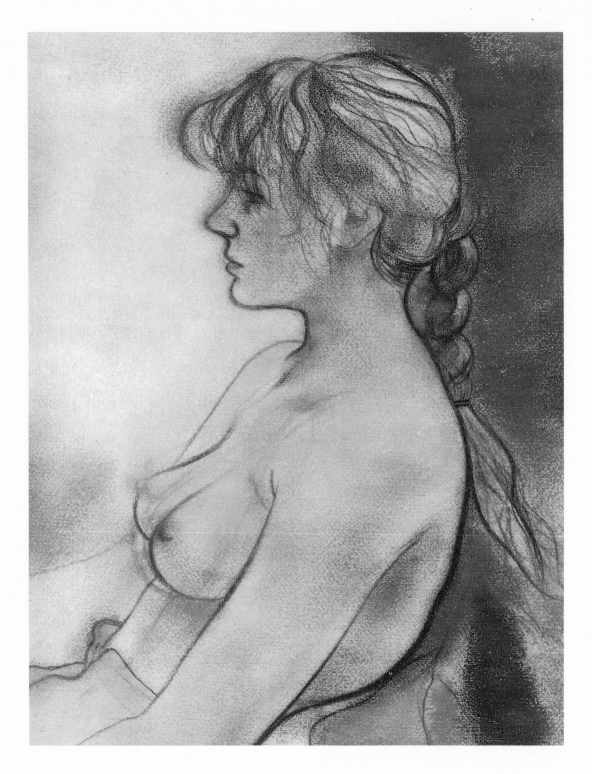

202

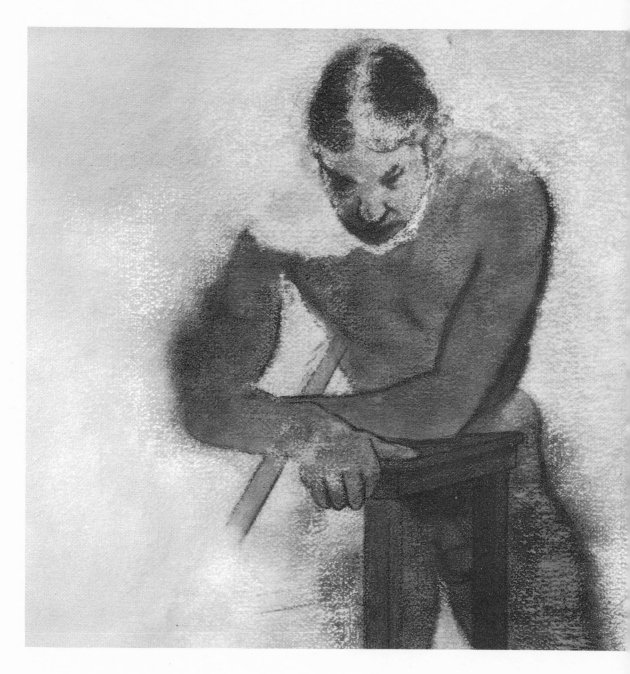

Dying Life Model, 1978

Miranda (face left), 1980

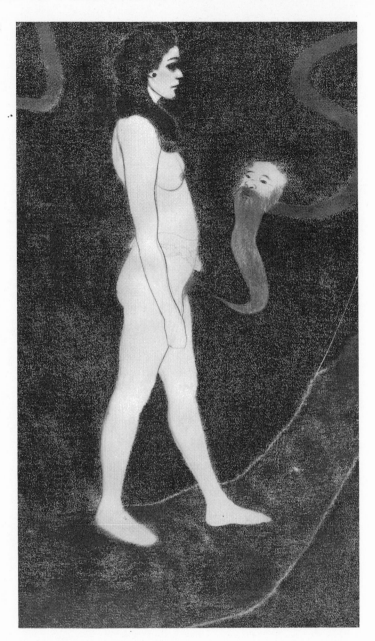

Nicky, c. 1979–81

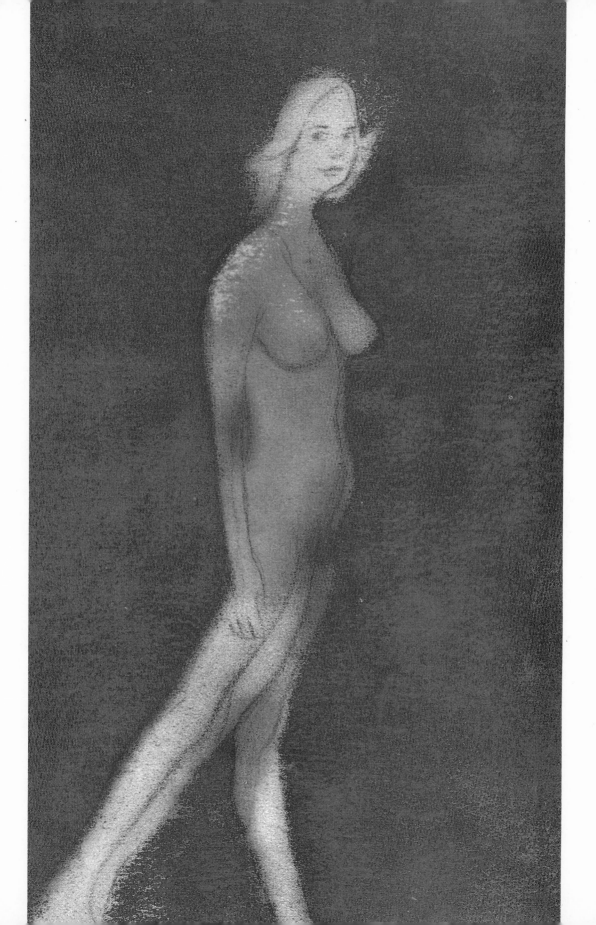

HEADS OR TALES

When I was sixteen, what I did attend was an art school in New York where everyone was painting with house-painters' brushes in the first flush of 'action painting', the masters of which were working two blocks away in 10th Street. My provincial heart was set on learning to paint like Hans Memlinc. No one could teach me how to do that and I never did chase down those Flemish secrets. They had been dumped into the respectable wastebins of history in the aftermath of new sets of instruction by ideologues like Roger Fry who mistrusted Flemish 'realism' for now shop-worn twentieth-century reasons. Now that our century is closing, those faces still set me dreaming, still stand for the adventure I was looking for when I began, because the narrow terms of the face, the demands of verisimilitude are like the confining rules of mountain-climbing and lead toward the stars in *any* time. Faces are very special. (Giacometti said that the head is sovereign.) I always expect and often fail to find something in a face which will make me happy. Expectation is conducted by drawing (in my life) and drawing of a very high order is like an epiphany.

R.B.K., *The Artist's Eye* (1980)

J.R. I would like to put the above quotation as a kind of thinking-cap on this chapter about heads. Giacometti's statement turns out to be exact, because sovereign means etymologically what is placed above. I presume that for you the head is also supreme, sovereign.

R.B.K. I think so too. But I really mean the face, which I believe distinguishes people more than any other thing about them. Is it not the face that flashes in the mind when someone's name is mentioned? Is it not at first how we generally remember people, and only later accompanied by other traits and things?

J.R. Evidently. And etymology supports this view. The word *visage*, 'face', is derived from *visus*, 'seen'. The face is what we see ... and it sees us.

His Cult of the Fragment, 1964

R.B.K. Once I said all this to Francis Bacon and he disagreed. I think he claimed sovereignty for postural configurations. He would, wouldn't he?

J.R. Certainly. Configurations and, in a peculiar way, when it is a question of portraits, disfigurations ... Bacon has spoken of his practice of the injury – of inflicting painting when he makes or perpetrates a portrait. But I recall now the expression of the other Francis Bacon, the author of *Essays*, who saw faces in a crowd as a 'gallery of pictures'. What a collection of heads and even, if you allow me the pun, what a tête à tête gallery your paintings could provide. Besides the portraits of real people, there are many imaginary or invented heads, a 'procession of heads', to use your own words in a recent letter to me.

R.B.K. I hope to 'name' these heads over the years and slowly develop some sense of their lives outside the pictures they come from.

J.R. Meanwhile, we could review some of these faces of fiction and make some commentaries, a kind of 'notes towards a supreme physiognomy'. Perhaps it would be appropriate to head this catalogue with *His Cult of the Fragment.*

207

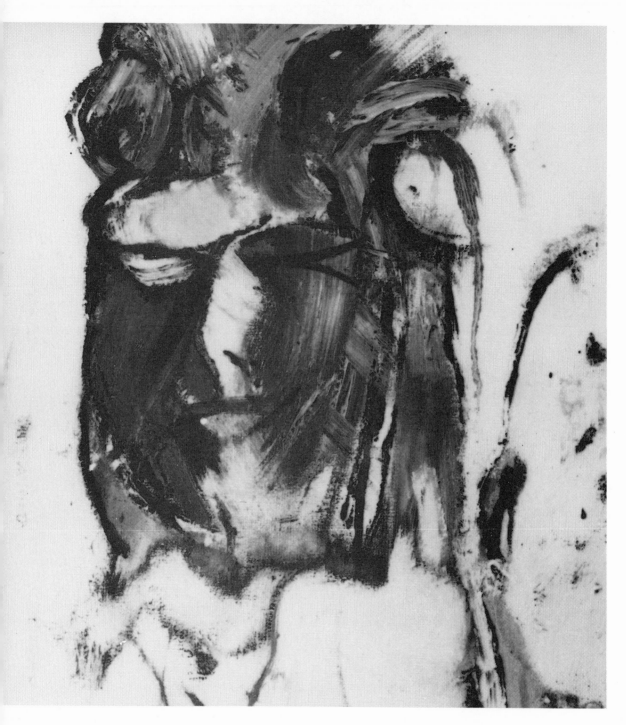

Erasmus Variations (detail), 1958

The most perfect and vivid expression of our time, in philosophy as well as in literature and art, is the fragment. The great works of our time are not compact blocks, but rather totalities of fragments, constructions always in motion by the same law of complementary opposition that rules the particles in physics and linguistics.

Octavio Paz, Alternate Current

R.B.K. His name is Hugh Penn. He was a physician I knew at Oxford who treated me, and then later at an English coastal town where he practised. During the 1960s we used to visit him and his mother every Easter Sunday. He liked to entertain my children by slipping masks over his face. I made this drawing in oil paint. The colour is *caput mortuum*. When my first wife died, I never saw or heard from Hugh again. All that remains of him is this fragment.

J.R. I know you share with Walter Benjamin and Company the cult of the fragment, so characteristic of our shattered times. I would like to compare this head with a fragment from *Erasmus Variations* and also with the flyer's face of *Aviator*.

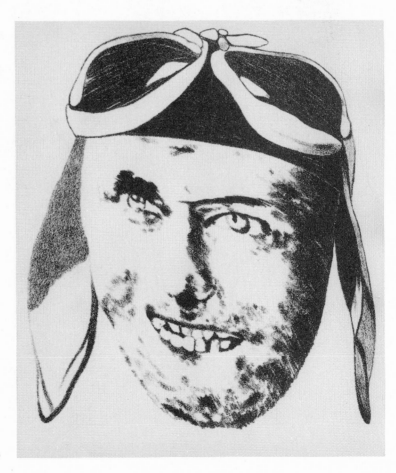

Aviator, c. 1970

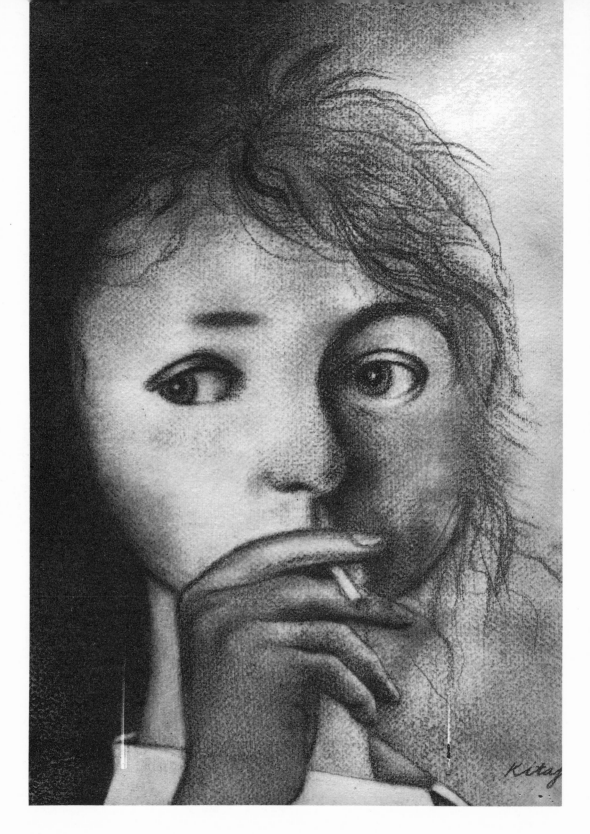

Her Law School Days, 1978

A Student of Vienna, 1961

J.R. *Her Law School Days* – was she a student from Oxford or from Vienna? I don't know why, but she reminds me of the face of some poet, Hölderlin perhaps. I'd swear I've seen that face somewhere. Maybe it's a delusion, because she could be another of your invented characters.

R.B.K. She was a law student at Berkeley who now practises law in Paris.

J.R. I will relate her with *A Student of Vienna*. I would like to see deep into these dilated pupils.

Rock Garden (*The Nation*), 1981

Study for the Rock Garden (Girl), 1981

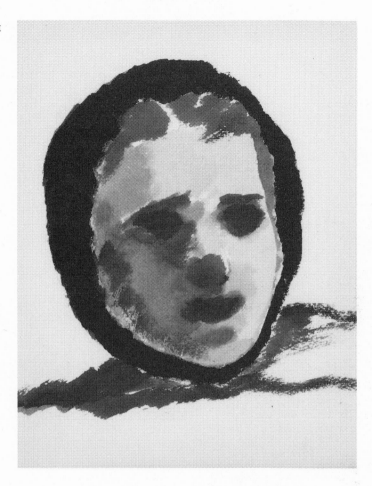

J.R. Your *Rock Garden* is a cemetery in ruins, and at the same time each head is a keystone for the foundation of a nation. 'Our Ghost-Nation,' as you said, 'called by a Hebrew poet the great empty Kingdom of Death.' But before going into your Garden it would be advisable to examine the studies you have done in Sant Feliu for this painting. They show you as a head-hunter, as much from life as from art history. The title-names of some of them – *Rose*, for example – suggest that you portrayed people you know. But except in the case of the old bearded man, you haven't transplanted these heads to the *Rock Garden*.

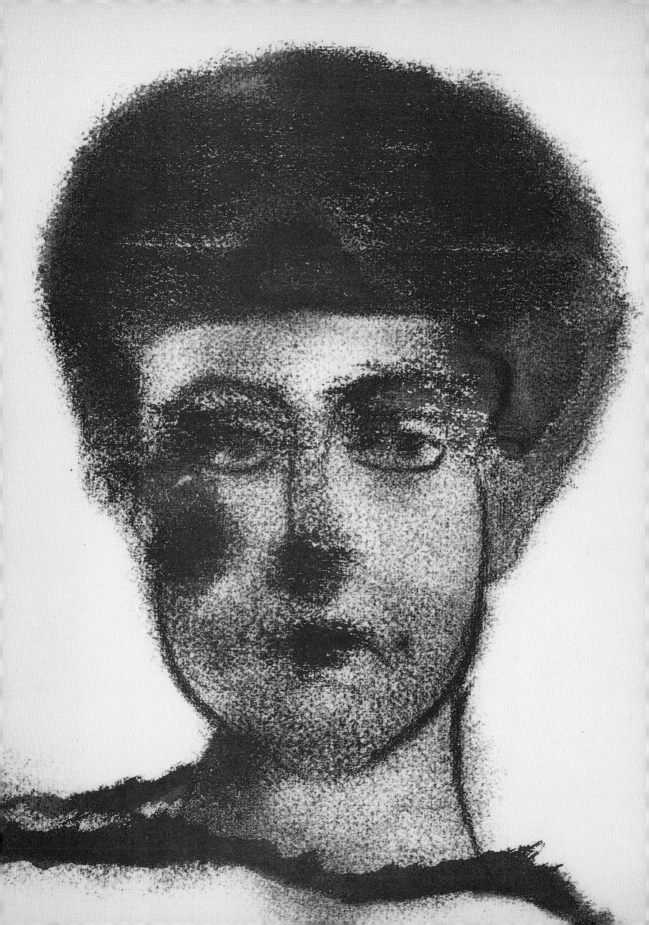

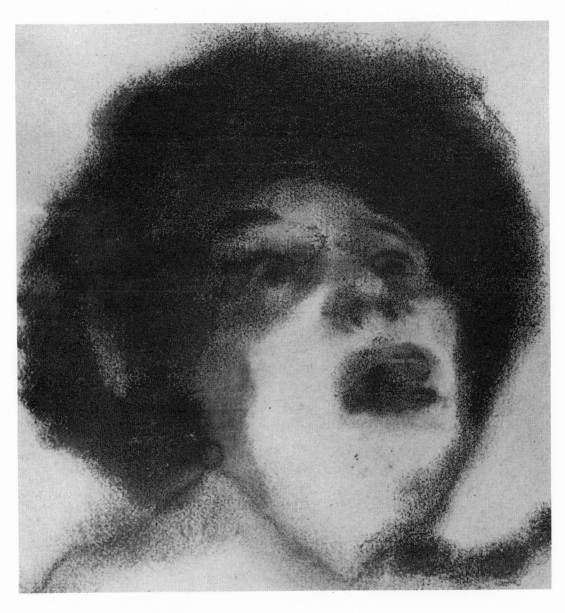

Study for the Rock Garden (Rose),
c. 1981

Study for the Rock Garden (Youth),
c. 1981

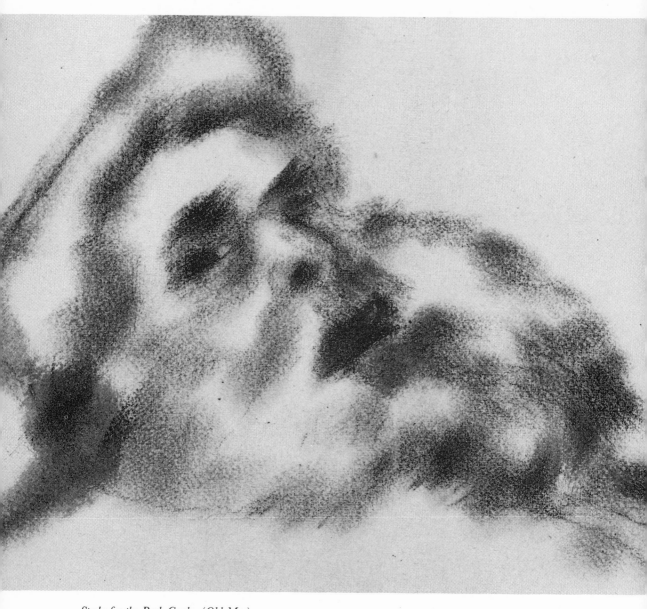

Study for the Rock Garden (Old Man),
c. 1981

J.R. One of these studies is after Goya. Is it from *Desaster 12*, *Para eso habéis nacido*?

R.B.K. No. It's not from a print. It might be from Goya's San Lucar sketchbooks, which I had at Sant Feliu. I don't know.

J.R. There is a man vomiting in a drawing of the so-called 'Album of Madrid', *Tuto parola e busía*, a study for Capricho 33: *Al Conde Palatino*. But there's a similarity of composition between *Rock Garden* and another Goya drawing, *Cómico descubrimiento*, from the Bordeaux albums. Goya's drawing is also very mysterious.

Study for the Rock Garden (after Goya),
c. 1981

Conveo descubro un coreo

Cómico descubrimiento by Francisco
de Goya (Fitzwilliam Museum,
Cambridge)

R.B.K. Yes, I know the *Cómico descubrimiento* plate you print, but I remember being struck by it *after* I painted *Rock Garden*.

J.R. I also contemplate your garden as a kind of Zen rock garden. In the Zen-inspired art of rock and sand gardening, or *bonseki*, the stones are carefully arranged, and each one is individually named after a spirit in the Buddhist pantheon. Could you name the headstones in your garden? Is it a secret garden or a transposition of your house's back garden?

R.B.K. I would *love* to name the headstones but the time is not ripe. It *is* a transposition of my garden. I've wanted to make some large sculptured heads and place them in my garden since I saw the great heads (Kings of Judaea?) knocked off Notre-Dame by revolutionary mobs and now in the Cluny Museum. I hope God will send me some energy for this plan.

J.R. Since the beginning of the Diaspora a long succession of Messiahs, some of them Spanish or with Spanish ancestry, such as the notorious Shabbetai Zevi, have made their marks on the history of Judaism. In this messianic mess everything can be found: mad messiahs or *meshuggeners*, visionaries, charlatans, mystagogues, mystifiers, *picaros*, fanatics, cabbalists, holy men, justified sinners, pious and naïve persons ... In which group will you rank your false Messiah? Who is *Messiah (Boy)*? If I may ask or if you can unearth the secret, although a cabbalist would say that there is always a secret under the *Sod* ...

R.B.K. *Messiah (Boy)* began a good many years ago as a copy of a little street girl by Whistler which I gradually cut down and repainted until I imagined the boy. Since everything else in Messianic literature is various and speculative, so must be the look of the Jewish Messiah, who never existed.

Messiah (Boy), 1982–6

J.R. The Bakunin face from *The Red Banquet* (1960) seems to arise from a tormented nineteenth-century Russian novel. Actually Bakunin was the model for Rudin, the protagonist of Turgenev's novel of the same title. Rudin belongs to that species found in Russian novels, the 'superfluous man', in company with Eugene Onegin, Oblomov, Pechorin. But if Bakunin was not always effective in his time as a revolutionary, his ideas, or rather ideals, would eventually act as a kind of time bomb many years after his death, especially in Spain, the adopted country of anarchism. Since *The Red Banquet* has a collaged 'footnote', we could now put beside the rude face of the prophet of anarchism his own famous words, from his first article, 'Reaction in Germany' (1842): 'The passion for destruction is also a creative passion.' This is not only an anarchist slogan, but an artistic

Bakunin (detail of *The Red Banquet*),
1960

one, as we can see from Mallarmé ('Destruction was my Béatrice')
to Picasso ('In my case a picture is a sum of destructions'), not
to mention Dada. In the case of Picasso, destruction is at the
vortex of his creation. 'The Destruction or Love' – this title by
a Spanish poet, Vicente Aleixandre, could serve as a résumé of
Picasso's whole career. Of course it's a constructive destruction.
But getting back to Bakunin, what interested you most about
him at the time you painted *The Red Banquet*?

R.B.K. I was never inclined towards anarchism. I used to
'watch' its followers as I now 'watch' religion and its prophets
of faith. I've been a selective watchman – I suspect you are too.
We educate ourselves in the thousand strange ways men find to
follow their passions, no? Like Picasso, I also believe in
constructive destruction. Maybe that means a very personal
deconstruction, where nothing is certain and one's own creative
faculty becomes the unique agent of constant metamorphosis.
In *The Red Banquet*, my youthful eye caught sight of these
incredible anarchists being entertained by American Jeffersonian
Democrats in far-off London and a kind of *Demoiselles d'Anarchisme*
presented its own theatre, like Picasso's philosophical
whorehouse.

J.R. After our words about destruction, we can now
contemplate *The Buddhist*, also called *The Rival Poet*, which with
two other oils on canvas, *They Went* and *Alone*, belonged to a
larger one you painted in New York in 1965, *Primer of Motives II
(Intuitions of Irregularity)*, and destroyed afterwards. Did this happen
in New York, shortly after you had finished painting it? Could
you say what were the motives that provoked that destruction?
Some intuition of irregularities?

R.B.K. I cut it up so the poor private parts could breathe.
The title was from Kenneth Burke, another American
obscurantist, like me; I lost faith in the picture, in the title and
in the wayward life I was leading in New York, so I cut my
losses and returned to London with my tail between my legs.

J.R. Are you completely sure that work was not a good one,
or that its three extant parts are better than the whole? Francis
Bacon destroyed some good works of his only because on certain
occasions the destruction 'instinct' was stronger than the
preservation one. But perhaps your *Buddhist* could stress a
Buddhist principle, older than any of physics: nothing is created
or destroyed, but everything transforms us.

R.B.K. To be transformed each morning, in front of each picture, to have forgotten how to paint and draw from one day to the next. How great. Yes, let my Buddhist stand for that!

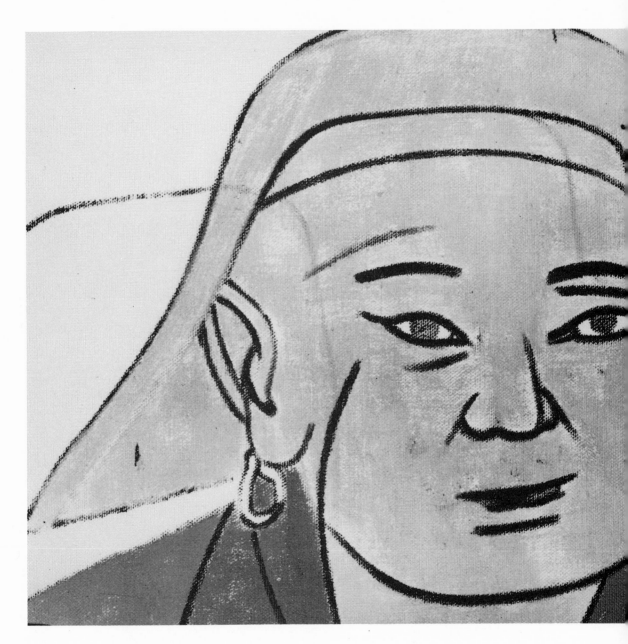

The Buddhist, c. 1966

J.R. *The Buddhist* could also be included in a special gallery of types, some of them real and others in part recreated, I presume, but all of them from foreign cultures: *The Arabist, The Orientalist, The Slavist, The Hispanist.* Besides being individuals they are also composite portraits, a compendium of their own cultural strata. It appears that *The Orientalist,* for example, was inspired by Hugh Trevor-Roper's biography of the enigmatic Sir Edmund Backhouse, but I would guess that other Orientalists, perhaps closer, were the models for this portrait. Am I right or not?

R.B.K. He is a compendium. I made him new. '

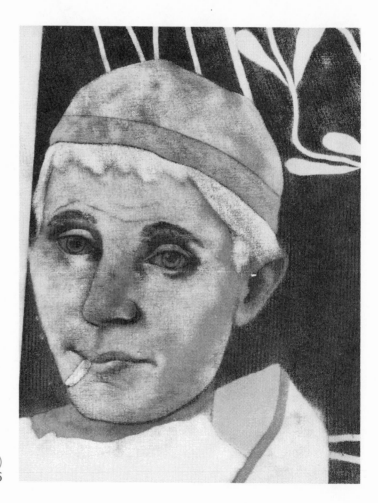

The Arabist (formerly *Moresque*) (detail), 1975–6

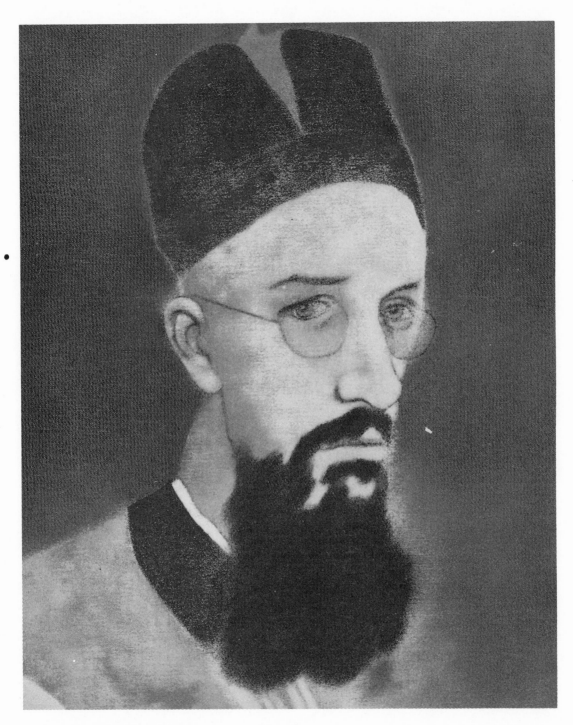

The Orientalist (detail), 1975–6

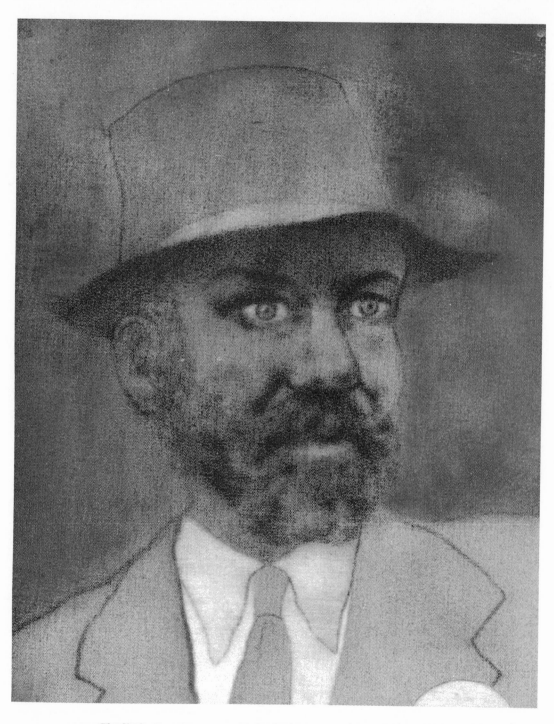

The Slavist, c. 1977

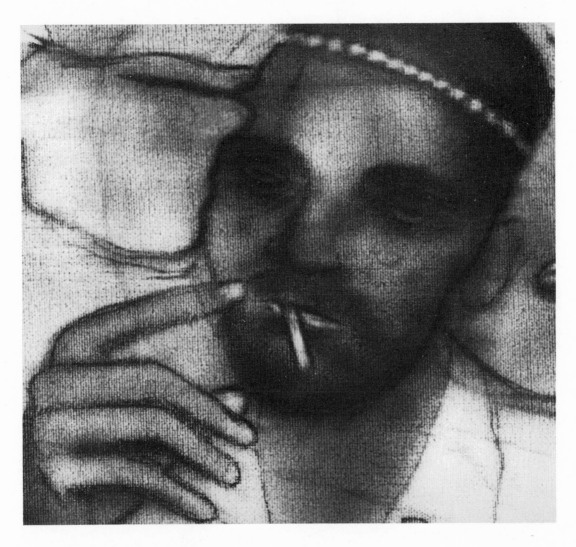

After Giotto (detail), 1977

J.R. Giotto seems your most important and providential 'provider' of heads. *After Giotto* is perhaps the least faithful – a composite variation on the Christ and the black flagellant from the *Flagellation*, in the Scrovegni chapel, I think. By contrast, this other head, *Tallien*, bears a great resemblance to that of St Stephen in Florence's Horne Museum.

Tallien, c. 1985

R.B.K. The Horne Museum was closed when I tried to get in there. This head belongs to Frederic Tuten's book, *Tallien.*

J.R. Last, this head with a helmet reminds me of that of the Roman soldier who raises his right arm in the dramatic scene of *Jesus before Caiaphas.* Or does your bad soldier come from a different legion?

R.B.K. He's a Chinese soldier from a failed and destroyed painting called *South China Sea.*

South China Sea (detail), *c.* 1966

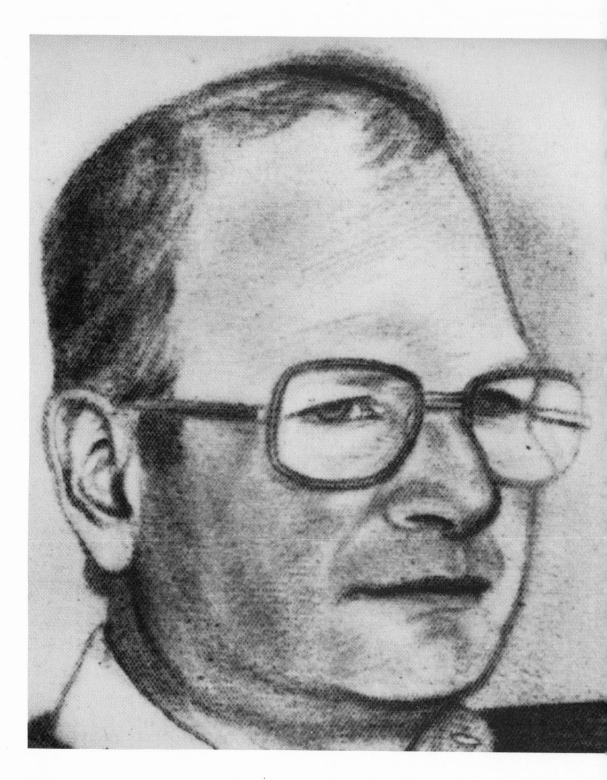

J.R. David Hockney, in his *David Hockney by David Hockney*, tells the story of his 'disembarkation' at the Marlborough Gallery, in 1961, with a bundle of pictures under his arm. Nobody there liked them except James Kirkman, who 'bought them for about ten pounds each'. I don't suppose – it would be too much – that in his private collection there are also some old ten-pounder Kitajs?

R.B.K. James is a friend without Kitajs *except* this portrait, traded to him for a Hockney.

J.R. From *David Hockney by David Hockney* I also found out that you first met the poet W. H. Auden in Hockney's company – in 1968, I believe. Hockney saw Auden as a grumpy and talkative man, complaining, for example, of a pornography invasion. What was your first impression of him?

R.B.K. Those incredible wrinkles, furrows drawn down his face. As we left, I asked Hockney if he thought the furrows went right down to his balls.

J.R. Before you was an English poet who in 1939 chose to live in America and became a US citizen, compensating in a way for the imports – James, Eliot, Pound. According to Borges, reality likes symmetries and slight anachronisms: did you see yourself reflected in Auden's inverted mirror?

R.B.K. No, I couldn't warm to him.

J.R. Did you portray him at the same time David Hockney did? Is your canvas portrait of Auden based on life drawings?

R.B.K. A poor likeness drawn on the spot there on a small canvas, no other drawings. *Caput mortuum* again. The drawing is not bad – it just doesn't remind me of him.

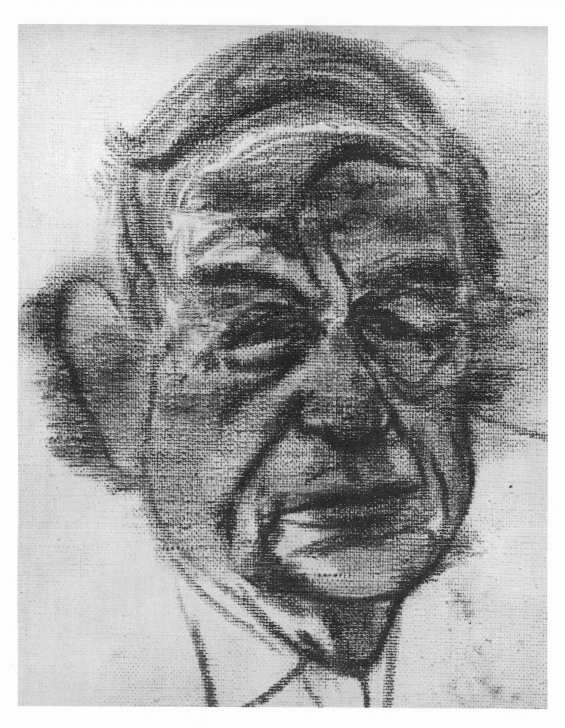

W. H. Auden, 1969

J.R. In 1964 you travelled to Lanark, Scotland, to visit the Scottish poet Hugh MacDiarmid. I imagine he didn't talk to you in Lallans or in his Synthetic Scots. Or perhaps he did about art questions. Do you retain a clear memory of that meeting? In your portrait he looks quite grieved.

... the principal question
Aboot a work o' art is frae hoo deep
A life it springs – and syne hoo faur
Up frae't it has the poo'er to leap.

Hugh MacDiarmid, *from* Second Hymn to Lenin

R.B.K. I enjoyed a wonderful, vivid visit to his little border crofter cottage, where he lived with a mad, firebrand wife. He told Hockney, 'Kitaj's portrait showed my anguish at the Modern World.' Said in his Scots brogue. Yes, Grieve grieved. He was an old Communist/Scots Nationalist sweetheart unlike W.H.A. I visited him with Jonathan Williams, but I think I drew him at a later meeting one evening when he was staying in London with Sean O'Casey's widow.

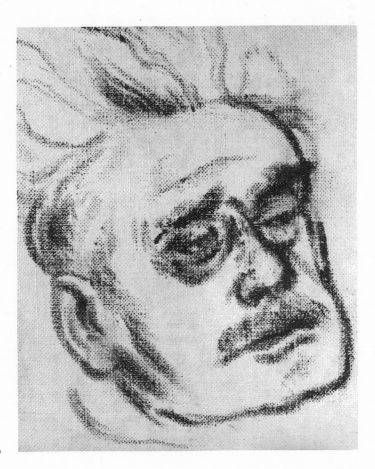

Hugh MacDiarmid, c. 1965

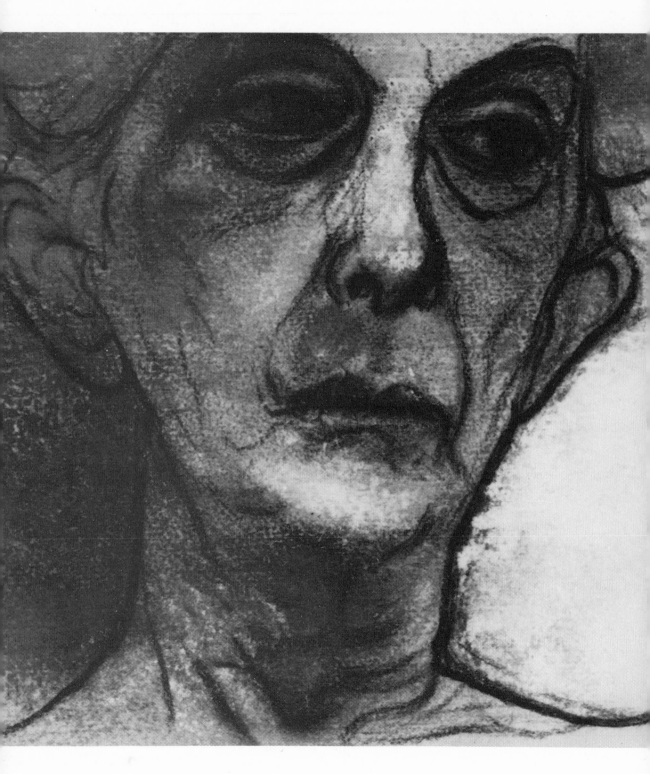

234

Quentin (detail), 1979 **J.R.** Which MacDiarmid interested you most: the language
forger, the Nationalist, the Marxist? Or the explosive
combination of all that? Like any complex artist, he was a
contradictory person in conflict with himself – at war with his
innards, as the Spanish poet Antonio Machado said. His
individualism, for example, didn't exclude an inclination towards
authoritarianism. If all this didn't appeal to you, at least it could
have fascinated you at that time, I suppose.

R.B.K. Fascinating, complex explosion, yes. And a palpable
compassion and even modesty. He was a Bukharin, Trotsky,
Radek, etc., who would be shot against a wall come the
revolution. What blinds these Leninist types, I wonder?

J.R. Here is *Quentin*, with a sad face. It seems you discovered
the secret of the Old Masters about *pain*ting. Yes, Auden saw
with lucidity, in 'Musée des Beaux Arts', that about suffering,
the Old Masters were never wrong. You have portrayed naked
the 'Naked Civil Servant', Quentin Crisp – a lesson in the
anatomy of melancholy. Is he an old friend of yours?

R.B.K. No, but he lived for forty years on my corner in a
squalid (rent-controlled) room, never cleaned. He often walked
past my house with his purple hair and unique drag. One day I
introduced myself and asked him to pose, which he did,
beautifully. He said he loved New York and he went there to
die in, I suppose, the squalid celebrity in which he lived.

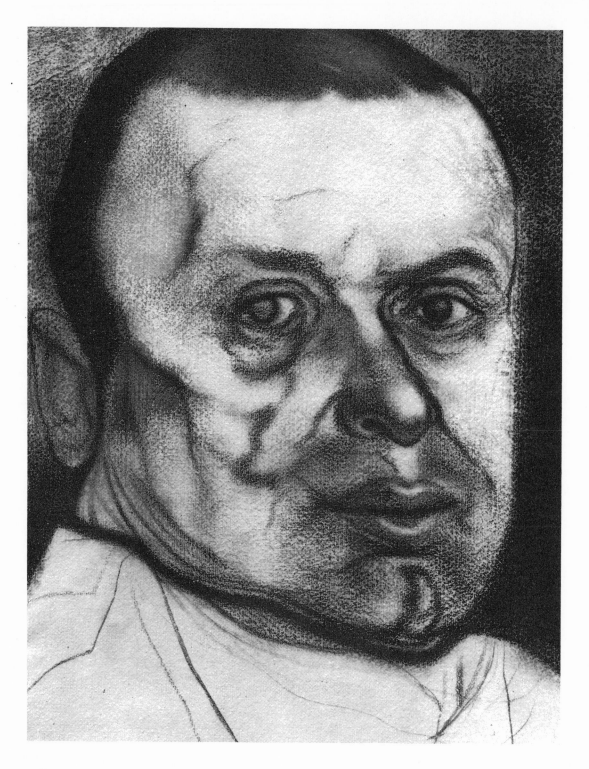

Doctor Kohn, 1978

J.R. Let us now turn to one of your most intense portraits: is Dr Kohn a psychiatrist?

R.B.K. This portrait drawing was not done from life exactly, but from a tiny sketch I drew of the doctor in Los Angeles in 1967. He lived in a fine house full of Corinth, Kubin, Liebermann and Slevogt drawings, and pretty women were always about. The final drawing, which I made at Dartmouth College, is in a sort of magic-realist style I used only a few times – I think because I'd just been taken near by to visit Ivan Albright just before *he* died, and he infected me, but also because Dr Kohn came out of a lost world where he had, for a time, touched souls with two magic-real men, Jiri Langer and Franz Kafka.

The human face is indeed like the face of the God of some 'Oriental theogony, a whole cluster of faces, crowded together but on different surfaces so that one does not see them all at once.

Marcel Proust, Remembrance of Things Past

J.R. Not unlike the moon, each face has several faces, or phases. The double-faced kinetic figure in your *Bad Faith* (*Warsaw*) and the moon faces/phases of your 'Voyage to Pogany', in homage to Brancusi, reminded me of a 'Cubist' passage in Proust's *Remembrance of Things Past* which is an invitation to explore the human face. *À la recherche des visages perdus* ... A face seems inexhaustible. The most exciting surface on the whole earth, as Lichtenberg put it. When you were portraying your most explored models, like Marynka or Mary-Ann, did you get the impression of discovering in them hidden faces/phases?

R.B.K. Oh yes! And the affinity or symmetry between the unique 'faceprint' and the 'everyface' is orgasmic.

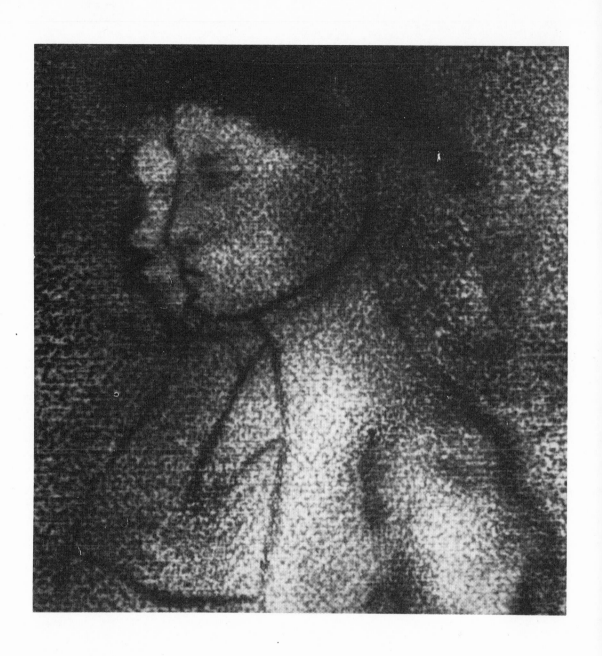

Bad Faith (*Warsaw*) (detail), 1978

238

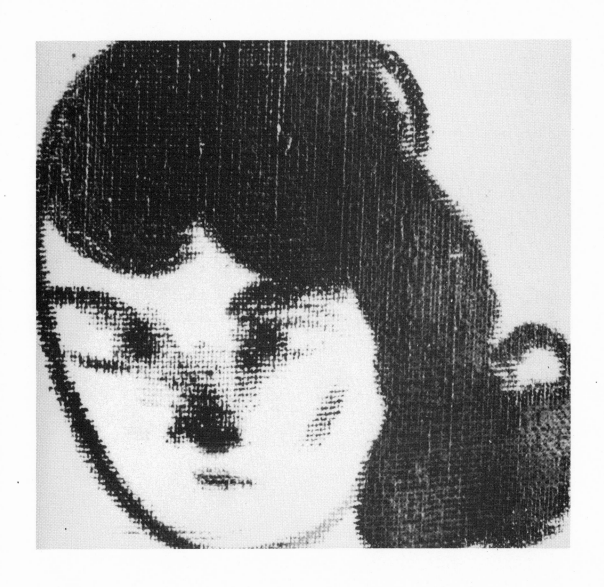

Pogany (detail), 1966

Marynka Pregnant in Black and White
(detail), 1981

Pogany II, 1966

241

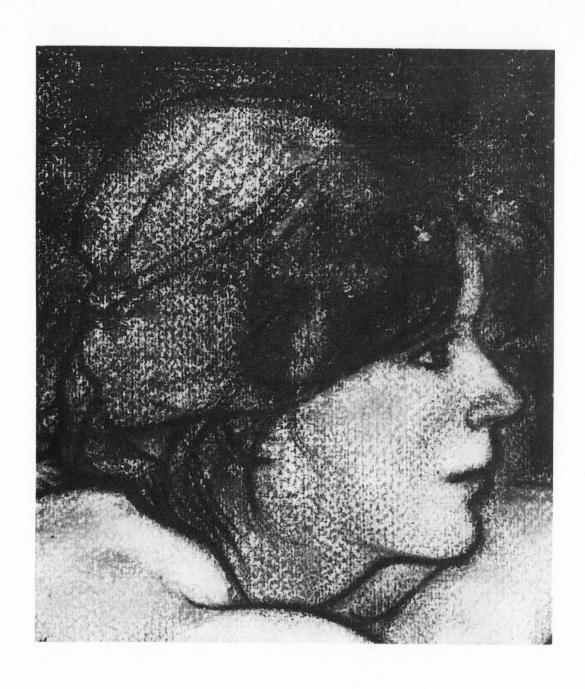

Mary-Ann Profile (face right), 1980

242

Pale Face, c. 1971

243

J.R. A mist of mystery veils this *Pale Face*. Who is she?

R.B.K. My first wife in death.

J.R. I think you painted the portrait of your mother, *The Mother*, from life, although I suppose you can draw her features even with your eyes closed. When did you first portray her?

R.B.K. She is not *my* mother. She is an imagined mother. I will write a Midrash on her before long. *My* mother, Jeanne Kitaj, appears in the following portrait, which was drawn from life. I only began to draw her after 1981, when Dr Kitaj died.

The Mother (detail), 1977

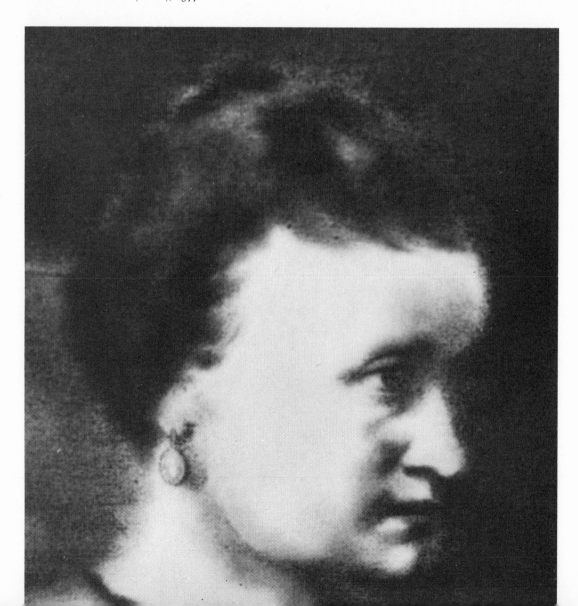

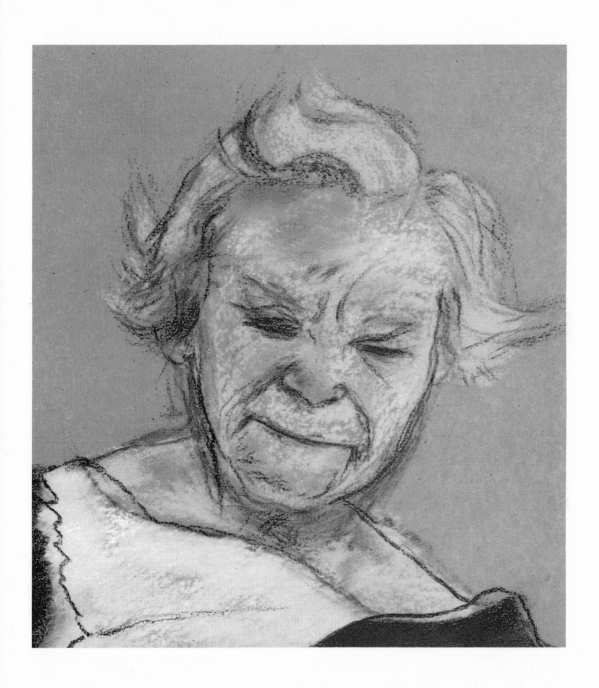

Mother, 1983

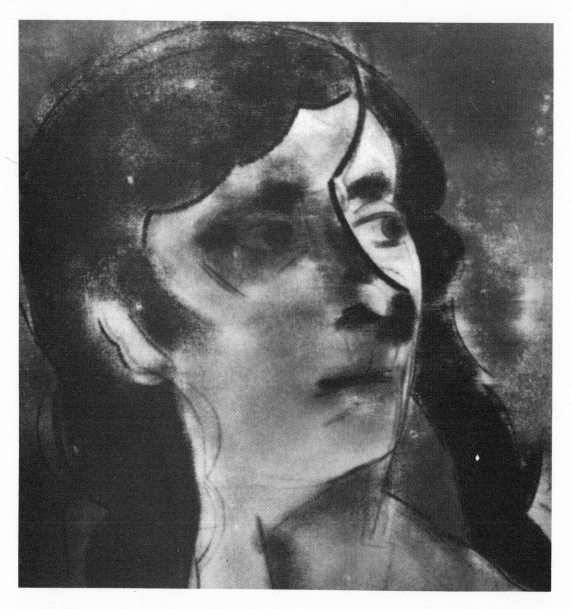

Still (The Other Woman) (detail), 1973

J.R. Is *The Other Woman* based on a film still or was she painted from life? Or a combination of both? Still life, at the still point?

R.B.K. The profile within the face is a gift from Picasso of course. There is a real-life story swirling around this picture which I haven't got around to writing yet. When I do that, I like to think I begin to unfinish a picture – a concept to which I'm devoted.

J.R. Warning to monogamists: *Les maris honnêtes sont les marionettes*. The head of *Mon Mari Est Polygame* is a strange one. It seems a *casse-tête*, so to speak, made of different parts from different heads. Or maybe it is a dissembled head, with false braids.

R.B.K. Yes, dissembled after Michelangelo, etc.

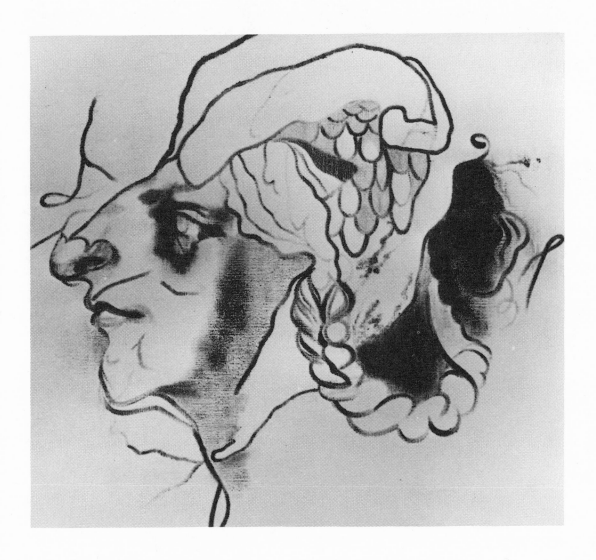

Mon Mari Est Polygame (detail),
1964

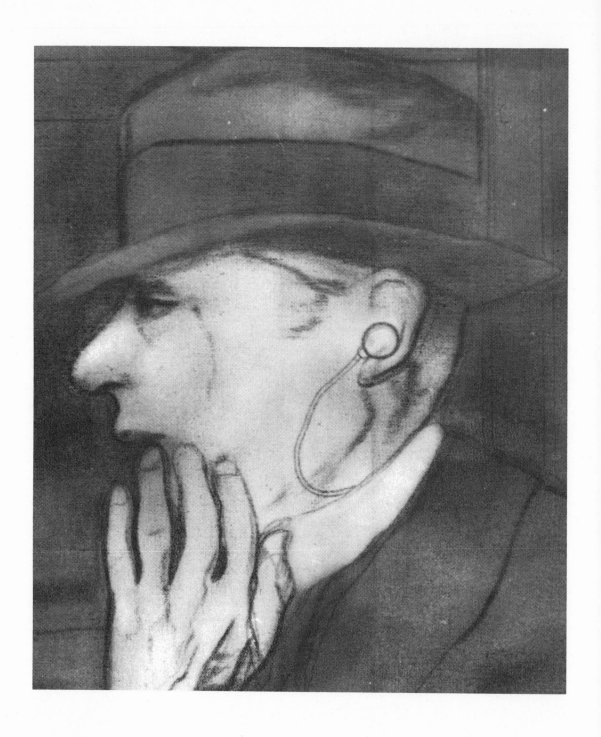

The Jew, Etc. (detail), 1976–9

J.R. Sometimes your train travellers have the appearance of real people. For example, it seems that *The Jewish Rider* (1984–5) is the art historian Michael Podro. In the archetypical *The Jew, Etc.*, your character Joe Singer rides again in what you have called 'his expiatory pilgrimage'. Joe Singer with no fixed body. Is his face in this painting based on a real one? Since he is a representative of your own *Galut* (exile), could he have borrowed something from you, besides the hearing-aid?

R.B.K. The face is invented. He borrows my longing, my romance; not my face.

J.R. Was this image of '*la petite morte*' a life drawing?

R.B.K. Yes. *Orgasm* was drawn from life.

Orgasm, 1975

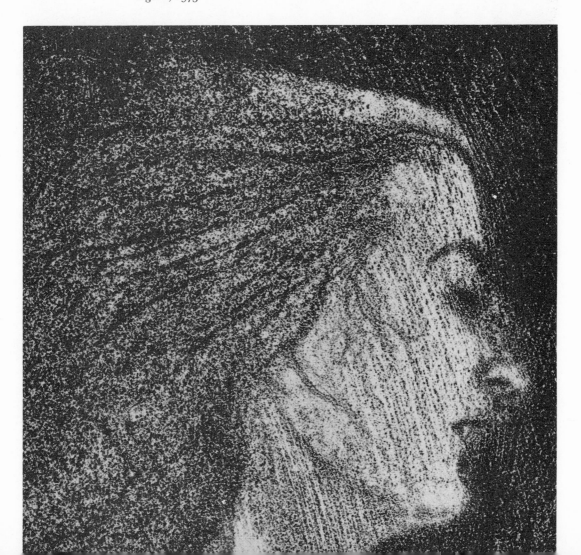

Amerika (John Ford on His Death Bed), 1983–4

AMERIKA (II)

Dearest Alice, I could come back to America (could be carried back on a stretcher) to die – but never, never to live.

Henry James (to Alice James)

J.R. In January 1987 you left London for Los Angeles, planning to be there at least six months, but you returned home long before that. You wrote to me from London, in February of that year, 'Los Angeles did not work out this time but we'll try again next year.' Your letter made me think immediately of Henry James's letter to his sister-in-law expressing the impossibility of living in America. But the comparison was neither exact nor fair, because, it is true, *you* always try.

For this chapter I would like to take as a point of departure your last voyage to America, or, in almost a quixotic sense, your last 'sally', because there are some similarities between the struggle of the Spanish knight's ancient ideals against the materialism of the modern world and, *mutatis mutandis*, your own struggle against the art factories and picture mills. It would be appropriate now to examine your *John Ford on His Death Bed*, which telescopes several scenes from different films by your favourite movie director. This preference, like some of your literary ones – Hemingway, for instance – is quite curious, since there aren't many affinities between his artistic personality and yours. Of course, a true artist is always longing for his opposites. Or is trying to be plural reconciling them.

The portrait of a capped Ford, with rosary in hand to emphasize his Catholicism, is based on a photograph you took

John Ford (photograph by Kitaj),
1970

of him in 1970 in Hollywood. Besides the photo, does something remain of that visit that could have had some influence in your painting fourteen years later? What impressions do you keep of Ford at home?

R.B.K. I made some sketches of Ford that day in 1970, by his bedside. They're no good. No one has ever seen them, but I can't bring myself to destroy them yet. My older son, Lem, who visited Ford with me, keeps a vast Ford archive at Elm Park Road, which I plundered for the painting. I think there *are* affinities, elective and otherwise – Romance, America, slightly fake macho, playing the Rebel, etc., but opposites too, yes.

J.R. What was the 'plot' of the epic Hollywood picture you started to compose and destroyed in 1970?

R.B.K. It looked like a movie poster – a pile of montage, like the pilot for *The Autumn of Central Paris*, but worse. The 'plot' was being worked out in the doing, like *Casablanca*, like a Hollywood movie where they don't know what they're doing. I put my foot through it at a beach house on the Pacific Ocean.

J.R. In the photograph, as well as in your painting, Ford has a baseball cap, it seems. Baseball is one of your perennial passions – a subject you 'catch' in several paintings, especially from 1967, the year you painted *The Williams Shift (For Lou Boudreau), Sisler and Schoendienst, Batboy*. The year before, 1966, you spent the month of April at baseball training camps in Florida, making drawings for *Sports Illustrated*.

Your most recent baseball picture, *Amerika (Baseball)*, is inspired by Velázquez's *La Montería del Hoyo (La Tela Real)* or *Boar Hunt*, which is in the National Gallery and represents one of Philip IV's extravagant hunts in the royal park of El Pardo. There are more than a hundred figures in the painting – a sort of résumé of the *dramatis personae* of Velázquez's whole work – and the parabolic perspective, adopted by the painter to delimit the oval where the hunting happens, makes one wonder if he was not in fact the inventor of the wide-angle shot. I suppose also that the free, secure and discontinuous brushstrokes which define even the minor details of the painting – and each fragment can be isolated and has a value and a meaning in itself – compelled you to transpose the hunt to a baseball anthology. The goads of the knights are transformed into bats. But I conjecture that in your painting not only the past of painting intervenes, but also your own past times, the memories of baseball games. Perhaps there are even some vestiges of the baseball players you drew as a boy in the margins of textbooks?

R.B.K. Ford's cap is an admiral's bridge cap, not a baseball cap. I believe he was made an admiral for filming the battle of Midway, but I'm not certain. As to my painting after Velázquez, you see it very well. At this moment I have little to add to what I wrote in the preface about this picture in the Phaidon book.

J.R. Let's then quote your words:

> For most of my life I've lived thousands of miles away from real baseball and I've got to recollect such things past from an English setting which has warped time through these thirty years of mostly exile from the Summer Game; in fact, since my poor lost tribe of Cleveland Indians last won a pennant and began their three decades

Amerika (Baseball), 1983–4

of decline by blowing four straight to Leo Durocher's Giants in the '54 Series. I sometimes fear my own decline began in that fall of 1954. Proust's sessions of sweet silent thought have deluded me into painted remembrance and I've not taken Satchel Paige's advice: 'Don't look back; something may be gaining on you.' Any baseball folk over the age of fifty who look hard will find that great man (Paige not Proust) in my painting, as I remember him when Bill Veeck brought him up to Cleveland from the Negro League in old age.

LUMINOUS DETAILS

A little light, like a rushlight
to lead back to splendour.

Ezra Pound, *Canto CXVI*

J.R. Since we have begun this chapter under the auspices of 'il miglior fabbro', I would like to recall an episode of his life which can be related to the detail reproduced here from *Junta* (1962). Twenty-year-old Ezra Pound was in Madrid, one of the crowd witnessing the parade on the wedding day, 31 May 1906, of King Alfonso XIII and Victoria Eugenia of Battenberg, when an attempt on the lives of the royal newlyweds occurred. The Spanish anarchist Mateo Morral threw a bomb similar to the one in *Junta*, hidden in flowers, at the King and his bride. Both just escaped, thanks to the King's presence of mind (*noblesse oblige!*), and Mateo Morral, who managed to run away in the confusion of the moment, committed suicide some days later, surrounded by the police. Your bomb blows up one of the commonplaces of Anarchist terrorism: the bomb of the flowers – there is no rose without a thorn. But the *Junta* bomb is not the typical ball with a fuse; it looks more like a mine. Could you specify what kind of bomb is in *Junta*?

R.B.K. I don't remember. I think it came from an Anarchist pamphlet I don't have any more.

Our Bomb of the Flowers (detail of
Junta), 1962

J.R. At the top of Giotto's *Last Judgement*, on both sides of the
great window, two archangels are rolling up the universe scroll –
the great book of the world. *L'Universo si squaderna*, it is said, in
the *Divine Comedy*. The representation of the great theatre of the
world is on the point of concluding. The fact that in *London,
England (Bathers)* you reuse Giotto's form, a sort of inverted
'comma' before the final full stop, seems to suggest or reinforce
the apocalyptic content of your painting. Does this detail also
represent a Last Judgement? World's End or the Flood in
London?

Detail from *The Last Judgement* by
Giotto in the Scrovegni Chapel,
Padua (photograph: Scala)

R.B.K. The detail is from Giotto of course. But I did not
intend a Last Judgement. Rather when I come to write its
preface I think I will describe an island capital dominated by
the sea all around (unconventional seas and channels to be sure).
As if she were a forbidding sea power still, Britannia had just
attacked Argentina and I concocted this Junior Apocalypse in my
Paris studio. Its iconography I will draw out slowly later.

J.R. You have frequently been inspired by Giotto. Some of his
faces are deeply engraved in your memory, as we have seen in
'Heads or Tales'. Perhaps it would be appropriate here to point
out that the gesture of the man in *His New Freedom* with the
hand on his chest recalls that of Caiaphas in Giotto's *Jesus before
Caiaphas* and especially that allegoric figure in his *Anger*. Isn't
that so?

London, England (*Bathers*) (detail),
1982

R.B.K. Yes indeed.

259

His New Freedom, 1978

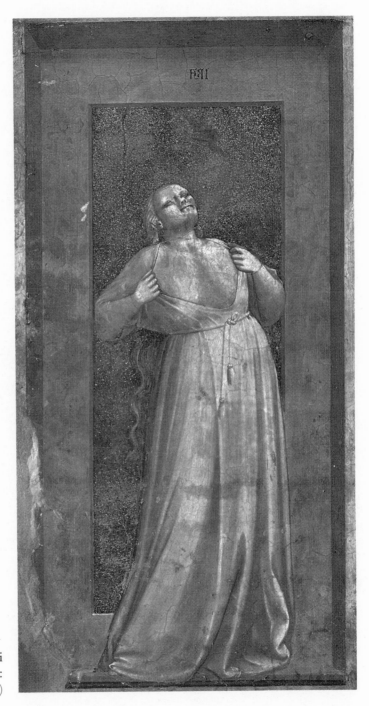

Anger by Giotto in the Scrovegni
Chapel, Padua (photograph:
Scala)

If Not, Not (detail), 1975–6

J.R. The Auschwitz gatehouse at the top of *If Not, Not* seems to me a sort of anthropomorphic building, a monster head *à la* Arcimboldo, and besides makes me think of the 'mouth of hell' in Bomarzo: *Lasciate ogni speranza voi ch'entrate …*

R.B.K. Those are superb readings I never thought of!

J.R. There is no revisionism without perils, but anyway can you now revise these two fragments of *Teenage Oil Painting*? Do you remember the theme in general? Can you shed some light on these two details?

Teenage Oil Painting (Fragment A),
c. 1950–51

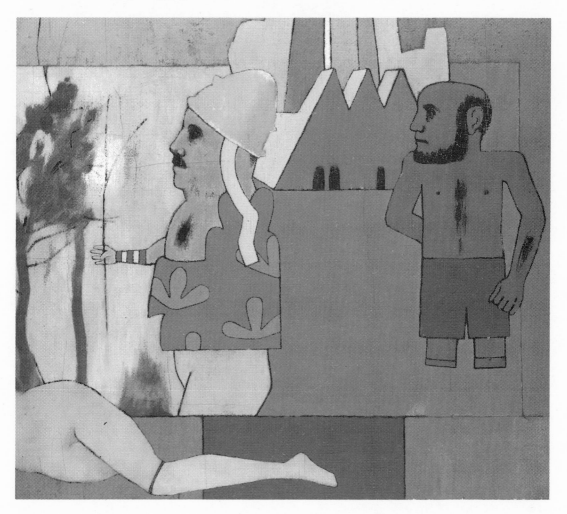

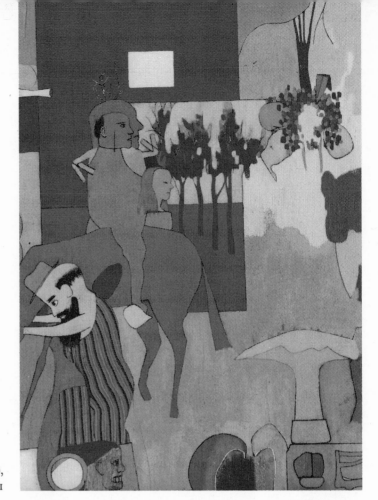

Teenage Oil Painting (Fragment B),
c. 1950–51

R.B.K. Like quite a few pictures in this book, these have never been reproduced before. No one has ever seen the originals, either. I cut them from a large painting which I began in New York as a teenager. I carried that damn painting to Vienna and then arrived with it and worked on it in Sant Feliu before I cut it up into fragments. The style was influenced by a teacher in New York at the Cooper Union, my first art school. He was a very neglected early American surrealist-symbolist named Delevante. He recently died unknown, aged about ninety. I have tried these last few days to extract a story from these fragments of forty years ago, but I have failed. You are welcome to try, Señor Novelist.

LONDON

Odds and Ends (from a London Notebook)

31.10.87. Grey Saturday. By Hungerford foot bridge, late afternoon. Shades of grey: clouds, water, the concrete masses of the South Bank, but vague behind the rain. The lights of the Royal Festival Hall, moored there on the other bank of the river. Suddenly the lightning and the explosion in the rails here near by when the train passes. Rain, train and speed.

Another burst, copperish, on entering minutes later the Hayward Gallery. Dark rump and calla lilies.

Rivera revisited – some months ago this retrospective was in Madrid. Before the Cubist portrait of Ramón Gómez de la Serna stands an elegant elderly couple, both with bluish eyes and tanned faces. *El Libro Mudo. The Silent Book.* She reads with an English accent the titles of the books that are in the painting and translates them. *El Rastro. The Trace.* 'A detective story?' he asks. (*El Rastro* is the Madrid flea-market.) In painting, the trace is so often lost.

But I came to the Hayward Gallery to see *The Londonist*, the painting with which Kitaj participates in Art History (Artists look at Contemporary Britain), a complement to the Rivera retrospective. A few days before the opening of the exhibition, I saw in Kitaj's studio the leaflet announcing it, with a colour reproduction of his painting. A muscled man stands reading a Penguin book. Since it wasn't clear from the reproduction, I

The Londonist, 1987

asked Kitaj the title of the book. He said it was *Turn of the Screw.*

There on the back wall is the ten-foot giant deep in *The Turn of the Screw.* His eyes are popping out and I imagine he's devouring the last page of the thrilling novella by Henry James. (But the book is opened in the middle. Precisely. In the Penguin edition – mine is from 1971 – two stories, also remarkable, follow *The Turn: The Pupil* and *The Third Person.*) His eyes are fixed for ever on one passage which will never pass. The last lines? 'We were alone with the quiet day, and his little heart, dispossessed, had stopped.' Miles away, in his little book.

Apotheosis of Groundlessness, 1964

Apotheosis of Groundlessness: in Waterloo Station, when you raise your head, long lighted metallic structures suspended in the night. Edifice of form. Is the title from a poem? And the image? One of Kitaj's most ambiguous. A construction – of the mind? – which awaits its deconstruction.

A few days ago, over lunch together, the hard-to-crack theme of deconstruction came briefly to light – or to darkness. What Kitaj finds particularly stimulating is the provisionality of every reading, including of course the author's.

The Old Vic, London SE1, 1986

As I go down the escalator in the Waterloo underground, I notice a red-sprayed HE added to the title of an Old Vic poster. KISS ME HEKATE. The Greek goddess of magic, of night and ghosts – very appropriate for the descent to the 'underground'. And especially on Hallowe'en night. Altered by the kiss. Kitaj's art is also an art of alteration.

The autumn of central London. Fluttering leaves. Collapsed on a bench, there's a man with a very long white beard who seems to have come out of *London, England (Bathers)*. Dark wet clothes. Or a resemblance to Bill? Shakespeare stares at him, his right hand under his chin.

The man with waistcoat and bow tie closing the reddish curtains of that window in Charing Cross Road. Did Joe Singer ever live in London?

Ghostly steps in Cecil Court, deserted at this hour. A bookshop called EPHEMERA. In the dark display window, the reflections of the glass that protects *Cecil Court (The Refugees)*, seen only a few hours ago in the Tate Gallery. In that painting the man with a bunch of flowers (Mr Seligmann) has in his right ear a hearing-aid. A device that could also serve – only disconnect – to hear silence. As Kitaj does sometimes.

A tramp with two hats – bowler over a wide-brimmed greenish one – pulled on tight, and two plastic bags at his feet, searching in the dustbin. Elegy of hats. Baudelaire's key figure is not the dandy but the *chiffonnier*. The ragman, the tramp. The best interpreter of our time. *Ragtime*. Ask Kitaj if a *chiffonnier* figure appears in *The Autumn of Central Paris*.

A black bottle here in the pub door – DANCING SHOES in neon letters – on the corner of Cecil Court and Charing Cross Road. Kitaj hasn't done very many paintings of London and yet he's spent more than half his life in this city. His friend and companion of the London School, Frank Auerbach, said in an interview that London has scarcely been painted. The visitors – Manet, Derain, Kokoschka – he pointed out, left more things on London than most of its residents. (Visitors or lovers. Who said that cities are women?) Paint London, or let London paint. Because London also paints. And thus the London School, with artists so varied, to confirm it.

The redhead with red stockings peeks out the door – FRENCH MODEL on the doorbell – and hesitates before she runs out into the rain, arms crossed, towards the Chinese restaurant opposite. *La femme du peuple* on a street corner in Soho (transplanted from the rue Saint-Denis?). Do you want to see my 'guenilles', my rags? Rose rags – octopus hanging in the window.

In Lisle Street next to the snack bar – PHO and a bunch of Chinese characters on the sign – the narrow doorway of a worn-out staircase. The guy going up, an immigrant, probably, scratches the back of his head. Dandruff or perplexity? The tramp, the whore, the *motherlandless*, in all of their manifestations: the out-outsiders.

Piccadilly, 1992

THE WHOLLY TRINITY. Black writing on the low wall of
Carlyle Garages in the King's Road, not far from Kitaj's house.

The skinny adolescent, her very white face sooted with mascara,
vomiting against the railings of the National Portrait Gallery.

Rags. Taking flight, on the corner of the Lord Chandos, sheets
of the *Sunday Times*: 'Picasseau', 'Eau-la-la'. Wet words. Put them
out to dry tomorrow.

THE WEST (WASTE) END

Vigo Street, 1991–2

271

De Morgan's House, 1991

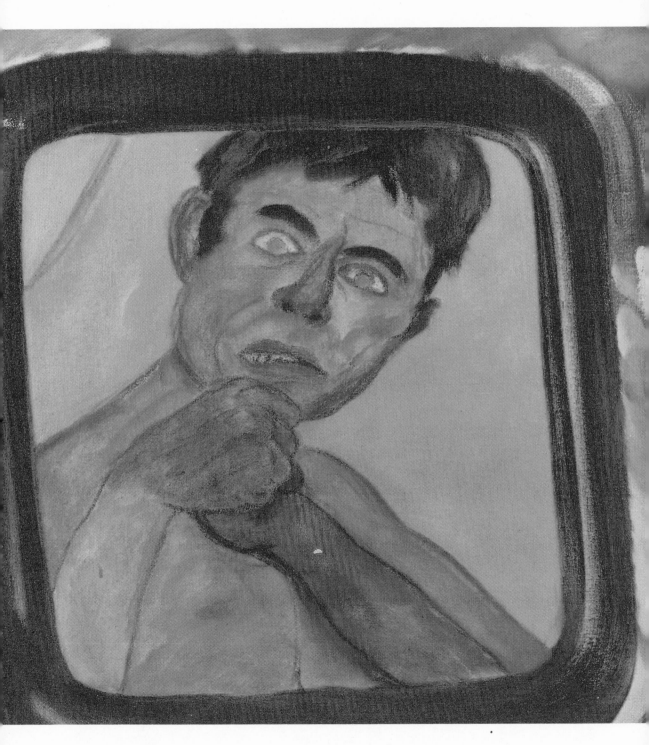

Mirror Boxer (Self-Portrait), 1991

LIST OF ILLUSTRATIONS

274